About the Author

David D. Busch was a roving photojournalist for mor̶̶ ̶ s,
magazine articles, and newspaper reports with awa̶ ̶ ̶ ll
time to writing and illustrating books. He's operated ̶ ̶ ̶ ed
in formal dress while shooting weddings-for-hire, and shot sports ̶ ̶ ̶ nd
Upstate New York college. His photos have been published in magazines as diverse as
Scientific American and *Petersen's PhotoGraphic*, and his articles have appeared in *Popular Photography & Imaging, The Rangefinder, The Professional Photographer*, and hundreds of other publications. He has reviewed dozens of digital cameras for CNet Networks and *Computer Shopper*.

When About.com named its top five books on Beginning Digital Photography, occupying the first two slots were Busch's *Digital Photography All-In-One Desk Reference For Dummies,* and *Mastering Digital Photography.* His 90-plus other books published since 1983 include best-sellers like *Digital SLR Cameras and Photography For Dummies,* and *Digital Photography For Dummies Quick Reference.*

Busch earned top category honors in the Computer Press Awards the first two years they were given (for *Sorry About The Explosion* and *Secrets of MacWrite, MacPaint and MacDraw*) and later served as Master of Ceremonies for the awards.

Credits

Acquisitions Editor
Courtney Allen

Project Editor
Chris Wolfgang

Technical Editor
Michael D. Sullivan

Copy Editor
Lauren Kennedy

Editorial Manager
Robyn B. Siesky

Vice President & Group Executive Publisher
Richard Swadley

Vice President & Publisher
Barry Pruett

Business Manager
Amy Knies

Project Coordinator
Adrienne Martinez

Graphics and Production Specialists
Denny Hager
Jennifer Mayberry
Barbara Moore
Brent Savage
Amanda Spagnuolo

Quality Control Technician
David Faust

Proofreading
ConText, David Faust

Indexing
Kevin Broccoli

Wiley Bicentennial Logo
Richard J. Pacifico

For Cathy.

Acknowledgments

Thanks to Courtney Allen, who is always a joy to work with, for her valuable input as this book developed; to Chris Wolfgang for keeping the project on track; and to tech editor Mike Sullivan, whose more than a decade of experience shooting Nikon-based digital cameras proved invaluable and, as a fellow Nikon D80 shooter, quietly contributed some of the best images in this book. Finally, thanks again to my agent, Carol McClendon, who has the amazing ability to keep both publishers and authors happy.

Contents

Chapter 2: Nikon D80 Essentials 43

Chapter 3: Setting Up Your Nikon D80 55

Part II: Creating Great Photos with the Nikon D80 73

Chapter 4: Exposure Essentials 75

Chapter 5: All About Lenses 89

Chapter 6: Working with Light 113

Chapter 7: Photo Subjects 131

Introduction

The company that we old-timers still think of as Nippon Kogaku (Japan Optical), but now goes by the moniker Nikon, has really outdone itself with its new Nikon D80 camera. The successor to the pioneering and wildly popular Nikon D70/D70s had a high bar to leap, but the Nikon D80 has easily surpassed its predecessor as well as other entry-level models in the line, including the Nikon D40.

Indeed, the D80 includes many of the same features found in Nikon's semi-pro model, the Nikon D200, for a much lower price. If you want a flexible, customizable camera with good performance and excellent image quality, this camera is tough to beat. It's an incredible camera in its own right and can serve as a worthy companion for anyone using one of Nikon's pricier cameras.

Nikon has taken all the features that were less than perfect in the D70/D70s and upgraded them, while adopting some useful features from the D200. For example, the D80's eyelevel viewfinder is big and bright, much improved over that of the D70 series, and the back panel color LCD is a huge and brilliant 2.5-inches (diagonally), compared to 1.8- and 2.0 inches with the D70/D70s.

I love the top panel LCD illuminator switch that's located concentrically with the on/off switch, and I was delirious when I discovered that the self-timer is *sticky*, not needing to be reset after each photo. The new camera is quite D200-like (using a similar 10.2 megapixel sensor), including a Function button that I use to switch between Matrix and Spot metering mode on the fly. Another D200 similarity is a modeling light built into the flash that enables you to preview the lighting effect you're going to get. The D80 has a more useful minimum sensitivity setting, and it uses more compact memory cards. There's an auxiliary battery pack available for extended shooting.

When it was introduced, you could buy the D80 for $999.95 (same as the D70 at introduction) or for $1,299.95 with the interesting new 18-135mm DX zoom lens. What's not to like about this powerful bargain camera?

Well, the manual that's furnished with the camera is not the best. It's thorough and complete, but doesn't explain things as clearly as it could, and you frequently must flip back and forth among two or three cross-references to find everything you need to know. That's one of the reasons I wrote this book: to provide an easy-to-understand introduction to the Nikon D80 and its features, accompanied by chapters on basic photographic concepts and techniques, and a series of recipes you can use to take great pictures in many of the most common shooting situations.

The Nikon D80's Advantages

There is a lot that's new about the D80, but there's also a great deal to like about what this camera shares with its predecessors and the other models in the Nikon line. Here are some of them:

Nikon lenses

Nikon has a vast selection of lenses, including the 18-55mm and 18-135mm kit lenses, which offer lots of versatility and performance at economical prices. You can find dozens of other lenses available from Nikon and third parties that provide excellent value. Of the other digital camera vendors, very few can match Nikon's broad selection of lenses that any photographer can afford.

Full feature set

You don't give up anything in terms of essential features when it comes to the Nikon D80. It has significant advantages over the D70/D70s it replaced, and rivals its more expensive sibling, the D200, in many ways. The D80 has a larger memory buffer, improved color LCD, a nifty black-and-white photography mode, and the ability to shoot both unprocessed RAW files and three quality levels of JPEG format files simultaneously. You can outfit your D80 with a powerful battery pack/vertical grip for pro-style shooting, an accessory that was available for the D70/D70s only from third parties.

Fast operation

The Nikon D80 operates more quickly than many other digital SLRs. It includes a memory buffer that's more than twice as large as the one found in some dSLRs, so you can shoot continuously for a longer period of time. It also writes images to the memory card rapidly. Many D80 users report being able to fire off shots almost as quickly as they can press the shutter release, for as long as their index finger (or memory card) holds out.

One popular low-end dSLR takes as long as three seconds after power-up before it can take a shot. If you don't take a picture for a while, it goes to sleep and you have to wait another three seconds to activate it each time. The D80 switches on instantly and fires with virtually no shutter lag. (Actually, it uses so little juice when idle that you can leave it on for days at a time without depleting the battery much.) Performance-wise, the D80 compares favorably with digital cameras costing much more. Unless you need a burst mode capable of more than three frames per second, this camera is likely to be faster than you are.

Great expandability

There are tons of add-ons you can buy that work great with the D80. These include bellows and extension rings for close-up photography, and at least three different electronic flash units from Nikon and third parties that cooperate with the camera's through-the-lens metering system. Because Nikon dSLRs have been around for awhile, there are lots of accessories available, new or used, and Nikon cameras are always among the first to be served by new gadgets as they're developed.

Where to go from here

If you're brand new to digital photography and digital SLRs, you should spend a lot of time with the Quick Tour, which includes all the basic information you need to learn just enough to go out and begin taking pictures. There's no need to memorize all the controls and learn what every function is. You can learn more making a few basic settings and then going out and enjoying yourself by taking a few hundred great photographs.

Within a short period of time, you'll be eager to learn more, and you can begin reading Chapter 1 to discover the location and function of all the dials, buttons, and other controls that are on the D80. You can learn about different exposure options in Chapter 2, how to use automatic exposure, work with the retouch menu to fix red-eye defects, or do minor fix-ups of your photos.

When you're ready to customize the more advanced settings of your camera, you can find everything you need to know in Chapter 3. But I think you probably want to take a detour first into the photography basics chapters of this book. Learn about exposure in Chapter 4, discover how lenses work and how to select the lenses you need in Chapter 5, and read everything you need to know about working with electronic flash and natural light in Chapter 6.

Should you want some tips for taking pictures under a variety of photo situations, you can find discussions of photo subjects like animal and action photography, fireworks, landscapes, sunsets, and close-up photography in Chapter 7. This chapter also discusses recommended lenses, settings, accessories, and shooting techniques to get the kind of pictures you expect from your D80.

Because this is a field guide, rather than a software manual, you won't find instructions in this book about how to use Photoshop or similar programs. In Chapter 8, you can find an introduction to Nikon Capture NX and other tools. If you're having trouble with your D80, you might find the troubleshooting tips in the Appendix helpful.

That's a lot of material to cover in a guidebook that I hope you carry along with you as you go out in the field with your D80; I hope I've given you the help you need to take the kind of pictures you expect.

Quick Tour

Y our Nikon D80 is one smart pixel-grabber. Even if you're a new recruit to the ranks of digital photography, you can easily take great pictures the first time you fire up your D80, using only the most basic settings. This camera is intelligent enough to set sharp focus for you and calculate the right exposure so you'll get clear, sharp photos immediately, even before you've explored the full range of its features and capabilities.

But wait — there's more! Although you can be taking good photos five minutes after you take the D80 out of the box, you can be shooting even better images if you take the time to read through this Quick Tour to become familiar with the camera and a few of its dials and controls. Although the D80 is a digital single lens reflex (dSLR) that works very well even if you have little or no experience with photography, it operates even better the more you know about it.

Unpack your D80, mount a lens, charge and insert the battery, load a memory card, and you're ready to go. Perhaps you're a more experienced photographer, someone who understands shutter speeds, f-stops, focusing, and has already taken a peek at the manual that comes with the D80. If not, I tell you everything you need to know about the most important aspects of digital photography later in this book. There's plenty of time to learn all that. Someone once said, "Do the important things first, because where you are headed is more important than how fast you are going."

This Quick Tour is one of those important things, an introduction that can help you get up to speed quickly. You can learn just the basics now, so that the good-looking images you produce during your first shooting session will whet your appetite to learn more.

Selecting a Shooting Mode

Turn your D80 on by rotating the lever that's concentric with the shutter release clockwise to the On position. Then, choose

an appropriate shooting mode for the kind of pictures you want to take, using the Mode dial on the left corner of the top panel of the camera. If you're willing to let the D80 make all the decisions for you, rotate the Mode dial to the P (programmed exposure) or Auto (full auto exposure) setting. Either of these works well for most picture-taking situations.

Programmed exposure mode

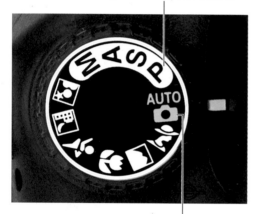

Full auto exposure mode

QT.1 Set the Mode dial to P (programmed exposure) or Auto (full auto exposure) if you want the D80 to make all the shooting decisions for you (other than when to press the shutter!).

Or, you can select one of the semiautomatic or manual modes (A, S, or M) or any of the six modes dedicated to specific kinds of shooting situations that Nikon calls Digital Vari-Program (DVP) modes (you may know them as Scene modes if you've used other digital cameras.)

Cross-Reference *I explain the use of DVP, P, A, S, and M modes in more detail in Chapter 1.*

In addition to Auto, there are six DVP modes that use settings appropriate for common types of shooting situations, such as portraits, landscapes, close-ups, action pictures, night scenes, and night portraits. These "scene" modes make all the adjustments on your behalf and, at the same time, limit how much fine-tuning you can do. Think of them as "auto-pilot" modes you can use when you're in a hurry and willing to trust your Nikon D80 to choose the most suitable settings for a particular type of picture. DVP modes give you a high percentage of good shots, even though, once you become more familiar with the camera, you can probably do a better job of tweaking the settings yourself. That's especially true when you want to make adjustments for creative purposes, say, to make a picture lighter or darker to produce a specific mood or look. The modes are as follows:

✦ **Full Auto.** *When to Use:* When you're taking quickie shots, or when friends who aren't familiar with your D80 use it. *Don't Use:* If you want absolutely consistent exposure from picture to picture. The Full Auto setting treats each shot as a new picture, and may change the exposure if you shoot from a different angle, or compose your image slightly differently.

✦ **Portrait.** *When to Use:* When you're shooting a portrait of a subject close to the camera. *Don't Use:* If your portrait subject is not the closest object to the camera, as the Portrait mode optimizes exposure and tones for the subjects nearest to the lens.

✦ **Landscape.** *When to Use:* When you want extra sharp images and vivid colors of distant landscapes. *Don't Use:* If you want to use flash to brighten shadows cast on human

subjects who are also in the photo, as Landscape mode disables the D80's built-in electronic flash.

✦ **Close-Up.** *When to Use:* When you're shooting flowers, coins, figurines, toy soldiers from your hobby collection, and other objects one foot or less from the camera, and centered in the viewfinder. *Don't Use:* If you want to place your subject somewhere other than in the center of the frame, or if you'd like to focus on one special part of the subject in order to highlight it.

✦ **Sports.** *When to Use:* When you're taking any kind of action photography of moving subjects. *Don't Use:* When you don't want a frozen look. Because Sports mode uses fast shutter speeds to freeze the action, avoid this DVP setting if you want to shoot subjects, such as motor sports, that often look best when a little blur remains to add a feeling of motion.

✦ **Night Landscape.** *When to Use:* When you want to take pictures of distant scenes at night, using longer shutter speeds to provide good exposures. You need a tripod or other support to steady the camera enough to avoid blur. *Don't Use:* If you can't steady the camera for the longer exposures.

✦ **Night Portrait.** *When to Use:* If you're shooting at night and want the subjects in the foreground to be properly illuminated with flash while also allowing the background to be properly exposed. *Don't Use:* If you are unable to hold the camera steady, or can't use a tripod or other steadying device during the long exposures this mode often produces.

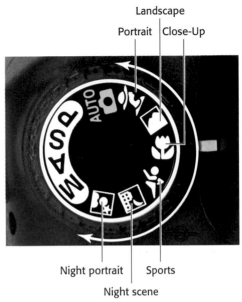

Landscape
Portrait | Close-Up
Night portrait | Sports
Night scene

QT.2 Automatic and Digital Vari-Program modes program all the basic settings for you.

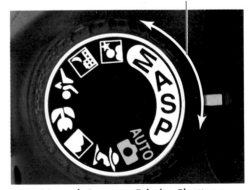

Manual, Aperture Priority, Shutter Priority, Program modes

QT.3 Manual, Aperture Priority, Shutter Priority, and Program modes

If you have some knowledge about using shutter speeds and f-stops, you might want to use one of these more advanced modes:

✦ **Manual.** *When to Use:* When you want to set the shutter speed and f-stop yourself, either for creative reasons, or because you are using an older lens that isn't compatible with the D80's exposure metering system. *Don't Use:* If you are unable to set exposure properly.

✦ **Aperture Priority.** *When to Use:* When you want to use a certain lens opening, to control the range of sharpness of your image (*depth of field*). The D80 selects a shutter speed appropriate for the aperture you've selected. *Don't Use:* If there is too much or too little light for a good exposure using the f-stop you've specified.

✦ **Shutter Priority.** *When to Use:* When you'd like to use a certain shutter speed to freeze action, reduce the effects of camera shake, or allow moving objects to blur in creative ways. The D80 selects an f-stop appropriate for the shutter speed you've chosen. *Don't Use:* If there is too much or too little light to produce a good exposure at the shutter speed you select.

✦ **Program.** *When to Use:* When you want your camera to make the basic settings, with the option of switching to a different f-stop or shutter speed, or dialing in a little more or less exposure to tweak your photograph. *Don't Use:* If you don't understand how these settings affect your picture.

Selecting a Focus Mode

Your Nikon D80 can focus for you automatically if you are using an autofocus lens. (Virtually all lenses produced in the past 25 years include the autofocus feature.) To activate the autofocus function, the camera focus mode selector must be set to the AF position (see figure QT.4), rather than the Manual focus (M) setting. Some lenses, including the 18-55mm, 18-70mm, and 18-135mm lenses often sold as *kit* lenses with the D80, include an M/A-M switch on the barrel of the lens. When the D80 is set to M/A, focus is automatic, but you can override the camera's focus setting by rotating the focus ring on the lens. (The focus ring may be the innermost or outermost ring, depending on the lens.)

When the lens autofocus/manual switch or the camera focus mode selector switch are set on M, you must focus manually at all times.

When the D80 is set for automatic focus, you can initiate focusing by pressing the shutter release halfway. The area or zone used to calculate focus is represented on the viewfinder screen by one or more brackets that are briefly illuminated in red. If you've selected a DVP/Scene mode other than Close-Up, the D80 chooses the focus zone that coincides with the subject that's closest to the camera. If you select the Close-Up DVP mode, the focus zone defaults to the center zone.

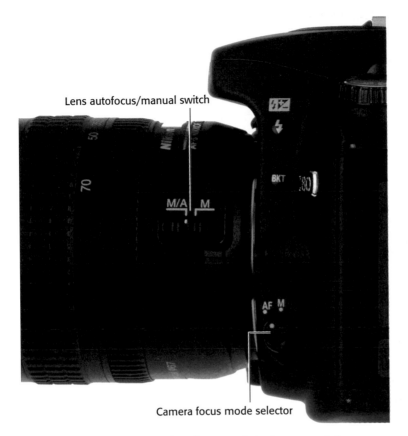

Lens autofocus/manual switch

M/A　M

AF　M

Camera focus mode selector

QT.4 The camera focus mode selector switch chooses autofocus or manual focus modes; the lens may also have an autofocus/manual switch of its own.

Cross-Reference *In Close-Up DVP mode and the other nonscene shooting modes, you can choose which focus zone is used, as noted in Chapter 1.*

When the autofocus mechanism has locked in the correct focus point, or when you are focusing manually and achieve correct focus, a green light in the viewfinder glows (see figure QT.5). If you want the focus and exposure to be locked at the current settings, so you can adjust the composition or take several similar photographs in succession, press and hold down the AE-L/AF-L button located to the right of the viewfinder.

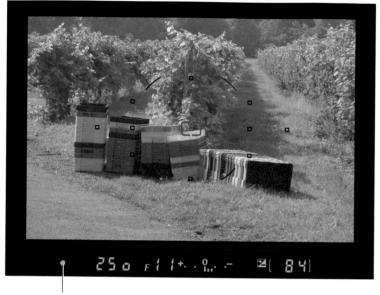

Autofocus confirm indicator

QT.5 The Autofocus confirm light in the lower-left corner of the viewfinder glows when correct focus is achieved.

Checking the Range of Sharpness

If you want to check the range of sharpness (or *depth of field*) to see how much of your image is in focus, use the depth-of-field (DOF) preview button located on the D80's body, under the right side of the lens (when you're behind the camera). You should be able to reach it with the middle finger of your right hand. When you press the button, the lens aperture temporarily closes down to the f-stop set for the current exposure. (Normally, the lens aperture is set to its widest opening for bright viewing until the instant the picture is taken and the actual f-stop required is used.)

The amount of the image that is in sharp focus depends on the f-stop, so you get more depth of field at the aperture used (if the picture isn't being taken with the lens "wide open"). The DOF preview gives you a better idea of what will appear in sharp focus when you actually take the picture.

Depth-of-field button

QT.6 Pressing the depth-of-field preview button shows you the range of sharp focus at the currently selected lens opening.

Using the Self-Timer and Remote Controls

Perhaps you want to get into the photo yourself, or activate the D80 from a few feet away. Maybe the light is dim and you expect the exposure will be long and want to avoid shaking the camera when you press the shutter release. Mount the camera on a tripod and use either the D80's built-in self-timer or the optional Nikon ML-L3 infrared remote control (see figure QT.7). You can also use an add-on cable like the one-meter-long Nikon MC-DC1 Remote Release Cord. Any of these allow you to shoot shake-free pictures without the need to press the shutter release manually.

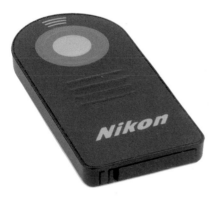

QT.7 The Nikon ML-L3 infrared remote control allows you to trigger the camera from several feet away.

To use the self-timer, follow these steps:

1. **Press and hold the shooting mode button, which is located to the right of the D80's top-panel monochrome status LCD.**

2. **Spin the main command dial (on the upper-right corner of the back of the camera) while watching the monochrome LCD display on top.**

3. **Stop when the Self-timer icon appears.**

4. **Frame your picture and press the shutter release button down all the way when you're ready to take a photo.** The self-timer starts, a white light on the front of the camera blinks, and a beep sounds to alert you that a picture is going to be taken. Approximately two seconds before the picture is taken, the lamp stops blinking and the beeping speeds up.

You can also take a picture using the ML-L3 infrared remote. This inexpensive device activates the camera only from the front, because the infrared sensor is on the front panel, just above the D80 logo. The range is about 16 feet. To activate the remote, use the same steps outlined previously, but spin the main command dial until either the Delayed Remote (which produces a two second pause) or Quick Response Remote (which activates the shutter immediately) icon appears. Figure QT.9 shows the Quick Response Remote icon. (The Delayed Remote icon is a combination of the Self-timer and remote icons.)

Self-timer icon

Drive mode button

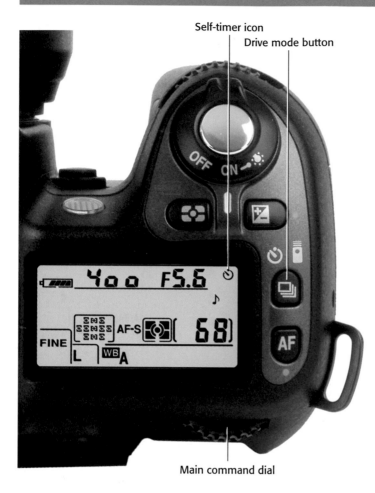

Main command dial

QT.8 Hold down the shooting mode button while rotating the main command dial to select the self-timer.

Remote control icon

QT.9 The Quick Response Remote icon appears on the LCD.

If you've purchased the Nikon MC-DC1 Remote release cord, open the lower rubber port cover on the left side of the D80 (as you hold the camera) and plug it in. Press the button on the module at the end of the cable to trigger the shutter.

> **Cross-Reference** *Learn how to change how long the remote control waits for a signal, and how to set the shutter to release 0.4 seconds after you press it, in Chapter 3.*

Reviewing Your Pictures

Once you've taken your first picture, the image appears for review on the LCD on the back panel of the camera, unless you've turned review display off. If you want to delete the image, press the Delete button (located to the left of the viewfinder window.) A confirmation screen will pop up asking if you really want to remove the image. Press the Delete button a second time to permanently delete the photo.

To review all the pictures you've taken, press the Playback button. The most recent image appears on the LCD screen. Press the Right button on the multi-selector/cursor pad to move forward from pictures taken earlier to later shots. Press the Left button to move backward through the images stored on your memory card. You can also rotate the main command dial left or right to review your images in forward or reverse order.

As you scroll through your pictures, the display wraps around so that when the last image you've taken is displayed, the first one you shot shows up next. The Up and Down buttons change the type and amount of shooting information about each image that is displayed on the LCD. You can also use the sub-command dial on the front of the handgrip to change this information display.

Cross-Reference *Learn how to use the various playback information options in Chapter 2.*

You can access other playback options using the buttons shown in figure QT.10:

✦ When a full-screen image is displayed, press the Thumbnail/Zoom out button to change to a display of four thumbnail images. Press the button a second time to switch to a nine-thumbnail display.

✦ When viewing thumbnail images, press the Thumbnail/Zoom out button to change from a nine-thumbnail display to a four-thumbnail display, or from four thumbnails to a full-screen image on the LCD.

✦ When viewing thumbnails, you can use the Multi-selector pad to navigate among the miniature images to highlight any of them. You can use the main command dial to move forward and backward among the thumbnails in numbered order. You can use the sub-command dial to move up or down within the currently selected column of thumbnails.

✦ When a thumbnail is highlighted, press the OK button to view that image full-size on the LCD.

✦ When viewing a full-size image on the LCD, press the Zoom in button to zoom in on the image. Press the Thumbnail/Zoom out button to zoom back out again. An inset miniature version of the image with a yellow highlighted box appears to show you the relative position of the zoomed area in the image.

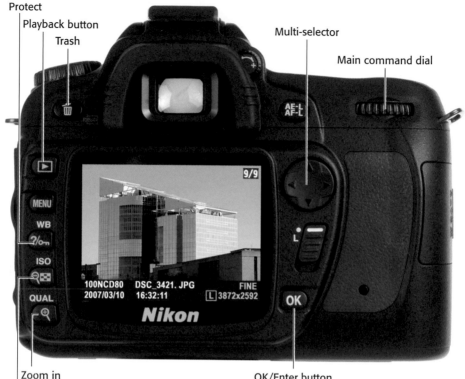

Protect

Playback button

Trash

Multi-selector

Main command dial

Zoom in

Thumbnail/Zoom out

OK/Enter button

QT.10 Press the Playback button and use the Right and Left keys on the multi-selector pad to scroll forward and back through the pictures you've taken on the LCD. The Up and Down keys adjust the type of shooting information displayed along with the picture.

✦ Press the Protect button to protect the selected full size image or thumbnail from accidental erasure. A key icon appears in the upper-right corner to show that the image is protected.

✦ Press the Delete button to erase a selected image.

Correcting Exposure

If the last photograph you took is too light or too dark, you can make a correction for the next picture taken under the same lighting conditions by using the D80's Exposure compensation feature. Hold down the Exposure compensation button (shown at the top in figure QT.11) and rotate the main

command dial to the left (to reduce exposure and make the next image darker) or to the right (to increase exposure and make the next photo lighter). The status LCD on top of the camera shows the amount of compensation you've dialed in, such as −0.3 or +1.0, and an exposure scale in the viewfinder (see the bottom of figure QT.11) displays the additional or reduced exposure.

Exposure compensation is added or subtracted in one-third or one-half Exposure Value (EV) increments, with a whole EV step producing twice as much or half as much exposure. (In Chapter 2, you can learn how to change the size of the increment from one-half to one-third step, or vice versa.) When correcting exposure, it's best to increase or decrease the setting by one increment (one-third or one-half step) to start, and then add or subtract more exposure if your first try doesn't produce the look you want.

Transferring Images to Your Computer

When you've finished with a picture-taking session, you probably want to transfer the images from your memory card to your computer. You can link your D80 to your computer directly using the supplied USB cable or remove the memory card from the camera and insert it into a card reader.

To connect using the USB cable:

1. **Turn the camera off.**

2. **Open the rubber cover that protects the D80's USB connection.** Plug the USB cable furnished with the camera into the port as shown in figure QT.12.

3. **Plug the other end of the cable into any USB port on your computer.**

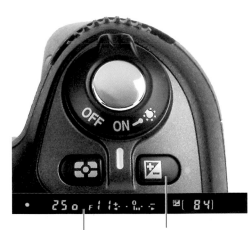

Exposure compensation button

Viewfinder EV readout

QT.11 Hold down the Exposure compensation button and spin the main command dial to increase or decrease exposure.

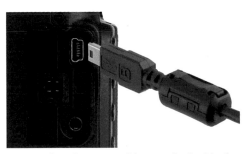

QT.12 Plug the USB cable supplied with the camera into the USB port on the side of the D80, and connect the other end to any USB port on your desktop or laptop computer.

4. **Turn the camera on.**

5. **Your operating system (Windows or Mac OS), or software you may have installed (such as Adobe Photoshop Elements 5.0 or Nikon Picture Project), detects the camera and pops up a dialog box that offers to transfer the pictures to your computer.** Alternatively, the camera may appear on your desktop as a mass storage device, which you can open and then drag-and-drop the photos to your computer.

To connect using a card reader:

1. **Turn the camera off.**

2. **Slide the memory card door on the right side of the camera open and press down on the memory card.** It pops up so you can remove it.

3. **Insert the memory card into the Secure Digital (SD) card slot on your memory card reader.** The reader may be an external device or a device built into your desktop or laptop computer.

4. **Your operating system (Windows or Mac OS), or software you may have installed (such as Adobe Photoshop Elements 5.0 or Nikon Picture Project), detects the memory card and produces a dialog box that offers to transfer the pictures to your computer.** Alternatively, the memory card may appear on your desktop as a mass storage device, which you can open and then drag-and-drop the photos to your computer.

Using the Nikon D80

◆ ◆ ◆ ◆

In This Part

◆ ◆ ◆ ◆

Exploring the Nikon D80

If you found your Quick Tour of your Nikon D80 interesting, you may want to explore the features of the camera in a little more detail, learning all the functions of the various buttons, dials, wheels, switches, and levers that dot its surface. There are a lot of them, but, as you see, having so many dedicated controls helps you work faster. You can access the most-used functions of the D80 by pressing a button and turning a main command dial that are both placed at your fingertips.

You can set features that send you to the menu system in a point-and-shoot camera directly with the D80. On the traditional easy-to-use vs. easy-to-learn scale, the D80 resides firmly at the easy-to-use end of the continuum. Menus may be easier to learn (because they are self-explanatory), but they slow you down once you become familiar with them. On the other hand, once you've taken the time to learn the functions of the D80's controls, it's definitely much faster to use.

I'm going to help you ease on up that learning curve in this chapter. Unlike the official manual that comes with the D80, which is impossibly dense and difficult to navigate, I provide individual full-color photographs of the camera from various views so you can quickly identify a control or component you want to locate. You should find this approach much friendlier than the original manual's tiny black-and-white line drawings, each bristling with numbered callouts that you must cross-reference against a lengthy list with two or three dozen labels.

Moreover, I'm going to explain what each control does within the roadmap, so you don't have to jump around the book to follow multiple cross references. This is a field guide, to be used when you're out taking pictures, rather than a "choose-your-own-adventure" book.

In this chapter, you can find a discussion of controls; in Chapter 2, I describe how to use the D80's basic features, such as metering and autofocus. Then, in Chapter 3, you can find a complete setup guide with an explanation of the camera's thicket of menus.

Up Front

Figure 1.1 shows the Nikon D80 from the front view vantage point of your subjects. To hold your camera steady and keep all the major controls at your fingertips, wrap your right hand around the handgrip and place your left hand underneath, supporting the underside of the lens with your thumb and index finger caressing the zoom ring.

By using this grip, you can reach the shutter release button with the index finger of your right hand, quickly turn the camera on or off with the same finger, and activate the top panel LCD's backlighting control (as I show you later). The middle finger of your left hand should be able to reach the Func button, which serves as a shortcut to features you specify (see Chapter 3) and the depth-of-field preview button.

While you keep the camera steady with your left hand (especially helpful under dim illumination for slower shutter speeds), your fingers are free to manipulate controls on that side of the D80, including the zoom ring, the focus ring (if you're adjusting focus manually), the electronic flash flip-up button, and several other controls. I explain all these controls later in this chapter, too.

1.1 A front view of the Nikon D80

I'm providing two views of the front of the camera, from left and right angles (as seen from the subject position). The easiest way to hold the D80 is by wrapping your fingers of your right hand around the handgrip, with your left hand providing support and usually activating most of the controls. However, there are a few controls within reach of your right hand's digits, as shown in figure 1.2. These controls and features include:

✦ **Autofocus assist/Self-timer/Red-eye reduction lamp:** This front-mounted white LED serves three different functions.

When the available illumination is dim, the lamp can flash to provide enough light to increase the contrast so the automatic focus mechanism can function. (You can disable this feature when it might prove obtrusive or distracting.) In self-timer mode, the lamp blinks during the delay period, serving as a countdown to the actual exposure. When you're using flash, the front panel lamp can issue a burst of light just before the exposure, which can help contract the pupils in your subjects' eyes (if they're looking at the camera) and reduce the dreaded *red-eye* effect.

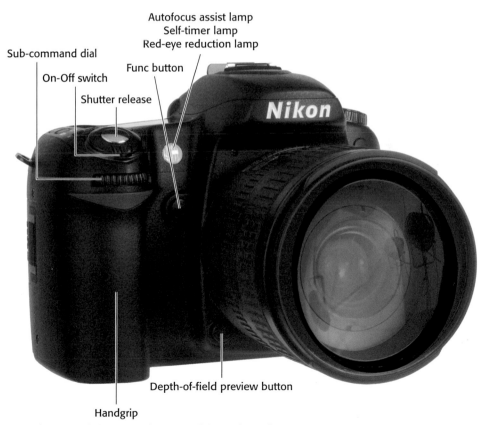

Autofocus assist lamp
Self-timer lamp
Red-eye reduction lamp

Sub-command dial

Func button

On-Off switch

Shutter release

Nikon

Depth-of-field preview button

Handgrip

1.2 Nikon D80 left front side, viewed from the subject's position

✦ **Func button:** You can define the feature activated by this button (learn how in Chapter 3) so you can quickly access a feature of your choice, say, to switch spot metering to zero exposure on a limited area, or to disable the flash when you don't want it to fire.

✦ **Shutter release:** Partially depress this button to lock exposure and focus settings. Press it all the way down to take the picture. Tapping the shutter release when the camera has turned off the autoexposure and autofocus mechanisms reactivates both. When a review image is displayed on the back-panel color LCD, tapping this button removes the image from the display and reactivates the autoexposure and autofocus mechanisms.

✦ **On-Off switch:** Rotate this switch one notch to turn the camera on, and rotate it all the way to activate the top panel LCD backlight. The spring-loaded switch returns to the On position once the backlight is illuminated, and the light remains on for a few seconds.

✦ **Sub-command dial:** The sub-command dial is a secondary control dial that provides alternate or complementary functions to the main command dial located on the back of the D80. For example, in Manual exposure mode, the main command dial sets the shutter speed, while the sub-command dial adjusts the aperture.

✦ **The handgrip:** The handgrip serves as a comfortable handle for the D80 that you can clasp with your fingers to support the camera, and it serves as the storage receptacle for the camera's battery.

✦ **Depth-of-field preview button:** Press and hold this button to close the lens down to the aperture that that will be used to take the picture (normally the lens aperture is kept wide open for bright, easy viewing, until the instant the picture is taken). This gives you a preview of the range of sharpness (depth of field). When you use the depth-of-field button, the view through the viewfinder dims, but you get a better idea of just how much of the image is in focus.

The other side of the D80 has its own complement of controls, as you can see in figure 1.3. These include:

✦ **Bracketing button:** Hold down this button and spin the main command dial to activate a bracketing sequence of either two or three shots. Rotate the sub-command dial while holding down this button to choose the size of the increment between bracketed shots, from 0.3 EV to 2.0 EV. The values selected appear on the top panel LCD. Learn more about bracketing in Chapter 4.

✦ **Flash mode button:** Press this button to pop up the built-in electronic flash (see figure 1.4). Hold down the button while rotating the command dial on the back of the camera to change flash modes, such as auto flash or red-eye reduction mode (see Chapter 6 for a full explanation of options). Spin the sub-command dial while holding down this button to add or subtract from the flash exposure to make your picture lighter or darker.

Bracketing button

Flash mode button

Lens release button

Infrared receiver

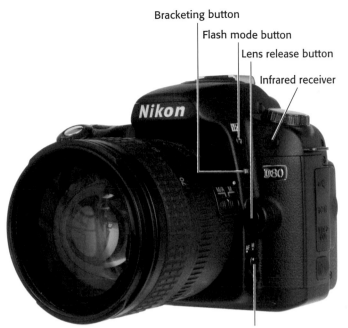

Focus mode selector button

1.3 Nikon D80 right front side, viewed from the subject's position

✦ **Infrared receiver:** This dark red window receives an infrared signal from the optional ML-L3 remote control. Note that the receiver's position on the front panel of the D80 means that you can't easily use it when standing behind the camera. You need to move to one side, stand in front of the camera, or reach over the camera to activate.

✦ **Lens release button:** Hold down this button while rotating the lens to remove the lens from the camera.

✦ **Focus mode selector button:** The autofocus/manual switch (AF/M) on the camera body can be flipped to set either autofocus or manual focus. Some lenses have their own AF/M switches, or an M/A-M switch (which enables you to fine-tune automatic focus manually when in the M/A position).

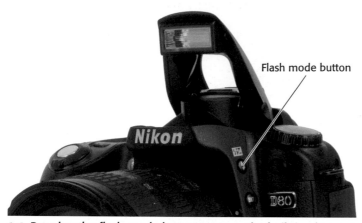

Flash mode button

1.4 Pressing the flash mode button pops up the built-in electronic flash, ready for use.

Sides and Bottom

The sides and bottom of the D80 have only a few controls, compartments, and connectors. They include:

✦ **AC Power/AV Connector/USB Connector covers:** On the left side of the camera (as you hold the camera to shoot) you can see two rubber covers which protect the D80's primary external connectors (see figure 1.5). Underneath the top cover is a port that accepts a USB cable for transferring pictures directly from the camera to your computer (see Chapter 8 for instructions) and also lets you control the camera's functions using the Nikon Camera Control Pro software (see figure 1.6). In the middle is a DC power connector you can use for an optional AC/DC adapter that can operate the camera without batteries for studio photography or time-lapse sequences. Underneath the DC connector is an AV plug you can use to link the D80 to an external monitor for viewing

USB/DC/Video port cover

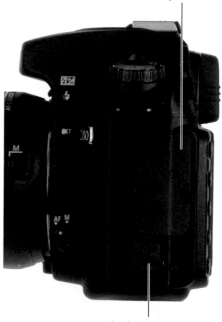

Wired remote cover

1.5 Four connector ports are hidden beneath a pair of rubber covers.

pictures or menus. Under the bottom rubber cover is a port you can use to connect the optional MC-DC1 wired remote control.

The right side of the camera (as you hold it to shoot) has only a single door that slides back toward you and then swings open to reveal a slot for the Secure Digital (SD) memory card (see figure 1.7.) Push down on the card to release the retaining catch, and it will pop out for easy removal.

On the bottom of the Nikon D80, there is a tripod socket, which is also used to secure the optional MB-D80 battery pack/grip vertical grip. The grip holds two EN-EL3e rechargeable batteries or a AA battery holder, and has its own AF-On button, shutter release, and main command and sub-command dials. A flip open door accepts a single EN-EL3e rechargeable lithium ion battery, as shown in figure 1.8.

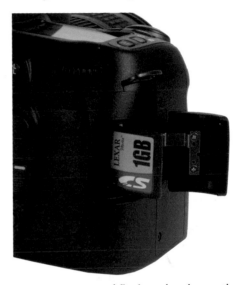

1.7 A memory card fits into the slot on the side of the camera.

DC port USB port

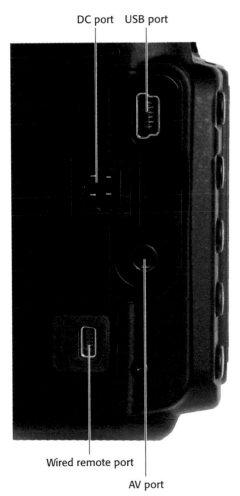

Wired remote port

AV port

1.6 Your USB, DC power, AV, and remote control devices plug into these connectors.

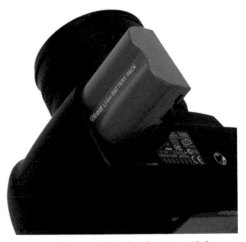

1.8 A compartment in the bottom of the D80 accepts a rechargeable battery.

On the Lens

The lenses you use with your Nikon D80 each have their own set of controls. In figure 1.9 you can see two typical lenses, the very basic 18–55mm f/3.5–5.6G ED II AF-S DX Zoom-Nikkor and the more upscale 18–200mm f/3.5–5.6G ED-IF AF-S VR DX Zoom-Nikkor vibration reduction lens. As you can see, not all lenses have all the possible controls. In fact, I'm going to have to show you three different lenses to illustrate them all. Additional controls are shown in figure 1.10, using the 105mm f/2.8G ED-IF AF-S Micro-Nikkor as an example.

By comparing the three lenses, you can see that the controls may be in different locations with different lenses, and can differ in size and operation, too. The key components shown in figure 1.9 are:

✦ **Lens hood alignment guide/bayonet:** Shown on the 18–200mm zoom, this lens hood bayonet mount (and its accompanying white dot used for alignment when fastening the hood) is used with lenses that don't use hoods that screw into the filter ring.

✦ **Filter thread:** Most lenses have a thread on the front that you can use to attach filters and other accessories.

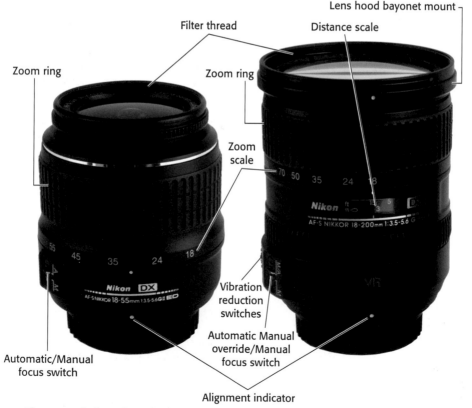

1.9 The controls found on the 18–55mm kit lens and 18–200mm vibration reduction lens

✦ **Focus ring:** Rotate this ring to manually focus or fine-tune focus when the lens or camera body focus mode switch is set to M. In addition, if the lens has an autofocus/manual over-ride position (M/A-M), you can adjust focus manually after the camera has focused automatically.

> **Note** *You may notice that the inexpensive 18–55mm kit lens has a much narrower focus ring than the 18–200mm lens, that the entire front element of the lens rotates during focus, and that the lens itself increases in length as you focus closer. More expensive lenses have nonrotating front elements and internal focus so the lens doesn't change in length as it focuses on nearer subjects.*

✦ **Distance scale:** This is a scale (shown on the 18–200mm lens, but not the 18–55 kit lens) that moves in unison with the lens's focus mechanism and shows approximately the distance at which the lens has been focused. It's a useful indicator for double-checking autofocus, and for roughly setting manual focus.

✦ **Zoom ring/zoom scale:** The zoom ring is rotated to change the zoom setting. The zoom scale markings show the currently set focal length.

✦ **Alignment indicator:** Match this white dot with the dot on the camera body (located at roughly 2 o'clock when you're looking at the front of the camera) to properly mount the lens.

✦ **Vibration reduction switches:** Vibration reduction (VR) lenses have switches that you can use to turn the vibration reduction feature on or off, or to toggle between Normal and Active mode (which

makes it possible to use VR even when panning the camera).

Figure 1.10 shows a single focal length, or *prime* lens, 105mm Nikkor macro lens used for close-up photography. This particular lens has some features not available on either of the two lenses shown in figure 1.9, but which you might find on some other lenses. As you might expect, this nonzooming lens doesn't have a zoom ring or zoom scale. But it does include:

✦ **Limit switch:** When using lenses that have an extensive focus range, you can see that some have a special switch that limits the range used by the autofocus system, locking out either distant subjects (when shooting close-up photos) or extreme macro focus distances (when you're taking photos of nonmacro subjects). The limit switch can speed up focusing considerably by reducing the amount of "seeking" that the lens does in looking for the correct focus point.

✦ **Aperture ring:** Nikon lenses with a G suffix in their name (like the 18–55mm kit lens and 18–200 VR lens) lack a manual aperture ring, and so can only be used with cameras (like all recent Nikon film and digital cameras) that are able to set the f-stop electronically from the camera body. Lenses that retain the aperture ring, like the macro lens shown, have a D suffix in their names.

✦ **Aperture lock:** If you want to use the D80's automatic exposure system with a D-series lens, you must set the aperture ring to the smallest f-stop (in this case f/32), and lock it in that position using the aperture lock switch. You need to unlock the aperture only if you

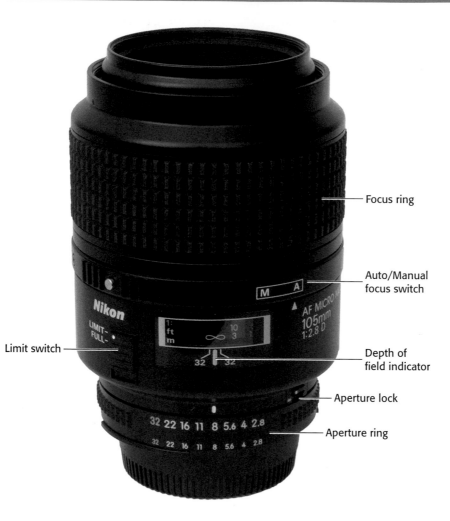

Focus ring

Auto/Manual focus switch

Limit switch

Depth of field indicator

Aperture lock

Aperture ring

1.10 This macro lens is an example of a prime (nonzoom) lens.

want to use the lens with an older camera that can't set the f-stop electronically, or you are using the lens with an accessory like an extension ring that doesn't allow coupling with the autoexposure system. (Most automatic extension rings retain full automatic exposure and focus capabilities, except when the effective maximum aperture of the lens is smaller than f/5.6. The D80 needs at least f/5.6's worth of light to operate.)

On Top

The top panel of the D80 has its own cluster of controls. They include:

✦ **Mode dial:** This knurled wheel is turned to change among the DVP/ Scene modes and Auto, Program, Shutter Priority, Aperture Priority, and Manual modes.

✦ **Focal plane indicator:** A few very specialized types of close-up

photography require knowing precisely the plane of the camera's sensor; this indicator, which may be hard to see, shows that plane (but not the actual location of the sensor itself).

✦ **Accessory shoe:** Attach an external electronic flash, such as the Nikon SB-400, SB-600, or SB-800 to this slide-in accessory shoe, which includes multiple electrical contacts that enable two-way communication

between your D80 and a dedicated speedlight (designed to work directly with compatible cameras). The "conversations" can include exposure, distance, zoom setting, and color temperature information. You can attach other accessories as well, including radio control devices, levels, and add-on viewfinders (useful when shooting "blind" because an infrared filter on your lens is blocking visible light).

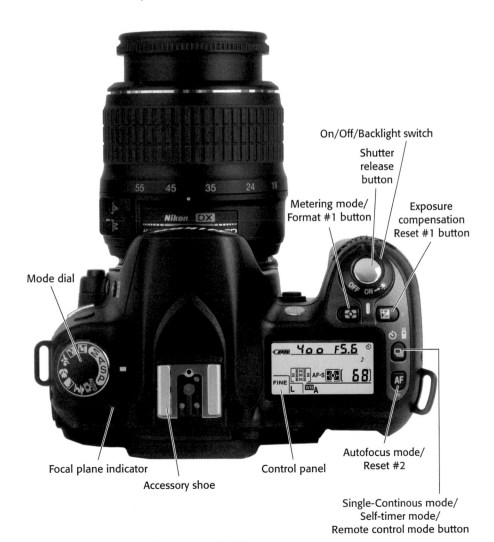

On/Off/Backlight switch

Shutter release button

Metering mode/ Format #1 button

Exposure compensation Reset #1 button

Mode dial

Focal plane indicator

Accessory shoe

Control panel

Autofocus mode/ Reset #2

Single-Continous mode/ Self-timer mode/ Remote control mode button

1.11 Key components on the top panel of the D80

✦ **Monochrome LCD control panel:** This LCD supplies data including the status of the camera, its battery, the number of pictures remaining, and various settings that have been made.

✦ **Autofocus mode/Reset #2:** Hold down this button and spin the main command dial to switch among AF-A, AF-C, and AF-S modes, as described in the Quick Tour. Hold down this button and the Metering mode button at the same time to activate a reset of the camera's settings to factory default values.

✦ **Single-Continuous/Self-timer/ Remote control mode button:** Hold down this button while rotating the main command dial to change the "drive" mode of the camera. As you turn the dial, the settings cycle among single shot mode to continuous shooting, self-timer, remote control with a two-second delay, or immediate response activation.

✦ **Exposure compensation/Reset #1 button:** Hold down this button while spinning the main command dial to add or subtract exposure from the basic setting calculated by the D80's autoexposure system. Hold down at the same time as the Autofocus mode button to reset the camera's settings to factory default values. This button and the AF button have matching green dots next to them to signify that they should be pressed simultaneously to reset the camera.

✦ **On/Off/Backlight switch:** Rotate this switch one notch clockwise to turn the D80 on; turn in the reverse direction to shut it off. Momentarily rotate the spring-loaded switch all the way clockwise to illuminate the top panel LCD backlight.

✦ **Shutter release button:** Partially depress this button to lock exposure and focus settings. Press it all the way down to take the picture. Tapping the shutter release when the camera has turned off the auto-exposure and autofocus mechanisms reactivates both. When a review image is displayed on the back-panel color LCD, tapping this button removes the image from the display and reactivates the autoexposure and autofocus mechanisms.

✦ **Metering mode/Format #1 button:** Press this button while spinning the main command dial on the back of the camera to change from matrix to center-weighted or spot metering modes (explained later in this chapter). You can also use the button to reformat the D80's digital memory card if you hold it down simultaneously with the Format #2 (the Trash) button on the back panel. Both buttons have matching red Format symbols to indicate that they should be pressed simultaneously to perform a format operation.

On the Back

The back panel of the Nikon D80 is really Control Central, with an even dozen controls, most of which serve double duty with multiple functions. These direct controls are the key to this camera's ease of use. You can press a button and rotate a dial to change settings like image quality, ISO sensitivity, or white balance, as well as many other options without the need to visit Menuland. Figure 1.12 shows the back of the D80 and its control center.

Upper half

The upper half of the back panel (shown in figure 1.13) has three buttons and two dials. Here's what they do:

✦ **Delete button/Format #2:** When the LCD displays an image, press the Delete button if you'd like to discard the image. A prompt shows up on the screen inviting you to press the Delete button again to erase the file, or the Playback button to cancel the operation. You can also hold down this button while simultaneously holding down the Metering mode button to activate a format of the memory card. There's no confirmation; if you hold down the pair of buttons for more than a few seconds, the control panel display disappears except for a *For* message that flashes on the the top panel LCD indicating that you should press the buttons again to start the format automatically.

1.12 Key components on the back panel of the D80

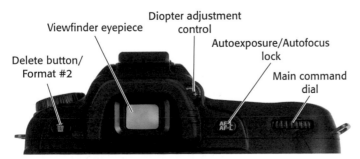

1.13 Key components on the upper half of the back panel of the D80

✦ **Viewfinder eyepiece/eyecup:**
Peer through the viewfinder window to frame your image (when the lens cap is off!). The rubber eyecup shields the viewfinder from extraneous light, much like a lens hood, which is helpful because light entering the viewfinder from the rear can affect the exposure meter. The eyecup is removable, and you can replace it with a cap to block that extra light when using the camera on a tripod. You can also replace it with the DK-21M magnifying eyepiece (which comes with its own rubber eyecup).

✦ **Diopter adjustment control:**
Rotate this dial to adjust the viewfinder's diopter correction for your eyesight if you wear glasses and would like to use the viewfinder without them, or need additional correction when using the viewfinder with your glasses.

✦ **Autoexposure/Autofocus lock:**
This button locks exposure, focus, or both, until you release the button or press it again. A menu option, described in Chapter 3, enables you to specify the behavior of this button.

✦ **Main command dial:** Spin this dial to change settings such as shutter speed, bracketing, or shooting mode, depending on what control button you're pressed at the same time.

Lower half

The most-used buttons on the D80 are located at the left side of the lower half of the camera. Most of them have more than one function, depending on the D80's current mode. If you're shooting pictures, a button may have one function, but when you're reviewing images you've already taken, it may have another. The buttons on the left side of the camera include:

✦ **Playback button:** Press once to display the most recent photo taken. Press again, or tap the shutter release button, to remove the image from the screen and exit Playback mode.

✦ **Menu button:** Press to access the five levels of the Nikon D80's menus.

✦ **Help/Protect/White Balance button:** When any menu item is highlighted (including the main menu headings), press this key to view a brief Help screen with explanations of the functions of the selected item. In Playback mode, press it to protect the current image from accidental erasure. In any shooting mode, hold and spin the main command dial to change the white balance preset; the setting you choose appears on the top panel LCD. Hold the button and spin the sub-command dial to dial in small amounts of correction, from +1 to +3 to make the white balance more bluish, or from −1 to −3 to make the white balance warmer.

✦ **Thumbnail/Zoom out/ISO button:** In Playback mode, when viewing a full-screen image, press the button once to change to a four thumbnail display, and again to switch to nine thumbnails. To return to full screen mode, press the OK button. When an image is zoomed in, press this button to zoom back out. In any shooting mode, hold this button and spin the main command dial to change ISO.

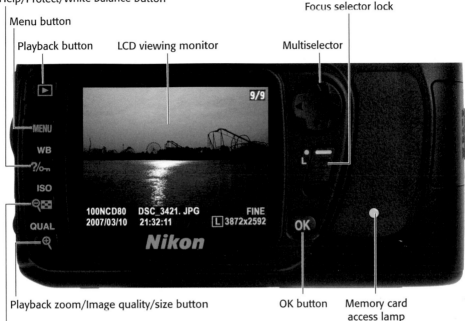

Help/Protect/White balance button

Menu button

Playback button LCD viewing monitor

Focus selector lock

Multiselector

Playback zoom/Image quality/size button

Thumbnail/Zoom out/ ISO button

OK button Memory card access lamp

1.14 Key components on the lower half of the back panel of the D80.

✦ **Playback zoom/Image quality/Image size button:** In Playback mode, press this button repeatedly to zoom in several magnifications. Use the Multiselector to move the zoomed area around in the frame. Press and spin the main command dial or sub-command dial to change the image quality or picture size, respectively.

In the center and right side of the lower half of the Nikon D80 are the LCD monitor and several more key components:

✦ **LCD viewing monitor:** The color LCD displays your images for review and shows the menus as you navigate through them.

✦ **Multiselector:** Press this four-way cursor button to navigate through

menus, to scroll through images as you review them, and to change the amount of information about each image that is displayed on the screen during picture review.

✦ **Focus selector lock:** Slide this lever down to enable manually selecting the focus zone. Slide it up to prevent manual focus area selection.

✦ **OK button:** This button serves as an Enter key to accept setting and menu selections or to confirm choices.

✦ **Memory card access lamp:** This LED blinks when an image is being written to the SD memory card, and when the camera is turned on or off.

Viewfinder Display

The D80 offers a great deal of information in the viewfinder. Not all of these indicators are visible at once (thank goodness!). Here's a list of each of them, and the information they provide:

✦ **Framing grid:** Turn this set of reference lines on as an aid for aligning images in the viewfinder.

✦ **Center-weighted metering reference circle:** Shows the 8mm circle that's the default area used for center-weighted meter readings.

✦ **No memory card warning:** Appears when the camera is turned on, but no memory card has been inserted.

✦ **Battery indicator:** Appears when the D80's battery power level is low.

✦ **Black-and-white indicator:** Shows that the D80 is in black-and-white shooting mode.

✦ **Flash value lock:** Indicates that the flash setting has been locked in.

✦ **Focus indicator:** Illuminates when an image is focused correctly.

✦ **ISO Auto sensitivity indicator:** Shows that ISO is being set automatically.

✦ **Autoexposure lock indicator:** Shows that exposure has been locked.

✦ **Shutter speed:** Displays the selected shutter speed.

✦ **Aperture:** Displays the selected lens opening.

✦ **Analog exposure display/EV compensation indicator:** Shows the amount of over or under exposure and exposure compensation (when the exposure compensation indicator is visible).

✦ **Battery indicator:** Current power level of the battery.

✦ **Bracketing indicator:** Shows whether white balance or exposure bracketing (or both) have been activated.

✦ **Number of exposures remaining/Other functions:** Also shows number of shots remaining before the buffer is filled, white balance present status, exposure or flash compensation values, and the PC/USB connection status.

✦ **Flash ready:** Shows when electronic flash is recharged for the next shot.

✦ **Thousands of exposures:** Appears when the remaining exposures exceeds 1,000.

✦ **Exposure compensation indicator:** Appears when exposure compensation has been dialed in.

✦ **Flash compensation indicator:** Appears when flash exposure compensation has been specified.

✦ **Currently selected focus area:** Shows the active focus zone.

✦ **Focus area brackets:** Displays the available focus zones.

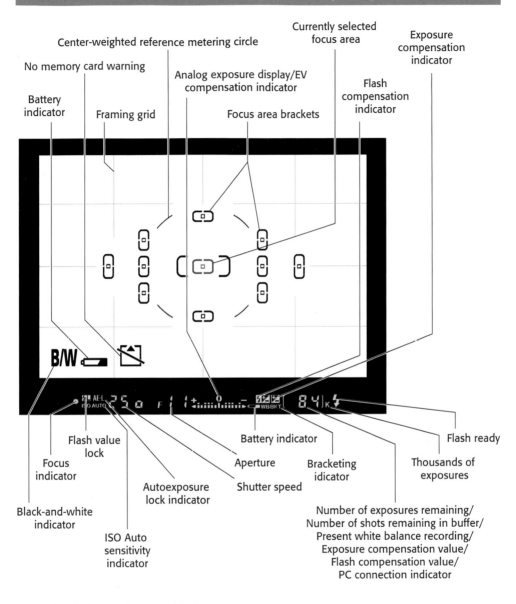

Currently selected focus area

Exposure compensation indicator

Center-weighted reference metering circle

No memory card warning

Analog exposure display/EV compensation indicator

Flash compensation indicator

Battery indicator

Framing grid

Focus area brackets

Flash value lock

Battery indicator

Flash ready

Focus indicator

Aperture

Bracketing idicator

Thousands of exposures

Autoexposure lock indicator

Shutter speed

Black-and-white indicator

Number of exposures remaining/
Number of shots remaining in buffer/
Present white balance recording/
Exposure compensation value/
Flash compensation value/
PC connection indicator

ISO Auto sensitivity indicator

1.15 Viewfinder readouts and indicators

LCD Display

The top-panel monochrome LCD display (see figure 1.16) shows a broad range of current status information. This display is a bit much to bite off in one chunk, so I color code the items that logically belong together (more or less) to make it easier to interpret the display.

✦ **ISO Auto indicator:** Indicates that ISO sensitivity is being set automatically by the camera.

✦ **Battery level indicator:** Shows power remaining in the D80's battery.

✦ **Flash sync mode:** Shows the current flash synchronization setting.

✦ **Focus area:** Displays the focus area zones in use.

✦ **Image quality:** Shows if image files are being saved in JPEG Fine, JPEG Norm (Normal), or JPEG Basic; in RAW format, or RAW+JPEG Fine, Normal, or Basic.

✦ **Image size:** Indicates current resolution being used, either 10.2 megapixels (L), 5.6 megapixels (M), or 2.5 megapixels (S).

✦ **Flexible program indicator:** Shows that Program mode is in use, and that you can change shutter speed/f-stop combinations to other equivalent exposures by rotating the main command dial.

✦ **Flash compensation indicator:** Indicates that flash exposure compensation is being used. The amount of compensation (for example +0.7) is shown in the shutter speed readout area immediately above this indicator.

✦ **Exposure compensation indicator:** Indicates that exposure compensation is being applied. The amount of compensation (for example +0.7) is shown in the shutter speed readout area immediately above this indicator.

✦ **Autofocus mode:** Shows whether AF-A, AF-S, or AF-C autofocus mode is in use.

✦ **Metering mode:** Indicates the current exposure metering mode.

✦ **White balance mode:** Shows whether white balance is being set automatically, to one of the built-in settings, or to a manually preset value.

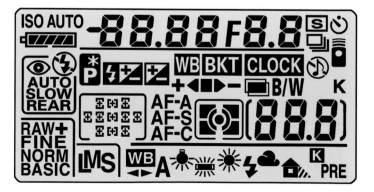

1.16 Monochrome control panel LCD readouts and indicators

✦ **Number of exposures remaining/Other functions:** Shows the number of exposures left on the memory card, the number of shots remaining until the buffer fills, the PC/USB connection mode, and the preset white balance recording.

✦ **Bracketing progress indicator:** Shows the progress of an ongoing bracketing operation.

✦ **Multiple exposure indicator:** Appears when the D80 is set to make multiple exposures.

✦ **Black-and-white indicator:** Shows that the camera is set to take black-and-white photos.

✦ **Thousands of exposures:** Appears when the number of remaining exposures exceeds 1,000.

✦ **Beep indicator:** Shows whether a beep will sound during certain camera functions, such as during a self-timer operation, or when single autofocus is achieved.

✦ **Shooting mode:** Shows whether single shot, self-timer, continuous shot, or remote control shooting modes are active.

✦ **Clock Not Set indicator:** Shows that the date/time should be set.

✦ **Bracketing indicator:** When bracketing is being used, this indicator appears.

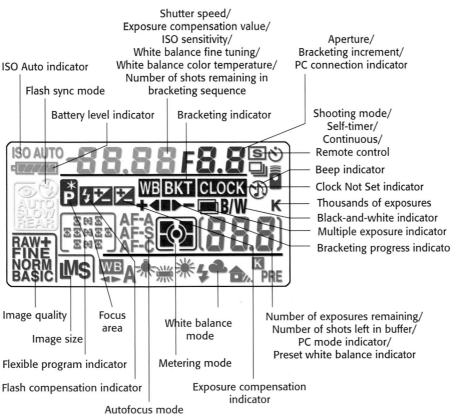

1.17 Color-coded control panel LCD readouts

✦ **Aperture/Other functions:** Shows current f-stop, plus bracketing increment, and PC/USB connection.

✦ **Shutter speed/Other functions:** Displays current shutter speed setting; exposure compensation value; ISO sensitivity; white balance fine tuning/color temperature; and number of shots remaining in bracketing sequence.

Viewing and Playing Back Images

The D80's Playback mode lets you review your images, trash the ones you don't want to keep, or jump to the Retouch menu to create a tweaked copy of images that could use improvement.

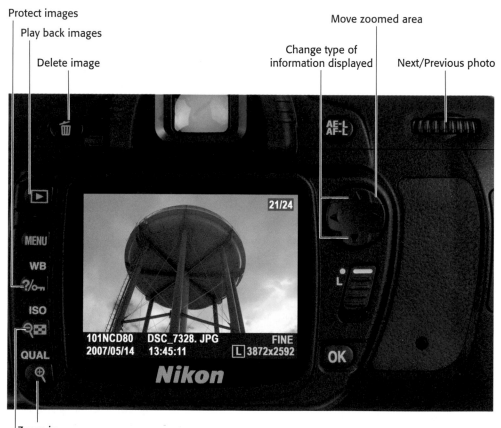

Protect images
Play back images
Delete image
Move zoomed area
Change type of information displayed
Next/Previous photo
Zoom in
Zoom out/Change thumbnails

1.18 Review your photos using the color LCD.

Follow these steps to review your images:

1. **Press the Playback button to produce the most recently taken photo on the back panel LCD.**

2. **Rotate the main command dial to the right or left to switch to earlier or later photos on the memory card.**

3. **Use the Thumbnail button to cycle through single-picture display, or tiled views that show four or nine reduced-size thumbnails at one time.** When viewing four or nine thumbnails, you use the Up and Down keys to navigate among the available images. Press OK to view a selected image on the LCD in full size.

4. **In single-picture display, the Left and Right keys on the multiselector also move to the next or previous image.** The Up/Down keys or the sub-command dial change the type of information about the current image displayed on the screen. Your options include:

 - **File Information:** Shows the image, its filename, frame number, size, quality, folder name, and so on.

 - **Shooting Data 1:** Gives you a screen with more information, including the info in the basic File Information page, plus the camera name, date, time, metering and exposure methods, shutter speed, aperture, lens focal length, flash information, and any EV adjustment you've made.

 - **Shooting Data 2:** Includes the File Information basics, plus the ISO setting, white balance,

 sharpening, color mode, hue, saturation, and some other data.

 - **Highlights:** The brightest areas of an image are represented with a flashing border so you can easily see any portions that might lack detail because of overexposure.

 - **Histogram:** Shows a luminance (brightness) histogram graph that displays the relationship between the dark and light tones in the image, and red/green/blue histograms that display the same information for each of the three color channels in the image.

5. **Press the Playback Zoom button to enlarge the viewed image on the screen. Press multiple times to increase the amount of zoom.** Press the Zoom Out button to reduce magnification.

6. **While zooming, use the multiselector's cursor keys to move the zoomed area around within the enlarged view.**

7. **Press the Protect key to keep the selected image from accidental erasure.** The photo can still be removed if the card is reformatted, however. Press the Protect key while viewing a marked image to remove the protection.

8. **Press the Delete button to erase the selected image.** When prompted, press Delete a second time to confirm removal of the photo.

9. **Press OK while reviewing an image to jump to the Retouch menu.** (You can learn how to use this menu's options in Chapter 2.)

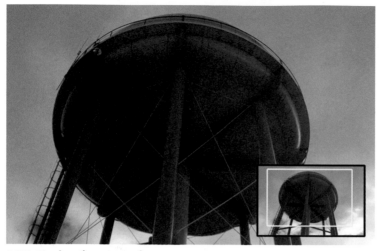

1.19 Moving the zoomed area

Activating the Onboard Flash

You can set the built-in electronic flash to pop up automatically when the D80 detects low light levels suitable for flash photography. Or, you can manually pop up the flash by pressing the Flash button on the left side of the camera. Once the flash is in place, you can choose from the options that follow by holding down the Flash button and spinning the main command dial. Note that not all flash options are available in every shooting mode. You can find a detailed explanation of which options are available in each mode in Chapter 6.

✦ If you're using Programmed or Aperture Priority modes, you can choose:

- **Front Curtain Sync (default/no indicator):** The flash fires as soon as the shutter opens. The Nikon D80 sets the shutter speed between 1/60 and 1/200 second.

- **Red Eye Reduction:** Triggers the front-panel lamp (also used for focus assist) one second prior to exposure to reduce red-eye effect.

- **Slow Sync:** Uses slow shutter speeds (as long as 30 seconds) to add background illumination to the flash exposure. Not available with Shutter Priority or Manual modes.

- **Slow Sync + Red Eye:** Adds red-eye reduction to slow sync mode.

- **Curtain + Slow Sync:** Also delays flash until just before the shutter closes, but adds long shutter speeds to add background illumination to the flash exposure. Not available with Shutter Priority or Manual modes.

✦ If you're using Shutter Priority or Manual modes, you can choose:

- **Front Curtain Sync (default/no indicator):** The flash fires as soon as the shutter opens. Set the shutter speed of your choice (generally up to 1/200 second.)

- **Red Eye Reduction:** Triggers the front-panel lamp (also used for focus assist) one second prior to exposure to reduce the red-eye effect.

- **Rear Curtain Sync:** The flash is delayed until just before the shutter closes. This puts any ghost images from the ambient light caused by moving objects to appear "behind" the flash image.

✦ If you're using Auto, Portrait, or Close-Up modes, hold down the Flash button and spin the main command dial to switch among:

- **Auto Front Curtain Sync:** Similar to Front Curtain Sync, but the flash pops up automatically.

- **Auto + Red-Eye:** Same as Auto Front Curtain Sync, with Red Eye reduction.

- **Off:** Flash does not fire.

✦ If you're using the Night Portrait mode, hold down the Flash button and spin the main command dial to choose.

- **Auto + Slow Sync:** Similar to Slow Sync, but the flash pops up automatically.

- **Auto + Slow Sync + Red Eye:** Same as Auto Slow Sync, but with Red Eye reduction.

- **Off:** Flash does not fire.

1.20 Flash options shown on the control panel LCD include red-eye correction, flash on/off, auto flash, slow sync, and rear sync.

Choosing Metering Modes

The D80 can use any of three different exposure metering methods when set to Programmed, Shutter Priority, Aperture Priority, or Manual mode. Select the mode by holding down the Metering Mode button and spinning the main command dial until one of these modes appears in the monochrome LCD:

✦ **Matrix:** The camera examines 420 segments in the frame and chooses the exposure based on that information. With Type G and D lenses it also incorporates distance range data.

✦ **Center-Weighted:** The camera collects exposure information over the entire frame, but when making its calculations emphasizes the 8mm center circle shown in the viewfinder (unless you've

1.21 Metering modes appear on the control panel LCD.

redefined the center-weighted area to 6mm or 10mm in the Custom Setting menu (CSM 12).

✦ **Spot:** Exposure is calculated entirely from a 3.5mm circular area, centered around the currently selected focus area. (In other words, you can spot-meter off-center subjects.)

Adjusting ISO Sensitivity

The D80 can choose the sensitivity setting (ISO) for you automatically, or you can manually select an ISO setting. Just follow these steps:

1. **If the LCD monitor is showing an image, tap the shutter button to cancel the display.**

2. **Hold down the ISO button on the back panel.**

3. **Rotate the main command dial to choose an ISO setting from ISO 100 to ISO 1600, plus H.03, H.07, or H1.0 (approximately ISO 2000, ISO 2500, and ISO 3200 equivalents).**

Alternatively, you can set ISO using the menu system, which I discuss in Chapter 2.

Setting White Balance

To more closely match the D80's color rendition to the color of the illumination used to expose an image, you can set the white balance. To use a preset value, follow these steps:

1. **If the LCD monitor is showing an image, tap the shutter button to cancel the display.**

2. **Hold down the White Balance button on the back panel.**

3. **Rotate the main command dial to choose a white balance from among Auto, Incandescent, Fluorescent, Direct Sunlight, Flash, Cloudy, Shade, and Preset.**

White Balance can also be set using the menu system, with additional options for fine-tuning or defining a preset value. You can learn how to use these options in Chapter 3.

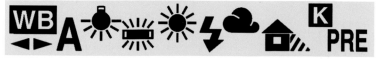

1.22 White Balance options appear on the Control Panel LCD.

Programmed Exposure Modes

The D80 has seven Digital Vari-Program, or Scene modes (see figure 1.23), which make some of the setting decisions for you, while preventing you from making decisions yourself, which can be a good thing or a bad thing, depending on your experience and the current shooting environment. You can choose any of these modes from the Mode dial. They include:

✦ **Full Auto:** In this mode, the D80 takes care of most of the settings, based on its perception of what kind of shot you've framed in the viewfinder. For example, the camera knows how far away the subject is (from the automatic focus mechanism), the color of the light (which tells the camera whether you're indoors or outdoors), and can make some pretty good guesses about

Auto Portrait Landscape

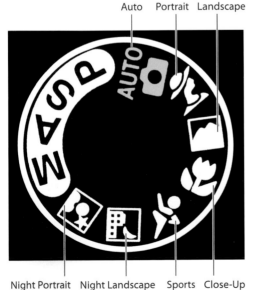

Night Portrait Night Landscape Sports Close-Up

1.23 Seven Digital Vari-Program, or Scene modes, are available.

the kind of subject matter (landscape, portrait, and so forth) from exposure data and other information. After comparing your shot to its 30,000-picture database, the D80 decides on the best settings to use when you press the shutter release. Auto is the mode to use when you hand your camera to the waiter and ask him to take a quick picture of your group. Don't use this mode if you want every picture in a series to be exposed exactly the same. If you change shooting angles or reframe your image, the D80 might match your shot with a different image in its database and produce a slightly different look.

✦ **Portrait:** Use this mode when taking a picture of a person or two posing relatively close to the camera. The D80 automatically focuses on the nearest subject and uses a wider lens opening to blur the background. The camera's sharpening effects are not used, to create a less-detailed picture with smoother skin tones. Exposure also tends to favor smooth tonal gradations to flatter for your subjects. Flash (if used) is set to reduce red-eye effects. Don't use this mode if your portrait subject is not the closest object to the camera.

✦ **Landscape:** Even though many landscape pictures are taken of distant objects, the D80 is smart enough to know you might have important subject matter closer to the camera, too, and uses a "nearest subject" focus. It locks out the flash, because the speedlight isn't much good for objects more than about 20 feet from the camera. At the same time, it increases sharpness and enriches colors to improve the appearance of foliage.

Don't use this mode if you need to use flash as a fill-in to illuminate shadows in subjects relatively close to the camera who are posing in front of your vistas.

✦ **Close-Up:** If you're shooting flowers or other close-up subjects, use this mode, which concentrates the D80's automatic focusing efforts on the center of the frame, where most close-up subjects are positioned.

✦ **Sports:** In this mode, the D80 switches into AF-C (continuous autofocus) mode so it can better track moving subjects and keep them sharp. The camera takes a photo even if focus is not locked in, because sometimes a slightly out-of-focus image at a crucial instant is better than no picture at all, or one that was taken a second too late. The camera also favors higher shutter speeds to freeze action, and disables the flash.

✦ **Night Landscape:** In this mode, the D80 uses longer shutter speeds to allow dark backgrounds and shadows to be properly exposed. The flash is turned off.

✦ **Night Portrait:** Similar to the Night Landscape mode, this mode adds flash capability and tries to balance flash exposure with the background illumination using front curtain slow synchronization.

Semiautomatic and Manual Exposure Modes

The Nikon D80 has three semiautomatic modes that enable you to specify shutter speed, aperture, or combinations of the two. If an appropriate exposure cannot be set, HI or LO messages appear in the viewfinder. There is also a Manual mode that enables you to set shutter speed and aperture individually. You set these four modes (see figure 1.24) using the Mode dial:

✦ **Program:** The D80 selects a shutter speed and aperture for you. It's still possible for you to override the camera's calculated exposure by holding down the EV button and rotating the main command dial left (to add exposure) or right (to subtract exposure). If you feel the exposure is satisfactory, but you'd like to use a different shutter speed or f-stop, rotate the main command dial to the right to select a higher shutter speed/larger aperture or to the left to change to a slower shutter speed/smaller aperture combination.

✦ **Shutter Priority:** Turn the main command dial to choose the shutter speed. The D80 selects an

appropriate aperture to provide the correct exposure.

✦ **Aperture Priority:** Use the sub-command dial to choose the aperture, and the D80 chooses the correct shutter speed for the right exposure.

✦ **Manual:** Select both the shutter speed and aperture using the main and sub-command dials. When the proper exposure is specified, the indicator in the analog exposure scale in the viewfinder will be centered between the + and – indicators.

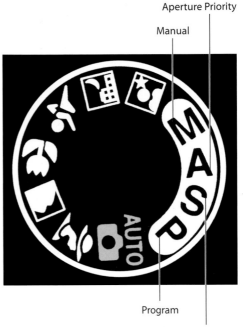

Aperture Priority

Manual

Program

Shutter Priority

1.24 Manual, Aperture Priority, Shutter Priority, and Program modes are also available.

Nikon D80 Essentials

The Quick Tour introduced you to your Nikon D80, and you got the opportunity to explore your camera and its controls in Chapter 1. Now it's time to dig in and master the basic tools for achieving the best exposure, focus, and sensitivity, along with doing a little simple image manipulation with the new Retouch menu. You can find explanations of all the D80 essentials in this chapter.

With that solid foundation of skills, you should be ready to tackle the rich bill of fare available as options in the D80's shooting, setup, and customization menus, which I describe in Chapter 3.

Choosing Metering Modes

The Nikon D80's three metering modes determine the method used to collect exposure information from a 420-pixel array in the viewfinder screen. In each of these modes, a different set of pixels is applied to the calculations. You can choose the mode used by holding down the metering mode button (located southwest of the shutter release on the top panel) and spinning the main command dial until the icon corresponding to the mode you want appears on the monochrome LCD control panel. The trio of icons should be familiar to you by now. Choose from matrix, center-weighted, or spot.

2.1 Select from matrix (top), center-weighted (middle), or spot (bottom) metering patterns.

Matrix metering

Because matrix metering is so "smart," it's usually your best choice for most situations. In matrix metering mode, the 420-pixel exposure sensor covers roughly 60 percent of the image frame (all but strips of image area at the top, bottom, and sides). A rough representation of the sensor grid is shown in figure 2.2.

The sensor measures both intensity and color of the individual points in the image, a scheme which Nikon calls *Color Matrix II* metering. (It's the second implementation of the metering technology the company has introduced.) If you're using a D- or G-type lens (which have a built-in computer chip to enable them to convey additional information), the metering system also takes into account the focus distance of your subject, which Nikon calls *3D Color Matrix II.*

The exposure information collected is processed by a set of algorithms that, using the position, color, and distance data, compares your scene with an internal database of 30,000 different sample images to make a guess about the kind of photo you're taking. For example, a picture with a centered image and the subject about 6 to 8 feet from the camera is probably a portrait; a similar image with the subject closer than 12 inches is likely to be a close-up of a flower or similar object. If the lens focuses at or near infinity, and the top half of the frame is much brighter than the bottom half, the algorithms might assume you're taking a scenic photo and try to balance the detail in the sky and foreground as much as possible. These guesses enable the D80 to vary the exposure slightly to tailor the settings for the kind of photo you're shooting.

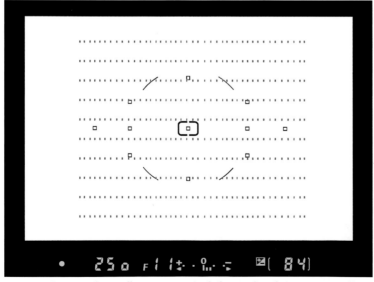

2.2 Matrix metering collects exposure information from a 420-cell sensor array (which isn't visible in actual use).

Moreover, the system can spot images that are high in contrast and choose whether to expose for the highlights, shadows, or, perhaps, to underexpose slightly to preserve detail in darker areas. The ability to discern color information, and thus spot an image that has light yellows or dark greens is much more useful than measuring intensity (on a black-and-white scale) alone.

 Cross-Reference *You can find more about exposure in Chapter 4.*

Center-weighted metering

Center-weighted metering is a good choice if your main subject is in the middle of the frame, and the areas outside the center have areas that are very bright or very dark and might confuse even the super-smart matrix metering system. Portraits and close-up photography often are exposed more accurately when you use center-weighting.

This mode emphasizes an 8mm circle in the center of the frame, assigning a 75 percent "weight" to that area, but also taking into account the rest of the image within the 420-pixel sensor grid; this gives it a 25 percent weight, as you can see in figure 2.3.

Cross-Reference *You can change the center area circle from 8mm to either 10mm or 13mm circles, using Custom Settings option CSM 12, as described in Chapter 3.*

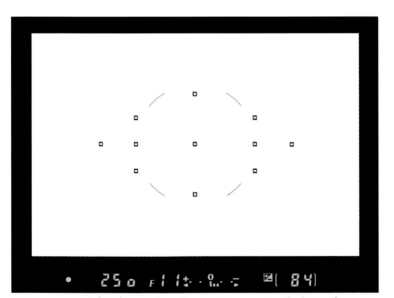

2.3 Center-weighted metering gives a 75 percent priority to the center of the frame.

Spot metering

Spot metering may be your best choice if there is a dramatic difference in illumination between your subject and its surroundings, particularly if the subject isn't moving rapidly. An actor delivering a soliloquy on a spot-lit stage is the kind of image that can be exposed successfully using spot metering.

In this mode, the Nikon D80 measures exposure solely from a 3.5mm circle positioned at the currently active focus area, roughly 2.5 percent of the entire frame. The spot does not have to be located dead-center: Whichever focus area the camera selects or you select manually will be used.

You can use spot metering successfully for off-center subjects. Unless you chose Auto-area Autofocus (Custom Setting CSM2, which prevents the photographer from changing the camera-selected focus area), move the focus zone lock (to the immediate right of the color LCD) to the down, unlocked position, and use the multi-selector pad to move the red-highlighted focus zone to the area you want to use for spot metering, as shown in figure 2.4.

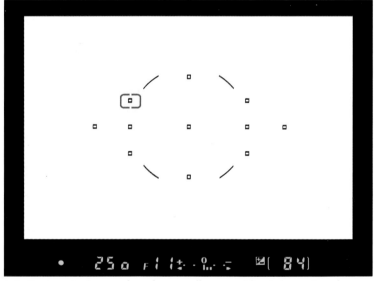

2.4 Spot metering reads only a small, moveable circle centered around an autofocus zone.

Adjusting Exposures with EV

You can add or subtract exposure from the settings calculated by the D80's meter using Exposure Value (EV) corrections. Each 1/3 or 1/2 EV increment represents 1/3 or 1/2 stops' worth of exposure. You can change the size of the increment in the Custom Settings menu (CSM 10) using the directions in Chapter 3. To add or subtract exposure compensation, hold down the EV button on top of the camera (located just southeast of the shutter release) and rotate the main command dial to the left (to add exposure) or right (to subtract exposure).

An icon appears in the monochrome LCD control panel and in the viewfinder (see Chapter 1 for their locations) to indicate that you've selected an exposure other than the metered value. The analog exposure scale in the viewfinder shows how much compensation — from +5.0 to −5.0 EV — you've applied. You can set up to +5.0 or −5.0 EV. Use the histogram display available for the last picture taken (Chapter 4 shows you how to do this) to decide how much of an adjustment to make for your next shot.

Your EV adjustment doesn't change after you've taken a photo, so be sure to change back to 0 EV when you want to return to using the actual metered value. If you don't and begin shooting a different subject, you can end up with photos that are underexposed or overexposed, because of the unnecessary EV adjustment.

 Flash exposures can also be increased or decreased using Flash EV changes. You can find directions on doing that in Chapter 6.

2.5 EV adjustments make it easy to change an original exposure (left) to make the next picture darker (center) or lighter (right).

Adjusting ISO Sensitivity

ISO is a numeric representation of the relative sensitivity to light of a digital camera's sensor. The basic sensitivity setting of the D80 is ISO 100, which is roughly equivalent to the "speed" of an ISO 100 photographic film. Your camera has the ability to amplify the incoming signal, producing higher settings up to the equivalent of ISO 3200, but with an increase in the graininess we call image *noise* with each sensitivity boost.

Lower sensitivity settings provide better overall image quality, but require using longer shutter speeds or larger lens apertures, which themselves can reduce the sharpness of the image. Higher ISO settings call for faster shutter speeds and/or smaller f-stops. Selecting the right ISO is a matter of deciding on the sensitivity that provides the right combination of image noise, shutter speed, and aperture.

Note *ISO isn't an acronym for anything with a particular photographic relevance. It simply represents an international standards body that establishes benchmarks for thousands of different standard yardsticks or measurements used in many different industries, including the photographic arena.*

Setting the ISO on the D80 is easy. Hold down the ISO button (found on the left side of the color LCD), spin the main command dial to choose any ISO setting from ISO 100 to ISO 1600, in 1/3-step increments. The D80 has three more "boosted" settings up to the equivalent of ISO 3200, and represented by H0.3, H0.7, and H1.0. The H stands for High Speed and is used instead of the numeric equivalents ISO 2000, ISO 2500, or ISO 3200 to help remind you that these stratospheric settings are a special case. You can also specify ISO with the ISO Sensitivity setting in the Shooting menu.

2.6 Higher ISO settings add noisy grain to your photos.

The D80 also includes an automatic ISO sensitivity option, which increases the ISO setting to a maximum of ISO 1600 when there isn't enough illumination at the current ISO setting to take an optimally exposed photograph. While this option is useful, you should use it with care, because it can switch you from a relatively grain-free ISO 400 setting to a far noisier ISO 1600 setting unexpectedly. While there is a flashing ISO Auto alert in the viewfinder and top panel status LCD, it's easy to overlook.

When using the ISO Auto feature, the D80 increases the ISO setting from 100 to as high as ISO 1600 whenever the exposure mode in use indicates a shutter speed of 1/30 second or slower. Unfortunately, that's not always your best option. If, for example, the camera is mounted on a tripod, you could probably keep the ISO at a much lower setting and use longer shutter speeds to get the right exposure.

Conversely, you might want to boost the ISO even when using a higher shutter speed, say, when you're using a telephoto lens that magnifies camera shake even at shutter speeds of 1/125 or 1/250 second. In those situations, you might want to increase the ISO setting so you could use 1/500 second or faster at the same lens aperture.

Because the ISO Auto feature might not make an ISO change that's the same as the one you might make yourself, you can turn the feature off entirely in Custom Settings menu CSM 07; either that, or tell the camera to go ahead and use the ISO Auto option, but use a shutter speed guideline you specify and a maximum ISO setting that you indicate. I show you how to set up your camera for these custom adjustments in Chapter 3.

Using Noise Reduction

Several different things can cause noisy grain. Increase the ISO sensitivity and your D80 amplifies the signal produced by incoming illumination so that a reduced number of photons are needed to produce an image in dark areas of your photograph. Unfortunately, random background pixels in the image, caused by electrical interference between adjacent pixels, are amplified and register in your image as noise. The higher you boost the ISO setting, the more noise you're likely to have in your image.

Longer exposure can also introduce noise, regardless of the ISO setting you're using. As the exposure time stretches out, the sensor begins to heat, and some of that heat produces spurious image artifacts that can be seen as noise, even at a low sensitivity setting such as ISO 100.

Your D80 automatically eliminates a certain amount of noise, but even stronger, more aggressive noise reduction processing is available. Unfortunately, over-enthusiastic noise reduction can rob an image of detail, so you can adjust the amount and type of noise reduction you apply in the Shooting menu. You can specify the amount of both high ISO noise reduction and long exposure noise reduction separately.

In brief, if you're planning on exposures of several seconds or longer, you simply access Long Exposure NR in the Shooting menu, and turn it on or off, depending on whether or not you want to apply noise reduction. To control the amount of NR used at higher ISO settings, choose High ISO NR in the Shooting menu and select Norm, Low, High,

or Off. I show you how to determine the best setting in Chapter 3.

If you don't want to use the D80's NR facilities or want to customize the amount of noise reduction you apply, you can also perform noise reduction tasks with image editors like Adobe Photoshop; cut noise when importing RAW files using Adobe Camera Raw, Nikon Capture NX, and other RAW utilities; or use noise zapping programs like Noise Ninja (which is now also incorporated into Nikon Capture NX, as I explain in Chapter 8).

Working with the Retouch Menu

Adjusting an image after the picture is already taken is commonly referred to as *post processing*. Of course, you usually perform that step using the resources of a personal computer. If you can't wait to make some quick adjustments to your photos (say, you want to upload a few and share them with friends, family, or colleagues via e-mail), you'll be pleased to learn you can do a surprising amount of image manipulation right in your Nikon D80.

You can brighten shadows, minimize redeye, crop your photos, change color pictures into artsy black-and-white renditions, add some cool filter effects, combine several photos into a double exposure, and then squeeze the finished shot down to a smaller size suitable for e-mailing. Best of all, your original shot remains unmodified. The Retouch menu, which is available only when you have images on your memory card and enough room to store a revised version, creates a duplicate image with all the changes you specify, and saves it onto your memory card along with the original picture.

In this section, I show you how to use these clever retouching tools. All can be accessed by pressing the Menu button, scrolling down to the Retouch menu, selecting the tool you want to work with, and then activating that tool by pressing the right directional key on the multi-selector, or by pressing the Enter button.

For the D-Lighting, Red-Eye Correction, Trim, and Image Overlay tools, you are immediately presented with a set of thumbnails of the images on your memory card. For the Monochrome, Filter Effects, and Small Picture tools you first need to choose an option within the submenu before selecting an image from the thumbnails. Use the multi-selector's left and right directional keys to scroll around among the available images, press the Enter button to select the image you want, and then work with the tool as directed.

D-Lighting

This option brightens dark shadows. Even with the best exposure techniques, you still end up with an occasional picture in which back-lit subjects are too dark. There may be lots of detail in the light areas of the photo, but the darker areas — which may be the most important parts of the picture — are murky and the details are hidden. D-Lighting is a perfect solution for those pictures, particularly when you don't mind if the lighter areas, such as sky or windows in the background, become brighter and lose some detail during the process (see figure 2.7).

2.7 You can brighten dark foregrounds (left) with the D-Lighting feature (right).

Select the image you want to modify, and press OK to select it. You are shown a pair of side-by-side images labeled Before and After, with Normal highlighted under the version on the right side. Press the up directional key to choose Enhanced lighting (to dramatically lighten the photo), or the down directional key to select Moderate lightening.

Hold down the Zoom button to briefly view the image on the LCD in full size. When you've evaluated the modified image, press OK when you're satisfied to save a tweaked version of the photo onto your memory card. If you'd rather return to the menu instead, press the Playback button.

Red-Eye Correction

If red-eye reduction efforts deployed when you took the picture didn't completely tame demon red eyes, this tool can often provide an additional measure of correction.

Choose your image and use the Zoom In and Zoom Out buttons to magnify or reduce the picture. You can use the multi-selector's directional keys to move the zoomed area around within the full image. Press OK to activate the Red-Eye Correction function (see figure 2.8). Note that the D80 modifies only images in which it is able to detect red-eye effects, and does not create a modified copy if it is unable to find any red eyes.

2.8 The D80's built-in Red-Eye Correction tool can eliminate red pupils.

Trim

To use this tool, view your image on the LCD, using the Zoom In and Zoom Out buttons, along with the multi-selector's directional keys to crop the image down to the area you'd like to appear in the finished picture. Then press OK, and the visible area on the LCD saves as a new, separate file on your memory card.

Monochrome

Choose among Black-and-white, Sepia, and Cyanotype monochrome effects. If you choose Sepia or Cyanotype, you see brownish or bluish versions (respectively) of your original image in a preview. Press the multi-selector up button to increase the color saturation (to make the color richer and brighter), or down to decrease the color saturation (and make your colors more muted). The monochrome copy of your image is created when you press OK.

Filter Effects

This tool has three options: Sky light (which adds a cooler, blue cast to the image), Warm filter (which adds a red cast), and Color balance (which enables you to change the color bias of the photo).

2.9 The Monochrome tool can convert your color image into a black-and-white, sepia, or cyanotype version.

To adjust color balance, press the multi-selector button up to add green; down to increase the magenta tone; left to add blue; and right to increase the red. A small thumbnail of the image is shown, flanked by red, green, and blue histograms that show the levels of the tones in each of the primary colors as you make your adjustments. Press OK to create a copy of the image with the filter effects you've chosen applied.

Small Picture

The Small Picture tool enables you to create smaller versions of your images, suitable for display on a television screen, on a Web page, or for e-mailing. Nikon's recommendations for an appropriate size are:

Display on television: 640 x 480
Display on Web pages: 320 x 240
Sending by e-mail: 320 x 240

In practice, you're not locked into those applications for any particular image size. Indeed, you might want to send slightly higher resolution versions of your images via e-mail, so that both 320 x 240 or 640 x 480 would be good. Or, you might want to use an image in a size other than 320 x 240 for Web display.

To use this tool, select Small Picture from the Retouch menu. Then select Choose Size and specify one of the three small picture sizes available. Press the multi-selector right directional button or press OK to return to the Small Picture menu. Then choose Select Picture and choose one or more images you want to convert. Use the left/right keys to move among the available thumbnails, and press the up/down keys to mark the shots you want to convert, or to unmark them if you change your mind.

When you've made your selection, press OK, and select Yes from the confirmation screen that appears to create your copies.

Image Overlay

This tool enables you to combine two RAW-format images on your memory card into a new, single shot. When you select the tool, a dialog box appears with spaces for Image 1, Image 2, and a preview of the combined version. The overlay feature works best when your two pictures have background areas that are plain so the image pair can merge seamlessly (see figure 2.10).

Highlight Image 1 and press OK. Then select the image you want to use (only RAW files can be selected), by scrolling among the available shots with the left/right directional buttons. Press OK to select your first image. Then highlight Image 2 and press OK again and repeat the process to select the second image.

You can now highlight either Image 1 or Image 2 with the left/right buttons, and press the up/down keys to increase or decrease the relative transparency of each image in relation to the other. Highlight the Preview thumbnail and choose Overlay to preview the combined image. You can press OK to save the merged shots, or press the Zoom Out button to make other adjustments, including selecting different pictures to combine. You can also choose Save and press OK to save a copy of the merged pictures without previewing them first.

2.10 Plain backgrounds allow two images to merge almost seamlessly.

Setting Up Your D80

Most of the basic adjustments of your D80 that you will frequently make are available through direct access buttons on the camera itself, a wise move by Nikon. If you want to set the white balance, ISO sensitivity, or image quality/size, you can do it by pressing a button and spinning one of the two command dials. If you want to add or subtract exposure, make your electronic flash illuminate a scene more strongly, or switch from single shots to continuous shooting, you can do all that, too, without accessing any menus. If you have used a point-and-shoot camera in the past, you probably know that these less-sophisticated consumer models often force you to wade through several levels of menus just to select an exposure mode. The Nikon D80 gives you access to 12 different exposure modes using a single dial.

However, you still need to visit the D80's menu system from time to time. There are dozens of setup and customizing options within the camera's four main menus (plus the Retouch menu, which is more of a tools/functions menu than a place to set parameters and preferences). You can find lots of things to do to adjust the behavior of your D80 so that it performs in the way you want. You can determine what shutter speeds are used with flash, define the Function key to perform the action you prefer, turn the camera's "beep" sound on or off, or adjust the brightness of the LCD.

In this chapter, I explain each of the entries in the Playback, Shooting, Setup, and Custom Settings menus (the Retouch menu was covered in Chapter 2). I give some menu items longer descriptions than others. For example, you don't need to know much about the Beep option, except that it makes it possible to switch the D80's warning sound on or off. But you might be interested in more advice about how to use the tricky and potentially troublesome ISO Auto feature.

This book is not intended to provide a rehash of the manual furnished with the D80, or to replace that manual entirely. Instead, I want to provide fast access to the key information you need with, where appropriate, longer explanations of some of the less-intuitive features. There is indeed some repetition of what appears in the official manual, but I hope you find the information easier to understand and more fully explained.

To get started, this is all you need to know: The settings chosen for each operation appear to the right of each menu listing, and the individual menus may have submenus with an indicator bar that shows you where you are within the menu list. Most of the menus are similar in appearance, with some special features added for particular functions.

Playback Menu Settings

The Playback menu, marked with a blue right-pointing triangle symbol, provides settings that control what your D80 does during picture review.

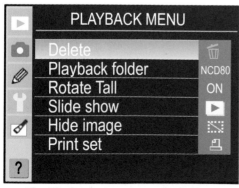

3.1 The Playback menu

The submenus shown in figure 3.1 include:

Delete

If you want to remove all the pictures on a memory card, use the Format Memory Card option found in the Setup menu instead of this option. Formatting is much faster, and restores your memory card to a fresh state with a blank file system, ready to receive new pictures.

The Delete submenu, on the other hand, provides a way to review the images on your card and delete only selected pictures, freeing up space on the card and also eliminating the chance that your real duds accidentally see the light of day.

The submenu has two choices, Selected and All. When you choose Selected, a screen with six thumbnails of the images in the folder currently being viewed appears, and you can scroll among the images, plus any additional ones on your card, by pressing the left/right multi-selector directional keys. Mark/unmark any of those images for removal by pressing the multi-selector up/down button. When you're finished marking images (each has a trash can icon superimposed), press OK to delete them.

Playback folder

Change the folder on your SD card that is currently being used to display images during ordinary playback, and when you run a slide show (discussed later in this section). You can choose Current to select the folder that was most recently used by the D80 to store an image, or All to show images from all the folders on your card.

To actually create a new folder or to switch the current folder to one of the other folders on your memory card, you need to visit the Folder command in the Setup menu. The Playback Folder submenu only lets you switch between the current folder and all folders, rather than to a specific folder.

Rotate Tall

As with most modern digital cameras, the D80 includes an orientation sensor, which can determine whether you're shooting a vertical or horizontal photograph. The D80 is able to embed that information in the image file, where it can be retrieved by the camera during playback, as well as by many image editing and image cataloging programs, which can then ·rotate the image to present vertical shots in an upright orientation.

You can use this option to instruct the D80 to go ahead and rotate vertical pictures during review (On) or not to do so (Off). You might want to disable the feature because the rotated picture is shown with its long dimension displayed using the shortest dimension of the D80's 2.5-inch color LCD. In other words, the image is smaller than if you didn't rotate it and just rotated the camera instead.

This choice has no effect on whether or not image orientation information is included in the picture file (set Auto Image Rotation to On in the Setup menu to activate that function); it only determines whether the D80 rotates vertical pictures that contain orientation data in their file. If you've set Auto Image Rotation to Off, the D80 does not rotate tall images, even if you've specified rotation in this menu.

Slide show

You can use this option for setting up and displaying automated slide shows on your D80's LCD (or an external monitor you've connected through the AV port on the side of the camera). The submenu has three options:

✦ **Start:** Displays up to 50 images in order, using the current settings.

✦ **Select Pictures:** You use this option to choose which images to display. You can choose All to show all images in the currently selected folder, or choose as many as 50 individual shots with the D80's standard picture selection screen. Scroll among the thumbnails with the left/right multi-selector directional keys. Mark/unmark any of those images for display in the slide show by pressing the multi-selector up/down button. When you're finished marking images (each chosen photo has a check mark icon superimposed), press OK to exit the selection screen.

✦ **Change Settings:** Here you can specify how the show runs, choosing either Standard (with user-selected intervals of 2, 3, 5, or 10 seconds between shots, but no background music or transitions); Pictmotion, which includes background music and pre-programmed transitions; and Background Music, which provides five tunes to choose from, including Pachelbel's "Canon in D Major," "Scarborough Fair," Elgar's "Pomp and Circumstance," Mozart's "Turkish March," and Work's "Grandfather's Clock," which you can hear if the camera is connected to a television through the AV cord.

During the show (which must be displayed by the camera, and can't be exported), you can move ahead or back one frame by pressing the left/right multi- selector directional keys (or use the main command dial). The images can be accompanied by an informational display (such as shooting data or histograms). You change the type of info displayed using the sub-command dial. (You can't use either of these options if a Pictmotion show is in progress.) Pause the slide show by pressing OK, or exit to the Playback menu or Playback mode by pressing the Menu and Playback buttons, respectively. The slide show stops automatically; should a picture opportunity pop up while you're viewing a slide show, just press the shutter release! The D80 exits the slide show and is ready to take your picture.

Hide image

Use this option to hide or reveal images on your memory card. Marked images do not display during playback, nor can you erase them using the Delete command. (They are removed during a Format, however.)

Mark images for hiding by using the D80's standard picture selection screen. Scroll through the thumbnails with the left/right multi-selector directional keys. Mark/unmark any of those images for hiding by pressing the multi-selector up/down button. When you're finished marking images (each chosen photo has an icon superimposed), press OK to exit the selection screen. To restore a hidden image, return to the Hide Image submenu and unmark the images individually, or choose Deselect All? to reveal all the hidden images.

Print set

The standard D80 picture selection screen comes into play again in this submenu, used to mark images on your memory card for printing. You can choose specific JPEG images (but not RAW images) and specify the number of copies and information to print along with the image. The DPOF (Digital Print Order Format) is used, so your memory card can be interpreted by any stand-alone retail print kiosk, as well as digital minilabs and some desktop printers.

Shooting Menu Preferences

You can find picture-taking preferences within the Shooting menu, represented by a green camera symbol. Here are the options available in the submenus (shown in figures 3.2 and 3.3):

Optimize Image

This submenu offers options for fine-tuning the color, contrast, sharpness, saturation, and hue of your photos. Your choices include:

✦ **Normal:** This setting, the default value, provides the best overall combination of sharpness, contrast, and colors.

✦ **Softer:** This setting reduces harsh detail in images for a smoother look. It's good for portraits.

✦ **Vivid:** This setting enriches the color saturation, boosts sharpness, and increases contrast to produce vibrant images. It's a good choice on overcast days.

✦ **More vivid:** This setting provides even more color saturation, exaggerated sharpness, and snappy contrast. Use this setting for dull days or to provide almost a flamboyant look.

✦ **Portrait:** This setting reduces contrast to produce an effect that can be flattering in portraits.

✦ **Custom:** This setting enables you to select image sharpening (normal, low, or high); tone compensation (from normal contrast to low and high contrast, or a custom contrast curve you upload to your camera using Nikon Capture NX); color mode, including two variations of sRGB plus Adobe RGB; saturation (automatic, normal, moderate, or enhanced), and hue adjustment.

✦ **Black-and-White:** This submenu has two choices: Standard, a normal black-and-white image; and Custom, which enables you to specify image sharpening, tone compensation (similar to the Custom option for color images, described previously); and filter effects for your black-and-white image.

SHOOTING MENU

▶		
📷	Optimize Image	ⓖ N
	Image quality	FINE
✏️	Image size	L
🔧	White balance	PRE
	ISO sensitivity	400
🖌️	Long exp. NR	ON
?	High ISO NR	Low

3.2 The Shooting menu

More on custom image optimization

Most of the optimization choices are self-explanatory: Softer is softer, and vivid is vivid. The Custom option can benefit from a little more detail.

When you choose Custom, you can set sharpening and saturation yourself, and have the option of choosing tone compensation adjustments using Nikon's choices that range from 0 (Normal) to −1 or −2 (lower contrast) or +1 and +2 for higher contrast. You can also upload a custom curve to your D80 from your computer, using Nikon Capture NX (see Chapter 8 for more information on editing and uploading curves).

The Custom option's Color Mode choice enables you to choose from three different *color spaces* or *gamuts*, which each contain a slightly different palette of colors best suited for particular types of output, such as computer display screens, personal printers, or professional printing. In theory, all three color modes reproduce the exact same number of colors, specifically 16.8 million hues in a 24-bit image. However, the actual colors within their gamuts differ. Color spaces Ia and IIIa (both based on the sRGB model) are intended for Web display or output to an inkjet printer, with Ia producing better results for portraits (it has more colors corresponding to skin tones), while IIIa is preferable for scenic photography (it contains a wider selection of greens). If you can imagine a really huge box of crayons with 16.8 million different colors, the Ia version is heavily stocked with many different variations of flesh-toned crayons, while the IIIa box emphasizes a huge variety of colors that can easily represent foliage and other subject matter that appears in landscapes.

The Mode II color space is based on the Adobe RGB color gamut. It, too, contains 16.8 million colors, but they are spread over a larger area, producing what is called a *wider gamut*. Use Mode II if your images will be printed professionally, or if you'll be doing a lot of post-processing.

Hue Adjustment is the other option that can be tricky to understand. It simply involves moving all the colors in your image 9 degrees around the color wheel either clockwise or counter-clockwise. Rotation in the plus direction makes reds more orange, greens more blue, and blues more purple. Rotation in the other direction makes reds more purple, blues more green, and greens more yellowish.

More on black-and-white optimization

As I mentioned, the Black-and-White optimization feature includes the Standard choice, for an unmodified monochrome image; plus the Custom option, which enables you to modify image sharpening and tonal compensation (just as you can for color images), as well as apply yellow, orange, red, or green filters to the image.

These color filters do not add color tones to the image; in other words, you don't end up with yellowish, orangish, reddish, or greenish images. (That particular process is called *toning.*) Instead, the filters produce a grayscale image that appears as it would if photographed with black-and-white film through one of these filters. That is, the Yellow filter makes the sky darker and the clouds stand out more, while the Orange filter makes the sky even darker and sunsets more full of detail. The Red filter produces the darkest sky of all and darkens green objects, such as leaves. Human skin may appear lighter than normal. The Green filter

has the opposite effect on leaves, making them appear lighter in tone.

Image quality

This submenu duplicates the file format selection functions (RAW, JPEG, RAW+JPEG) of the Qual button and main command dial. You can read about your options in Chapter 1. If you're having trouble making image quality settings because the top monochrome control panel is hard to read (you forgot your bifocals, or the camera is mounted high on a tripod and you can't see the top of the camera), you can use this menu entry to make any necessary changes.

Image size

This submenu duplicates the resolution selection functions of the Qual button sub-command dial, as explained in Chapter 1. Again, this menu item comes in handy when you can't use the top panel readout, or don't want to when choosing L, M, S (large, medium, small) resolutions.

White balance

This submenu enables you to set white balance, duplicating the functions of the WB button on the Mode dial. In addition, you can create new white balance presets, choose existing presets, or set an exact color temperature. The section that follows explains these functions in more detail.

White balance quick start

As you can learn in Chapter 6 (where you can find a good overview of white balance), white balance is the relative color of the light source, measured in terms of *color temperature*. Indoor, incandescent illumination has a relatively low (warm) color temperature in

the 3,000K (degrees Kelvin) range; outdoors in sunlight, the color temperature is higher (colder) from about 5,000K to 8,000K. Electronic flash units have a color temperature of about 5,400K, but this can vary with the length of the exposure. (Flash units provide reduced exposure by quenching the flash energy sometime during the flash itself.) The flash built into the D80, and Nikon dedicated flash units like the SB-600 and SB-800, can actually report the color temperature they will use to the camera for automatic adjustment.

Your camera can make some pretty good guesses about the color temperature of its environment by measuring the color of the image using the 420-cell exposure sensor in the viewfinder. In addition, you can specify white balance when working in P, S, A, and M modes using several different camera controls. Choose any of these:

✦ **Hold down the WB button on the back of the camera to choose one of the built-in color balance settings, including automatic (A), incandescent, fluorescent, direct sunlight, flash, cloudy conditions, and shade.** The possible settings are shown in the bottom row of the LCD status panel. (The settings show up one at a time, not all at once.)

✦ **Hold down the WB button and spin the sub-command dial on the front of the handgrip to fine tune the settings for any of these built-in values (but not the K or PRE settings).** Move the sub-command dial to the right to make the image more blue or to the left to add a yellow tinge. You can make adjustments in the range

of +/−3. An indicator appears under the WB icon on the monochrome top panel LCD to show that you've tweaked the white balance.

✦ **Hold down the WB button and spin the main command dial to select the K icon.** In this mode, the color temperature value appears on the top row of the LCD panel, and you can dial in a specific temperature from 2,500 to 9,900K using the sub-command dial.

✦ **Hold down the WB button and spin the main command dial until PRE is selected.** The D80 uses the currently selected user-defined white balance preset value.

Creating white balance presets

You can create your own white balance presets, or use the white balance of an existing photo. To create a white balance preset from an existing photo, follow these steps:

1. **Hold down the WB button and rotate the main command dial to select PRE.**

2. **In the Shooting menu choose White Balance ➪ White balance preset.**

3. **Select Use Photo.** The most recent image taken appears. You can use that by pressing OK, or select a different image by choosing Select Image.

4. **Next, select the folder on your memory card in which the image you want to use appears.** Work with the D80's standard image selection screen to find the image you want. Scroll through the

images by pressing the left/right multi-selector directional keys. When you find the image you want, press OK.

To create a new white balance preset, follow these steps:

1. **Hold down the WB button and rotate the main command dial to select PRE.**

2. **Release the WB button, and then press and hold the button until PRE starts to flash on the top panel monochrome LCD, or in the D80's viewfinder.**

3. **While looking through the viewfinder, fill the frame with a neutral white or gray object, and then press the shutter release completely.** The camera measures the white balance of your subject. The top line of the LCD status panel flashes **Good** or **no Gd**, and the viewfinder displays either **Gd** or **no Gd** to indicate whether or not the white balance was successfully captured. If white balance capture fails, repeat the steps and try again.

ISO sensitivity

This submenu duplicates the functions of the ISO button/main command dial sequence, as explained in Chapter 2.

Long exposure NR

You can activate noise reduction in any exposure mode, including the seven DVP/Scene modes. In this menu is the option to turn on or off noise reduction applied by the D80 to exposures longer than about 8 seconds, as described in Chapter 2. Note that

this process works by taking a second, blank frame following the actual exposure, effectively doubling the time needed to take a picture. An indicator reading **Job nr** appears in the viewfinder and on the top panel LCD during the post-shot processing. You might want to switch off this option if you don't want to wait for the long exposure noise reduction to be applied.

High ISO NR

You can also apply noise reduction to images you've taken using higher ISO settings. Your options for this feature are:

✦ **Normal:** At this default setting, noise reduction is applied at settings higher than ISO 400.

✦ **Low:** A small amount of noise reduction is applied, reducing graininess while retaining as much image detail as possible.

✦ **High:** More aggressive NR eliminates additional noise, but may cost you some detail.

✦ **Off:** This setting is something of a misnomer. Noise reduction is still applied when using ISO settings higher than ISO 800, but only a minimal amount is used.

Multiple exposure

When using P, S, A, and M modes, you can use this feature to merge two or three pictures as you take them. Within the menu you can choose the number of shots, and tell the D80 whether to adjust the exposure increment (using 1/2 as much exposure for each picture with a two-shot sequence; 1/3 as much for a three-shot sequence) so the combined picture isn't overexposed.

Once you've turned the multiple exposure feature on, the next pictures you take (either two or three) combine, as long as you don't pause for more than 30 seconds. (The sequence ends when the D80's exposure meter switches off automatically.) If you want a longer threshold before the multiple exposure sequence is aborted, use CSM 28 (described in the next section) and select a value of 30 minutes to have the exposure meter remain on for a longer period.

Custom Settings

The Nikon D80 has a whopping 32 customizable parameters in its Custom Setting menu (CSM), represented by a red pencil symbol. You might not immediately see why some of these settings are desirable, but after you've used your D80 for awhile, you'll eventually come to appreciate them all. In the next section, I provide explanations of each of them.

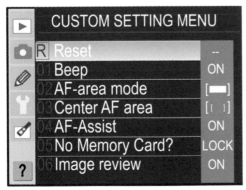

3.3 The Custom Setting menu

R Reset

Use this option to restore all your custom settings to their factory default values, including those not restored using the D80's two-button reset (by holding down the EV and AF buttons on top of the camera simultaneously). Use this menu item when you've made extensive changes to your D80's custom settings, may not remember what they all are or what they do, and want to start over.

CSM 01: Beep

Your D80 can chirp at you during a self-timer countdown, when the camera locks in focus, and in other situations. If you're taking pictures in a museum, library, lecture, house of worship, or other quiet location you can turn the beep off here.

CSM 02: AF-area mode

This setting determines the method the D80 uses to choose an autofocus zone. Choose Single Area to focus only on subjects within the active focus area that you select. Dynamic Area uses the focus area you select, but if a moving subject leaves that area, the camera uses information from other focus areas instead. This is a good choice for sports, and is used by the Sports DVP mode. Auto-area AF tells the camera to select the appropriate focus zone itself. Auto, Portrait, Landscape, Night Scene, and Night Portrait modes use this setting by default.

CSM 03: Center AF area

You can set the central focus area of the D80 to Normal Zone (to concentrate focus on a small area of the frame) or Wide Zone (which may work better with fast-moving objects that zip around the frame). You can't choose Wide Zone when Dynamic area autofocus is selected using CSM 02, as the D80 chooses a focus zone dynamically in that mode.

CSM 04: AF-Assist

This option (which you can set to On or Off) enables or disables the Autofocus Assist lamp; this provides additional illumination to aid the autofocus system under dim lighting conditions when using AF-S mode (or the AF-S mode of the AF-C setting), as long as you choose Single Area or Auto-Area AF in CSM 02. AF Assist is also available when you select Dynamic area in CSM 02 and the center focus zone becomes active. The AF Assist lamp is most effective only at distances of a few feet, and may be distracting in some venues, so you can turn it off here.

CSM 05: No Memory Card?

You can lock the shutter release when no memory card is inserted in the D80; or allow the camera to operate normally and display the images you "take," but the pictures are not be stored, of course. Choose either Release Locked or Enable Release.

CSM 06: Image review

When you switch this option on, images display on the color LCD for about four seconds immediately after they are taken. You can turn image review off to save battery power, or when the bright LCD might be distracting or obtrusive to others (at a concert, say).

CSM 07: ISO auto

I describe this tricky option, which you can use in P, S, A, and M modes only, in Chapter 2. It determines whether the camera boosts ISO automatically to achieve proper exposure, and the parameters used to make the

adjustments. Your choices with this setting include:

✦ **Off:** With this default setting, ISO remains at the value set with the ISO button, or using the ISO menu choice in the Shooting menu. Automatic adjustment of ISO is disabled.

✦ **On:** ISO is automatically adjusted, using the Max. sensitivity and Min. shutter speed parameters you enter.

✦ **Max. sensitivity:** Here you can set the highest ISO setting that ISO Auto uses when making its adjustment. If you want to avoid the noise levels that can result from higher ISO settings, but you're willing to accept a moderate boost, set the maximum sensitivity to a low value, such as ISO 400. The D80 then uses only ISO 100, 125, 160, 200, 250, 320, or 400. If you're willing to accept more noise, use a higher value, such as ISO 800 or ISO 1600. (The boosted values H0.3, H0.7 and H1.0 cannot be specified as a maximum, nor does ISO Auto shift sensitivity into those lofty levels.)

✦ **Min. shutter speed:** Use this value to indicate the slowest shutter speed that should be allowed before ISO Auto kicks in. You can choose from 1/125 second to 1 second. If you're using a short telephoto lens, you might want to activate ISO Auto any time a shutter speed slower than 1/125 might be needed; conversely, with the camera mounted on a tripod, you might feel that no ISO boost is needed until shutter speeds exceed 1 second.

CSM 08: Grid display

Use this to turn the optional viewfinder display grid lines that can be used as a framing or alignment aid on or off.

CSM 09: Viewfinder warning

The D80 can display several different warnings in the viewfinder to alert you about certain conditions: low battery condition, a missing memory card, or when the camera is switched into black-and-white shooting mode. Use this setting to enable or disable these warnings on an all warnings/no warnings basis.

CSM 10: EV step

Use this option to specify whether EV adjustments are set using 1/3 or 1/2 steps. Use 1/3 when you want small increments for fine-tuning; 1/2 steps provide larger exposure jumps.

CSM 11: Exposure compensation

When this option is switched off, EV changes are made by pressing the EV button and rotating the main command dial. To activate Easy EV, set this option to On, so that EV changes can be made by spinning the main command dial alone (in Aperture Priority Mode), or by spinning the sub-command dial (when using Program or Shutter Priority modes). If you reverse the action of the command dials using CSM 15, then the main command dial sets EV in Program and Shutter Priority modes, and the sub-command dial is used in Aperture Priority mode.

CSM 12: Center-weighted

Use this to change the center-weighting area from the default 8mm circle to 6mm or 10mm.

CSM 13: Auto BKT set

Use this option to choose whether auto exposure and flash, autoexposure only, flash only, or white balance is bracketed when using autobracketing.

CSM 14: Auto BKT order

Use this option to specify the order in which bracketing is applied. For flash and exposure bracketing, the order can be metered exposure/underexposure/overexposure (the default) or underexposure/metered exposure/overexposure. When bracketing white balance values, you can change the order from the default value of normal/bluer/redder to bluer/normal/redder.

More about bracketing

Auto bracketing is a fast way to apply different settings to several successive exposures, using parameters that include exposure, flash exposure, and white balance. You can bracket exposure or flash exposure only, or both of them, or white balance only.

To set up your camera for automatic exposure bracketing, follow these steps:

1. **Choose which type of bracketing you want to use (for example, exposure only, flash only, or exposure plus flash exposure) in the Custom Setting menu CSM 13.**

2. **Select the order in which you want the bracketed exposures to be applied in CSM 14.** You can choose from Default Order (Metered Exposure/Under Exposure/Over Exposure) or Under ⇨ MTR ⇨ Over (Under Exposure/Metered Exposure/Over Exposure). There is little practical difference among these; the choice is your personal preference. The latter setting provides a natural progression from dark to lighter to lightest, and is the one I prefer.

3. **Hold down the BKT button on the left side of the camera between the lens release button and the flash button, and rotate the main command dial to choose the number exposures in the bracketed set (either two or three).** Rotate to the right to start with overexposure, or to the left to start with underexposure.

4. **Spin the sub-command dial while holding down the BKT button to choose the bracketing increment from 0.3 EV to 2.0 EV (or 0.5 to 2.0 EV if you've set exposure increments to 1/2 steps instead of 1/3 steps in CSM 10).**

CUSTOM SETTING MENU	
07 ISO auto	OFF
08 Grid display	ON
09 Viewfinder warning	ON
10 EV step	1/3
11 Exposure comp.	ON
12 Center-weighted	(●) 8
13 Auto BKT set	AE

3.4 The Custom Setting menu (continued)

CUSTOM SETTING MENU	
14 Auto BKT order	N
15 Command dials	OFF
16 FUNC button	ISO
17 Ilumination	OFF
18 AE-L/AF-L	[▢]
19 AE Lock	OFF
20 Focus area	OFF

3.5 The Custom Setting menu (continued)

5. **Take your photos.** Bracketing is applied for the number of shots you've chosen.

CSM 15: Command dials

This option exchanges the functions of the main and sub-command dials, using the Reversed setting. To return the dials to their normal functions, select Off.

CSM 16: FUNC button

The Function button is the button on the front of the Nikon D80 just below the focus assist lamp, within easy reach of your index finger as you grip the camera. You can assign any of nine different functions to this button. My favorite is to use it to switch into spot metering mode from whatever metering mode I happen to be using (generally matrix metering). Your other choices for the button when used alone include: displaying the current ISO value in the viewfinder and on the top panel monochrome LCD; locking/unlocking the current electronic flash value; turning off the flash while the button is held down; and switching to matrix, center-weighted, or spot metering when the button is pressed. When you rotate the main command dial while

pressing the Func button, these actions can be available: turning the viewfinder framing grid on or off, choosing AF area mode, or switching between normal and wide area center autofocus zones.

CSM 17: Illumination

The monochrome LCD control panel's backlight normally illuminates for about 8 seconds only when the power switch is rotated all the way clockwise. If you're shooting in dim light for a long time, it can be annoying to have to turn the backlight on repeatedly. Set this option to On to keep the backlighting illuminated any time the exposure meters are active. Set it to Off to return to the normal behavior.

CMS 18: AE-L/AF-L

Use this feature to determine the behavior of the AE-L/AF-L button. You can choose to have this button lock both the exposure and focus, lock only either exposure or focus, or lock exposure (only) when the button is pressed, and keep it locked until the button is pressed again (to take several consecutive photos using the same exposure), or to keep it locked until the button is pressed again, but unlock exposure when the meter turns off. You can also define the AE-L/AF-L button to serve as a flash value lock, or to serve as a focus zone selection activator. There are 11 options in all, and if you think this array of choices is confusing, you're right. It really requires a chart to spell everything out., which is why I've provided Table 3.1.

Table 3.1
AE-L/AF-L Functions

Option	Description
AE/AF Lock	Exposure and focus are locked when the button is pressed.
AE Lock Only	Only the exposure is locked when the button is pressed.
AF Lock	Only focus is locked when the button is pressed.
AE Lock Hold	Exposure is locked when the button is pressed, and remains locked until you press the button again, or the exposure meters turn off.
AF-ON	Pressing the button activates autofocus instead of partially depressing the shutter release.
FV Lock	The built-in flash or Nikon dedicated flash units are locked at the current flash value when the button is pressed. The flash value is unlocked when the button is pressed a second time.
Focus area selection	Press the button and rotate the sub-command dial to select a focus zone.
AE-L/AF-L/AF area	Press the button to lock focus and exposure, and to choose a focus zone while rotating the sub-command dial.
AE-L/AF area	Press the button to lock exposure only, while rotating the sub-command dial to choose a focus zone.

Continued

Table 3.1 *(continued)*	
Option	**Description**
AF-L/AF area	Lock autofocus when the button is pressed, while rotating the sub-command dial to select the focus area.
AF-ON/AF area	Activate autofocus when the button is pressed, hold button and rotate sub-command dial to select a focus zone.

CSM 19: AE Lock

This specifies which controls can be used to lock the exposure at its current value. You can choose the AE-L/AF-L button (the default) or add the shutter release button (which normally locks the exposure only as long as you keep it partially depressed).

CSM 20: Focus area

When you're manually selecting the active focus area with the multi-selector, the cursor can wrap around to the opposite edge when you select Wrap here, or stop at the edge when you choose No Wrap.

CUSTOM SETTING MENU

21 AF area illumination	ON
22 Built-in flash	TTL⌃
23 Flash warning	ON
24 Flash shutter speed	1/60
25 Auto FP	OFF
26 Modeling flash	OFF
27 Monitor off	⏲20s

3.6 The Custom Setting menu (continued)

CSM 21: AF area illumination

This choice enables or disables the red light that illuminates the active focus zone in the viewfinder. You can choose On, Off, or Auto, which activates the light only when needed to provide sufficient contrast in the viewfinder.

CSM 22: Built-in flash

This is a multilevel menu with a clutch of options for the D80's built-in flash unit. You can choose:

✦ **TTL (through the lens metering):** The flash level is set for you automatically by the D80's flash metering system.

✦ **Manual flash setting:** You can choose a fixed power level from full power to 1/128 power. This option is useful when you want to adjust your flash exposure manually.

✦ **Repeating flash:** The flash fires multiple times when the shutter is open. You can select output level, the number of times the flash fires (from two to as many as 35), and

the number of times per second the flash fires (from one flash to as many as 50 per second). The number of successive flashes available varies depending on the power output; the higher the power, the fewer multiple flashes are available (because the flash unit is taking a fixed amount of power and distributing it among the individual bursts). For example, at 1/4 power, only two bursts in succession are available. At 1/128th power, you can specify as many as 35 individual bursts.

✦ **Commander mode:** You can set the built-in flash to serve as a wireless commander for optional SB-800, SB-600, or SB-R200 flash units in one or two groups.

CSM 23: Flash warning

You can turn the blinking "flash needed" warning in the viewfinder on or off with this option.

CSM 24: Flash shutter speed

Use this option to select the slowest shutter speed used for flash photography in P and A modes. This setting can help eliminate ghost images that can result when a slow shutter speed is used with flash, as both the flash and ambient light can contribute to separate exposures. (See Chapter 6 for a complete explanation of this phenomenon.)

To avoid ghost secondary images, you can disable the flash when using shutter speeds that are likely to produce them. The default value is 1/60 second, but you can select speeds from 1/60 second to 1 second. The setting you enter is ignored when Slow Sync (which specifically enables slower shutter speeds with flash) is used.

CSM 25: Auto FP

Use this option to turn high-speed flash synchronization on or off. When set to On, you can use shutter speeds faster than 1/200 second with compatible Nikon flash units, which produces a series of short bursts that lasts for the entire time the shutter is open. Chapter 6 explains more about FP flash.

CSM 26: Modeling flash

The D80 and compatible external speedlights from Nikon have a modeling-light feature that triggers a series of low-level flashes for a short period when the depth-of-field preview button is pressed, to help you judge the lighting effects you'll get. Use this option to turn the modeling flash on or off.

CSM 27: Monitor off

Because the D80's color LCD uses a great deal of power, you can use this option to specify how long it remains on when the camera is idle. Choose 5, 10, 20, or 60 seconds, or delays of 5 to 10 minutes.

CSM 28: Auto Meter Off

This controls how long the exposure meter remains active, and can be set for 4, 6, 8, 16, or 30 seconds, or 30 minutes (a setting sometimes used by photojournalists who don't want to chance missing a shot due to the slight lag for the meter to switch on again).

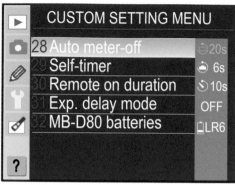

3.7 The Custom Setting menu (continued)

CSM 29: Self-timer

You can set the self-timer to delays of 2, 5, 10, or 20 seconds.

CSM 30: Remote on duration

This setting tells the D80 how long it should wait for a signal from the optional infrared remote control before deactivating.

CSM 31: Exp. delay mode

This option helps reduce blur caused by camera shake when the D80 is mounted on a tripod, microscope, telescope, or other device by delaying the exposure for 0.4 seconds after the shutter release is pressed.

CSM 32: MB-D80 batteries

Enables you to specify which type of AA batteries are loaded into the optional MB-D80 vertical grip/battery pack. You can choose from alkaline, nickel-metal hydride, lithium, or nickel-manganese battery types.

Setup Menu Options

In this menu, represented by a yellow wrench symbol, you can find options that you set and forget about — such as the current time or your language preferences — plus a few, including memory card formatting, that you'll use more often.

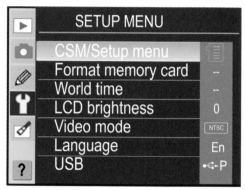

3.8 The Setup Menu

CSM/Setup menu

If you find all the menu options intimidating, you can limit the number of choices available using this option. You can select Simple, which causes the D80 to display only the most basic options in the Custom Setting and Setup menus; Full, which shows all available menu options; and My Menu, which enables you to choose exactly which menu items are shown in the Playback, Shooting, Custom Setting, Setup, and Retouch menus.

Format memory card

Use this feature to format a new memory card for use, and to reformat existing cards to remove all the photos on them and return them to a fresh, clean condition.

World time

Set the D80's internal clock to the current date and time, and choose the time zone, date format, and whether Daylight Savings Time should be observed. This information is written to the image file along with the exposure and other camera settings, so you can tell when the image was taken when you review it in your image editor.

LCD brightness

When this option is selected, a grayscale brightness chart is displayed that you can use to increase the brightness of the LCD (to make it more viewable in bright light) or decrease the brightness (which may help cut glare when using the D80 indoors in dim light).

Video mode

Use this option to toggle the AV port still image output of the D80 from NTSC (used in the U.S., Japan, and some other countries) to PAL (used in much of Europe and other regions) for television display.

Language

Choose the language you want your D80 to use in its menus.

USB

Use this option to tell your D80 to operate in either a PTP (Picture Transfer Protocol) or Mass Storage device mode. You can use both for transferring pictures. In Mass Storage mode, the D80 behaves like a card reader and your memory card is the equivalent of a floppy disk or hard drive. In the more sophisticated PTP mode, the camera

and software can communicate more completely in both directions, giving the software (such as Nikon Capture Control Pro) the capability of controlling the camera.

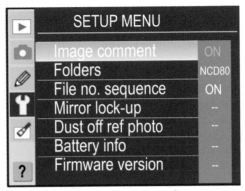

3.9 The Setup menu (continued)

Image comment

If you elect to use this feature, it appends a comment that is added to each image file. You can enter the comment using the text entry screen supplied, or type the comment on your computer using Nikon Capture NX and upload it to the camera.

Folders

Use this option to create, rename, or delete folders. Naming is done using the same text entry screen as the Image Comment feature.

File no. sequence

This option determines how sequential numbers are created for your filenames on the memory card. If you choose Off, the D80 resets the file number to 0001 each time you create a new folder or you use a new or reformatted memory card. When switched on, file numbers increase up to 9,999 and then start over. Choose Reset,

and the numbers start over again at 0001. If you insert a memory card with images numbered higher than the current image number in the D80's memory, the camera starts with that number instead, to avoid duplicate images.

Mirror lock-up

This mirror lock-up option is not a picture-taking feature but rather a means of getting the mirror out of the way and the shutter open so you can clean your sensor. It's only available when the D80's batteries are fully charged, or the camera is connected to an AC adapter or the MB-D80 vertical grip/battery pack is equipped with alkaline batteries.

Dust off ref photo

This option enables you to take a dust reference photo that images any artifacts clinging to your sensor, so that Nikon Capture NX can use the information to filter out the dust from your images. If you keep your sensor clean, or are willing to retouch a few dust spots yourself, you'll never need to use this feature, which is, at best, clumsy.

Battery info

The D80 stores information about its battery's current condition, including battery level, in percentage of full charge, the number of times the shutter has been tripped since the battery was charged, and a "useful life" indicator that tells you when the battery has reached the end of the road (in terms of its ability to retain a charge) and should be replaced.

Firmware version

This display shows the current camera firmware version.

Auto Image Rotation

This option (not visible in the figure) tells the D80 to embed in the image file information about the camera's orientation — either horizontal or vertical — when the picture was taken. Many software programs can use this information to display the image in the proper orientation; the D80's Rotate Tall playback option can also use this data to present images shot in a vertical format on the LCD in their proper rotation.

Creating Great Photos with the Nikon D80

Exposure
Essentials

Yuo don't need to know how the internal combustion engine works to drive a car, but it's useful to understand what happens when you accelerate while taking a hairpin turn. In the same spirit, digital camera owners can take great pictures even if they know very little about how sensors and digital image processors operate, but it's still important to be familiar with the elements of proper exposure, how to adjust the range of sharpness in an image, and a few other photography essentials. Then, when the call of creativity is irresistible, you can confidently make the adjustments that result in photographic hairpin turns without fear of disaster.

Advanced preparation is an excellent idea. After all, your Nikon D80 may be smart enough to make exposure settings for you and automatically focus an image, but it doesn't have the creativity that you bring to the photographic endeavor. Perhaps you want an image that is a little darker than normal to create a moody look, or one that is much lighter to build a high-key effect. Maybe you don't want the focus set on the subject that's closest to the camera and would prefer to emphasize an object lurking in the background by focusing sharply on it instead.

That's where your accumulated knowledge of photography basics is handy. In this chapter, I focus (so to speak) on the essentials of exposure. In Chapter 5, I provide a refresher course on choosing and using lenses and working with the range of sharpness called *depth of field*. I explain how to work with various types of illumination (including electronic flash) in Chapter 6.

Because this is a *field guide* and not a comprehensive course on photography, I'm going to concentrate on the basic information you might want to check as a reminder before tackling a tough shot out in the field.

Understanding Exposure

With the Nikon D80, you never have to work without a net. You can choose to let the camera select an appropriate exposure using the Auto mode or one of the pre-programmed Digital Vari-Program (DVP)/Scene modes. You might prefer to put your camera on autopilot with override, using the P mode that sets the basic exposure but still enables you to add or subtract exposure, or to choose a different shutter speed/lens opening combination at the same exposure if you want a faster/slower shutter speed or a particular f-stop for creative reasons.

You can also mandate a particular shutter speed or lens aperture using the D80's Shutter Priority or Aperture Priority modes, and your camera chooses the other value (aperture or shutter speed) to match (again, you are able to use your judgment to modify the camera's exposure selection if you choose).

The D80 even gives you a safety net if you switch to Manual mode and set exposure yourself. A helpful scale in the viewfinder provides a reminder of the exposure the camera would have selected if you'd been using one of the automated or semiautomated modes. You can use the scale to set your manual exposure, or choose to ignore it entirely.

The common factor in these options (aside from the full-auto DVP/Scene modes and Auto) is that your understanding of how exposure works gives you the power to accept the D80's recommendations, or modify them to suit the needs of a particular image. In the next section, I provide an overview of exposure, which can serve as a reminder to photographic veterans and as an introduction for newer users.

Exposure scale

4.1 Even when you're using Manual mode, the scale in the viewfinder shows you whether your settings are providing more or less than the metered exposure.

The term *exposure* can have multiple meanings within the realm of photography. All of the meanings, however, imply the act of producing an image by exposing a light-sensitive surface (film or digital sensor) to photons, which are transformed into visible picture elements (film grains or pixels) that we can see. An *exposure* can mean the image itself (or, more than one image in the case of a *double exposure*), a way of producing an image (as in *time exposure*), or the amount of light required to create the optimum visible image (the *correct exposure*). In all these variations, the term exposure has something of the same sense as it does outside the world of photography: an *uncovering*.

In photography, exposure involves four different concepts: the amount of light produced in a scene, the light levels that are admitted by the lens into the camera, how long that light is allowed to fall on the film/sensor, and how much of that light is actually captured. The photographer has at least some control over each of these factors.

The important thing to remember is that in digital photography (especially) the elements of exposure are reciprocal and proportional. You can increase or decrease the amount of light in a scene, the light transmitted by the lens, the length of time that illumination falls on the sensor, and the sensitivity of the sensor to adjust the exposure. Increase one of these elements while decreasing another by an equal value, and the exposure stays the same. To produce more or less exposure, increase or decrease any of the four elements by the same amount, and your results should be equivalent. (That's not always 100 percent true in the case of film, which is why digital imaging has a particular advantage when it comes to calculating exposures.)

Light produced by a scene

The first element of exposure is the *amount* of light produced by a scene. Outdoors in daylight, *reflected light* originates with the sun, but a lot can happen to it before it reaches the camera lens. Daylight may be diffused by clouds, filtered by trees and other forms of shade, and bounced off bright walls (or reflectors you introduce) before being reflected off your subjects toward the camera. Indoors, such continuous reflected light might come from lamps and other artificial forms of illumination, or perhaps from sunlight streaming through windows. Reflected light can be absorbed or blocked before it reaches your subject, too.

4.2 Light in a scene can be direct and bright, or soft and diffused, as the mixed illumination in this image demonstrates.

In addition to reflected light, some illumination can come from *transmitted light*, which passes through translucent objects that are lit from behind. A leaf backlit by the sun, a stained glass window, or an ice sculpture are all subjects that you can photograph successfully using transmitted light.

Finally, the light can come from objects that emit their own illumination, such as fireworks, candles, television screens, and glowing fireplaces. It's possible to photograph subjects that include more than one of these forms of illumination, too, such as an automobile shot late in the afternoon with its headlights on.

In exposure terms, you can influence the amount of light produced by a scene by increasing or decreasing the light levels in some way. That may involve adding or removing existing lights, pumping a little extra illumination into the scene by using an electronic flash, or redirecting the light with a reflector. If you're working with a human or other moveable subject, you can relocate to an area that's better illuminated or one that has less light, depending on the mood or intent you want the image to take.

In practice, you change the nature of the light in a scene for one of three reasons: either there is too little (or, less often, too much) overall illumination; or, the *balance* of the light is wrong — some areas are too bright, while others are too dim; or the *quality* of the light is wrong — it may be too harsh or too soft. For the current discussion, I'm concerned only about the quantity of light. If you imagine the light in a scene traveling from the subject to the sensor within the confines of a garden hose (an odd analogy that works better as you continue in this chapter), the illumination can consist of a trickle, a gushing flow, or something in-between.

 Cross-Reference *You can learn more about manipulating light in Chapter 6.*

Light transmitted by the lens

Once reflected, transmitted, or emitted light reaches the camera, it must pass through the lens as it wends its way to the sensor. Not all of that illumination makes it all the way through. Filters on the lens can block some light, while the rest of the light has to pass through a variable-sized diaphragm called the *aperture*, which resides within the barrel of the lens. You can think of the diaphragm as a garden hose of differing diameters, ranging from a large tube that admits all the available water (or light, in this case), to a smaller pipe that can allow only a small amount through at one time.

The light-blocking action of filters is easy to understand. Filters are most often mounted in front of the first lens element. Sometimes filters are located elsewhere in the optical path with specialized lenses, such as those with great magnification (super telephoto lenses) or those that distort images into fish-eye renditions.

In all cases, though, filters are designed to remove light, blocking some of that flow through the pipe. Some filters remove specific colors to make an image appear to be more blue, orange, or some other hue. Others (called *neutral density* filters) remove all colors equally to reduce the amount of light so exposures can intentionally be longer. There are even *split filters* with different types of filtering material in their upper and lower halves, designed to, for example, balance an overly bright sky with a foreground that is less generously illuminated.

So-called *polarizing filters* remove light bouncing at certain angles to reduce the amount of glare from reflective surfaces, or to darken the sky. Any time you use a filter of any sort, you're cutting down on the amount of light that reaches the sensor. (Normally, you don't need to worry about that, as the D80's automatic exposure system compensates for that loss. In addition, some very pale types of filters, such as skylight or UV filters, remove so little light that you don't need to factor them in.)

Of course, you may never use a filter or use them only rarely. The lens diaphragm, on the other hand, is called into play every time you take a picture. This mechanism consists of an arrangement of (usually) five to eight blades that create what is called an *iris aperture* (or just *aperture*) that dilates and contracts to admit more or less light to enter the lens. The relative size of the aperture is called the *f-stop*.

These f-stops are numbered in a confusing way: the larger the number, the less light admitted. So, f/11 allows half as much light as f/8, but twice as much as f/16. Think of f-stops as the denominators of fractions: 1/8 is larger than 1/11, which is larger than 1/16, and so forth. A second point of confusion comes in the numbers themselves: they are calculated from the square root of 2 (1.414), so f/8 is not twice as large as f/16: It's *four times* as large. To double (or halve) the exposure, you have to use an "in between" f-stop, in this case, f/11. The actual common progression of f-stops, from larger to smaller in *one stop* increments (each allowing twice as much light as the last) is:

✦ f/1.4 ✦ f/8

✦ f/2.0 ✦ f/11

✦ f/2.8 ✦ f/16

✦ f/4 ✦ f/22

✦ f/5.6 ✦ f/32

There are also "fractional" f-stops between those numbers in increments of 1/3 or 1/2 f-stop. They appear in your D80's indicators as figures like f/4.2, and so forth, as you or the camera adjusts the aperture. As you work with lenses and f-stops, you'll find yourself (or the D80's exposure system) increasing the amount of light passing through the lens by changing to a larger f-stop (a smaller number) or decreasing the amount of light by changing to a smaller f-stop (a larger number).

Changing the size of the lens opening has other effects on your photography besides exposure. Using a larger or smaller f-stop can affect the sharpness of the lens (many lenses produce better images at an intermediate f-stop than at the largest or smallest openings); and the range of sharpness (depth of field.)

Diaphragm

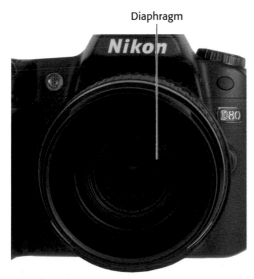

4.3 The diaphragm dilates and contracts to change the size of the lens opening.

 You can find an explanation of these factors, and others related to lens apertures, in Chapter 5.

 You can learn how to choose a shutter speed to stop action in Chapter 6.

To adjust the f-stop directly when using your Nikon D80, you need to work in either M (Manual) or A (Aperture Priority) modes. Spin the sub-command dial on the front of the handgrip and the aperture changes. When the meter is active, you see the current f-stop displayed on the top panel LCD and in the viewfinder.

To adjust the shutter speed directly when using your Nikon D80, you need to be working in either M or A modes. Spin the command dial on the back of the camera, and the shutter speed changes. When the meter is active, you see the shutter speed displayed on the top panel LCD and in the viewfinder.

Light admitted by the shutter

Think of the shutter as a valve that opens and closes, allowing the flow of light for only a specific period of time. When you adjust the shutter speed, you change the exposure by reducing or increasing the amount of time the light is allowed to fall on the sensor. With the Nikon D80, the shutter speed can vary automatically from 30 seconds (or even longer in Manual mode using the Bulb exposure setting) to 1/4000 second.

In addition to its effects on exposure, the shutter speed controls the amount of blur (or lack thereof) in your images. Slow shutter speeds allow moving objects to blur and camera motion to affect image sharpness. Higher shutter speeds freeze action and counter any camera shake. The exact shutter speed required to reduce/allow blur varies according to the speed of movement of your subject, the amount of camera shake, and the relative magnification of the image: Fast-moving objects, shaky photographers, and highly magnified subjects photographed close-up or with a telephoto lens all call for higher shutter speeds.

Light captured by the sensor

The fourth element that affects exposure is the sensitivity of the sensor. The Nikon D80 has a basic sensitivity setting of ISO 100, which is roughly equivalent to the sensitivity of an ISO 100 film, as determined by the body that governs such things, the International Organization for Standardization (which is abbreviated ISO, and not IOS, by the way).

You can change your camera's ISO from its basic ISO 100 value all the way up to ISO 1600 in 1/3 stop increments (and from there up to the equivalent of ISO 3200 with the H.03, H.07, and H1.0 settings.) That is, you can adjust the setting from ISO 100 to ISO 200 (which represents twice as much sensitivity as the basic setting) with intermediate stops of ISO 125 and ISO 160 along the way.

So, if you wanted to double the amount of exposure for a particular image, you could produce the same effect by doubling the ISO, by using a shutter speed that's twice as long, or by selecting an f-stop that's twice as large. Of course, there's a catch: Just as changing the shutter speed affects blur and

adjusting the f-stop affects the range of sharpness, increasing the ISO setting has an effect of its own. The higher the ISO, the more random grain, called *noise*, that appears in your photographs. Noise artifacts are those multicolored speckles that are most easily discerned in shadow areas of your images, but can be bothersome in the lighter areas, too.

The amount of noise increases as ISO is boosted, because the D80 achieves its higher sensitivity ratings by amplifying the light captured by the sensor. The amplification also multiplies random, non-image information. Fortunately, the D80 does an excellent job of suppressing this noise, and you're unlikely to even notice it at settings between ISO 100–ISO 400. It begins to pop up at ISO 800–ISO 1600, and probably will

provide a rich background texture for any photographs taken at higher ISOs (represented by H.03, H.07, and H1.0) on the monochrome status LCD.

You can change the ISO setting when using any of the D80's modes, from the DVP/Scene modes to Auto, or M, A, S, or P modes. Hold down the ISO button on the back of the camera to the left of the LCD, and rotate the command dial to select a value from ISO 100 to ISO 1600, plus H.03, H.07, and H1.0. If you're using Auto exposure mode or one of the DVP/Scene modes, you can also choose Auto ISO, which directs the camera to choose an ISO setting for you.

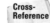 **Cross-Reference** *You can find more about setting ISO in Chapter 2.*

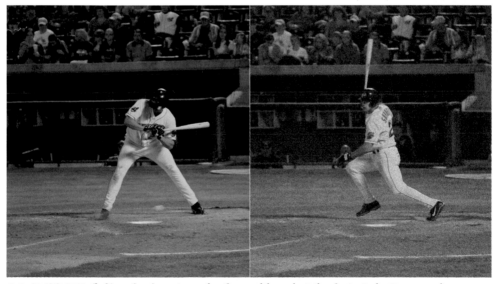

4.4 At ISO 800 (left) noise is not much of a problem, but the fastest shutter speed available won't stop the action. ISO 3200 equivalent (right) allows a higher shutter speed, but the noise is horrendous.

Getting the Right Exposure

As stated in Chapter 2, obtaining the right exposure involves choosing the correct metering mode (matrix, center-weighted, or spot), and either allowing the D80 to determine the ideal exposure from its database of picture information, or overriding the camera's exposure decisions to provide a tweak of your own. Chapter 2 includes information on viewing the D80's histogram feature to determine when those tweaks are necessary.

But, given the sophisticated electronics in your Nikon camera, why aren't exposures always right on the money? Why is it even possible to get images that are too light, too dark, or which contain highlight or shadow areas with no detail?

Unfortunately, no sensor can capture all the details possible in an image at every possible light level. Some details are too dim to capture, and others overload the photosites in the sensor, so you end up with dark or light areas that should contain detail, but don't. Because a digital sensor can't handle the largest variations between light and dark areas, the best exposure for a given picture is likely to be one that preserves the detail at one end of the scale, while sacrificing detail at the other end. For a photograph taken around a campfire, you might want to see facial details in the shadows, and not mind if the campfire itself appears a little too bright and washed out. A picture taken on the beach might look best if as much detail in the brightest highlights is preserved, even at the cost of, say, detail in the shadows cast by a beach umbrella.

Because you, as the photographer, are in the best position to determine which tones in an image should be preserved, that makes you smarter than your D80's exposure meter. You're the one who needs to make the exposure adjustments that might be required to give you the kind of image and range of tones that you want.

Keep in mind that the D80 makes its basic exposure setting based on the assumption that your subject is reflecting about the same amount of light as a neutral gray card with a reflectance of 18 percent. It makes that assumption because different subjects reflect different amounts of light. In a photo containing a white cat, a dark gray cat, and a black cat, the white cat might reflect five times as much light as the gray cat, and ten times as much light as the black cat.

An exposure based on the white cat causes the gray cat to appear to be black, and the black cat to be an inky, dark blob. An exposure based only on the black cat makes the white cat seem to be washed out, and the gray cat somewhat darker than usual. If the gray cat happened to reflect about 18 percent of the light bouncing off it, it's actually possible that all three cats would be rendered realistically, assuming that the white cat isn't too white, and the black cat isn't too black. In that case, the tonal range of the scene would be too broad to be captured by the sensor. It's these troublesome black and white cats that force photographers to make exposure adjustments.

Figure 4.5 pictures just one cat, of the black variety, with the exposure optimized (at left) for the cat's surroundings, causing the cat itself to become a black blob. At right, the exposure was set for the cat itself, providing lots of detail in the fur, but overexposing the cat's garden environment.

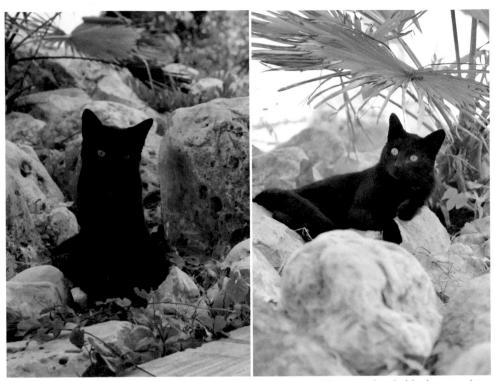

4.5 Exposing for the background (left) causes the cat to render completely black; exposing for the cat itself (right) makes the background detail too light.

Enter the histogram

The tonal range is the distribution of light and dark shades in your image. You can view that distribution using the D80's histogram feature. View the histogram chart for any image by pressing the Playback button to the left of the LCD, scrolling to the image you want with the left/right multi-controller keys, and then pressing the up/down buttons until the histogram information display appears, as shown in figure 4.6.

Four histograms are shown: separate red, green, and blue charts for the colors in your image at the right side of the screen, and a brightness, or *luminance*, chart at the bottom. The brightness histogram is a simplified bar graph that shows the numbers of

pixels at each of 256 brightness levels. (The color histograms show the same information, but for the individual color channels only.) Each vertical line in the graph represents the number of pixels in the image for each brightness value, from 0 (black) on the left and 255 (white) on the right. The vertical axis measures the number of pixels at each particular brightness level.

A typical histogram (see figure 4.7) shows most of the pixels concentrated roughly in the center of the graph, trailing off to fewer pixels at the dark end (on the left) and light end (on the right) of the scale. Ideally, there should be some pixels across the full scale, but none clipped off at either side (showing that dark or light pixels weren't properly recorded), and relatively few very dark pixels

Image preview

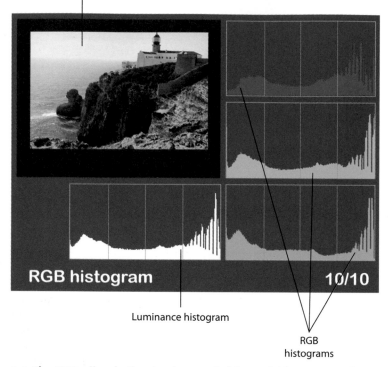

RGB histogram 10/10

Luminance histogram

RGB
histograms

4.6 The D80 offers both a luminance (brightness) histogram and separate graphs for red, green, and blue colors.

(on the left) or very light pixels (on the right). A perfect histogram would have the toes of the curve snuggle up comfortably with both the left and right ends of the scale.

If the exposure is not perfect, a histogram shows that. With an underexposed image, some of the dark tones are clipped off at the left end of the scale, and highlight tones that belong at the far right reside toward the center of the graph, leaving an area of unused tones in the gap (see figure 4.8). Increasing the exposure moves all the tones toward the right, so the dark tones aren't clipped and the lighter tones occupy their proper position at the right side of the histogram.

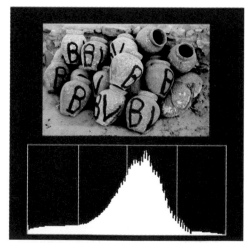

4.7 A normal exposure has most of the tones in the middle, with dark and light tones trailing off to the left and right ends of the graph.

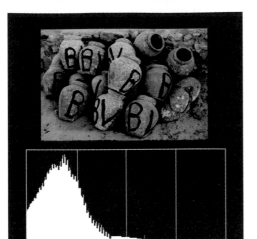

4.8 With an underexposed image, the dark tones are clipped off at the left side of the histogram.

With an overexposed image, some highlight tones are lost off to the right side of the scale (see figure 4.9), and the dark tones move toward the middle. In this case, reducing the exposure produces a better image.

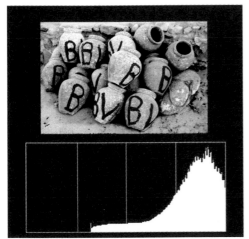

4.9 In an overexposed image, the light tones are clipped off at the right side of the histogram.

Adjusting exposure

If you're using M, A, S, or P modes, you can adjust the exposure in several different ways, depending on which of these modes you're using. In Manual mode, of course, you can simply use the main command dial to change the shutter speed, the sub-command dial to adjust the aperture, and the ISO button plus the main command dial to modify the sensitivity setting.

In Program, Shutter Priority, or Aperture-Priority modes, you have a little more flexibility.

Exposure value compensation

You can set the D80 to automatically add or subtract a certain amount of exposure from the value that it calculates by applying EV (Exposure Value) compensation. You can specify up to plus or minus five full stops worth of compensation in 1/2 or 1/3 stop increments (depending on the increment size you've set in the Custom Setting menu). Once you've activated EV compensation, the camera adds or subtracts this amount of exposure from every shot you take until you change to another EV setting, or turn the feature off by setting the EV back to zero.

It's important to keep that in mind, because you can easily dial in some EV changes that suit a particular shooting environment, and then forget that you've made the setting when you begin taking pictures of a different scene. The D80 is nice enough to include an indicator on both the top panel monochrome LCD and in the viewfinder that show that you've departed from the recommended exposure with an EV change, but both are easy to overlook in the heat of a shooting session.

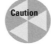 *Always remember to check your EV settings from time to time!*

To apply EV settings, hold down the EV button (located behind and to the left of the shutter release), and spin the main command dial to dial to the right to subtract exposure, and to the left to add exposure from the D80's default meter reading (see figure 4.10). In A mode the camera uses the shutter speed to make the adjustment; in S mode it uses the aperture; and if you're working in P mode, the D80 uses its internal programming to determine which value to change. The new shutter speed or f-stop appears in the viewfinder and in the LCD status panel.

4.10 As you dial in more or less exposure using EV compensation, the amount you've added or subtracted appears in the status LCD.

Tip

In Program mode, if you want to use the metered exposure, but would prefer a different shutter speed or f-stop combination for that exposure, just rotate the main command dial without pressing the EV button. The exposure remains the same, but the D80 switches to a different f-stop/shutter speed combination. Use this facility to change from, say, 1/125 second at f/16 to 1/500 second at f/8 when you want a faster shutter speed to stop action.

Bracketing

Bracketing is a feature that makes it possible to take several shots at different settings, in the hopes that one of them will be spot on. The Nikon D80 allows you to bracket exposure only, flash exposure only, both conventional and flash exposure, or white balance, as I explain in Chapter 3. You can also choose the number of shots in the bracketed sequence (either two or three) and the order in which they are taken.

Bracketing is a handy tool when you'd like a set of images with varying exposures, either to help zero in on the optimum exposure or to see how different exposures work from a creative standpoint. For example, bracketing a backlit subject can give you a set of three pictures ranging from a full silhouette of your subject to one in which your subject is properly exposed.

To access bracketing, hold down the BKT button on the front left side of the camera, just above the lens release button. Spin the main command dial to choose the number of shots in the bracketed sequence: zero (which turns bracketing off), two, or three. Rotate the sub-command dial to select a bracketing increment, from 0.3EV to 2.0EV. You set up the type of bracketing in the Custom Setting menu, using CSM 13 and CSM 14, respectively, as I describe in Chapter 3.

4.11 Bracketing enables you to take up to three images consecutively, each with a different exposure (or, if you like, with a different white balance).

Tone compensation

The final exposure tweak you can make is called *tone compensation*, which is a method for controlling how the D80 handles exposure of the darkest and lightest areas of your image. You can use tone compensation to adjust the contrast of the image as you take the picture, which is usually a better solution than trying to fix faulty contrast later on in your image editor. The drawback to using tone compensation in the camera is that a custom change you make applies to all the shots you take until you switch back to noncustom mode.

Even so, some D80 users prefer a different default contrast range for all the pictures they shoot, and dial in a custom tone compensation setting. Either that or you can upload one of the pre-programmed settings available on the Internet, uploading to the camera with an optional program called Nikon Camera Control Pro (see figure 4.12).

4.12 Nikon Camera Control Pro enables you to edit custom contrast curves and upload them to the D80.

You can access tone compensation in the Shooting menu. Select Optimize Image ⇨ Custom ⇨ Tone Compensation. Then you can choose from Normal, Less Contrast, Medium Low, Medium High, More Contrast, or Custom (which applies a tonal curve you've uploaded using Nikon Camera Control Pro).

All About Lenses

One of the key advantages of a single lens reflex (SLR) camera like the Nikon D80 is the ability to remove one lens and replace it with another. This flexibility gives you a longer reach with the added magnification of telephoto lenses, the broader perspective that comes from using wide-angle lenses, and the power to focus closer or take pictures in lower light levels than you could with any single, fixed lens permanently mounted on your camera. Interchangeability is versatility!

Certainly, there are fixed-lens non-SLR cameras with super-zoom lenses with 12X zoom ratios or better that include just about every focal length you might think you'd need, from moderate wide-angle to ultra-telephoto, in a single lens. But for each image you can produce with such a camera, you can find others that are possible with the D80 using lenses that are wider, longer, more sensitive to light, or able to focus closer.

In fact, for many D80 owners, add-on lenses are the number one accessory option they rely on for stretching the capabilities of what is already a multitalented picture-taker. In this chapter, I cover all the bases of selecting and using lenses for the Nikon D80 digital SLR.

Evaluating Your Basic Options

When Nikon introduced the D80, it offered the camera in three basic configurations. You can buy the camera in a kit with the 18-55mm f/3.5-5.6G ED AF-S DX Zoom-Nikkor (or, more recently, the newer 18-55mm f/3.5-5.6G II ED AF-S DX Zoom-Nikkor, which was introduced at the same time as the D80's sta-blemate, the Nikon D40). When you purchase it in a kit, either lens will cost you about $100 more than the camera alone.

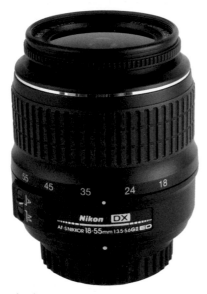

5.1 The least expensive D80 kit includes this 18-55mm zoom lens.

You can also buy the D80 in a kit with the 18-135mm f/3.5-5.6G ED-IF AF-S DX Zoom-Nikkor, a slightly more expensive lens that has the same wide-angle perspective as the 18-55mm zoom, but a more useful 135mm telephoto maximum focal length. In a kit package, the 18-135mm zoom adds about $300 to the price of the D80 body alone.

Finally, you can purchase the camera as a body only, with no lens included. That might be your best choice if you already have suitable Nikon lenses because you've owned a Nikon SLR in the past, or if you want to outfit your new D80 with a lens that's not offered in one of the basic configurations. If that's the case, you might want to opt for one of the lenses that are available separately or as kit lenses for two other Nikon cameras: the 18-70mm f3.5-4.5G ED-IF AF-S DX Zoom Nikkor originally offered with the

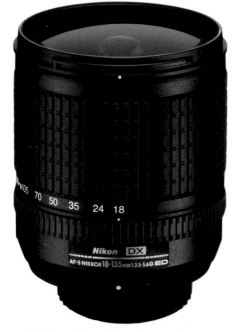

5.2 This 18-135mm lens is part of an upgraded D80 kit.

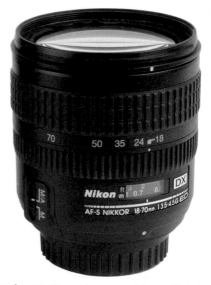

5.3 The 18-70mm lens provides a slightly longer zoom range than the basic D80 kit lens, at a moderate increase in cost.

Nikon D70/D70s (about $300 separately), and the amazing 18-200mm f/3.5-5.6G ED-IF AF-S VR DX Zoom-Nikkor, which has built-in vibration reduction (a kit option with the upscale Nikon D200, or about $750 separately).

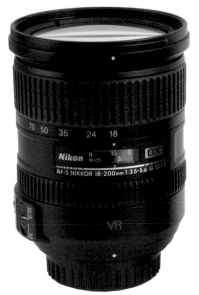

5.4 The 18-200mm f/3.5-5.6G ED-IF AF-S VR DX Zoom-Nikkor, with vibration reduction, is probably the ultimate "walking around" lens.

Advantages of the kit lenses

Any of the four basic kit lenses make good starter lenses for the Nikon D80, and any of them can perform flexibly in a wide range of picture-taking situations. If you must work with one lens only (usually because you had to stretch your budget to purchase the D80 and its initial lens), it will do a good job for you. Here are some advantages that broadly apply to the entire quartet of basic lens options.

✦ **Minimal cost:** At $100 when you purchase it in the kit, the 18-55mm zoom is a remarkable bargain. It offers the equivalent of a moderate wide-angle to short-telephoto lens in a compact package. The extra $300 to $400 for the 18-70mm or 18-135mm zooms is well worth it for the extra telephoto reach you get. I'd have to describe the 18-200mm vibration reduction (VR) lens as reasonable cost rather than minimal cost, but when you consider its 11X zoom range and shake-reducing vibration reduction, it can easily replace two or more lenses that would be even more expensive to purchase.

✦ **Useful zoom range:** These four lenses have 3X, 3.8X, 7.5X, and 11X zoom ranges (for the 18-55mm, 18-70mm, 18-135mm, and 18-200mm models). As I've mentioned before, the D80's sensor, because it is smaller than a full 24 x 36mm film frame, crops the field of view of all lenses (when compared to a full-frame digital or film camera). All of them begin at 18mm, which is the full-frame equivalent of 27mm, and reach out to the equivalent of 82.5mm, 105mm, 202mm, and 300mm (respectively). Depending on how much sports or wildlife photography you do (which tends to thrive on longer telephoto focal lengths), any of these may do the job for you.

✦ **Adequate aperture speed:** All four lenses have a maximum aperture of f/3.5 at the wide-angle position, which shrinks to f/5.6 at the telephoto end (except for the 18-70mm kit lens, which has an f/4.5 maximum aperture at the 70mm setting). You may find this

aperture range limiting for available light shooting (particularly sports when in telephoto mode), but remember that faster lenses are much more expensive. Nikon's 17-55mm lens, with a fixed (non-changing) f/2.8 maximum aperture tops $1,300. Also keep in mind that you can often use the 18-200mm VR lens at a slower shutter speed because of its anti-shake proper-ties, which effectively gives you an extra f-stop or two of "speed."

✦ **Good image quality:** All four of these lenses include extra-low dis-persion glass and aspherical ele-ments that minimize distortion and chromatic aberration, and produce sharp images. Considering the low (or reasonable) price tags on these optics, they are image-quality bargains suitable for all but the

most demanding photographic applications.

✦ **Compact size:** At a featherweight 6.8 ounces (for the 18-55mm zoom) to about 19 ounces (for the 18-200mm VR lens), any of these four are light enough in weight and compact enough in size to perform as "walking around" lenses when you want to leave the camera bag at home and venture out with your D80 and just one lens.

✦ **Fast, close focusing:** These lenses all focus quickly and silently, and, while none of them are macro lenses, they do let you focus as close down to a foot or two.

Figures 5.5 and 5.6 show just how much zoom you can get from the four basic starter lenses for the D80. Figure 5.5 shows the full

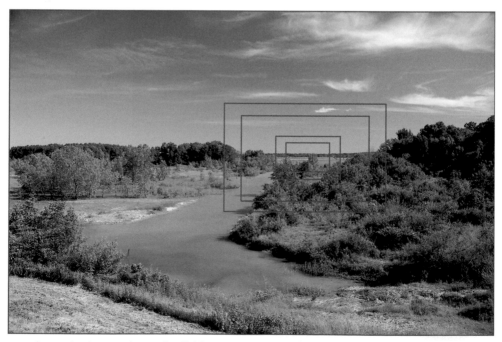

5.5 The entire image shows the field of view you might get at 18mm.

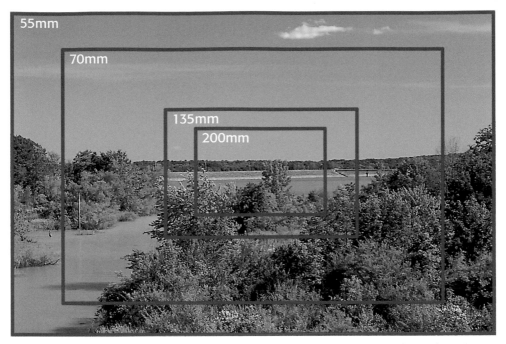

5.6 At the maximum zoom settings of the 18-55mm, 18-70mm, 18-135mm, and 18-200mm lenses, you would see these perspectives.

view you might get from any of these lenses at the 18mm zoom position, with insets illustrating the field of view at each of the maximum zoom settings of the respective lenses. Figure 5.6 is an enlarged view of all four maximum zoom views, showing 55mm, 70mm, 135mm, and 200mm perspectives.

Upgrading your capabilities

You may take lots of great pictures using nothing but your basic lens, but, sooner or later, you may find an image you want to capture that calls for capabilities that just aren't built into the lens you have. That's when you want to consider adding to your stable of interchangeable optics with an add-on lens or two. The chief limitations you'll be looking to overcome include:

✦ **The need to bring your subject closer:** Telephoto lenses and tele-zooms bring distant objects closer to your camera, so you can still take tightly cropped photos of sub-jects that you can't physically get closer to. You can capture that intriguing mountain cabin perched on a distant peak, the football action taking place on the other side of the field, or a timid deer pausing for a drink more easily with telephoto lenses. Such lenses can also help you isolate subjects and reduce the apparent distance between objects. For the D80, tele-photo focal lengths encompass everything from around 55mm to 500mm, or, even more if you can afford a super-telephoto lens.

✦ **The desire for a wider view:** Wide-angle lenses and wide-angle zooms enable you to photograph broad vistas or capture everything in a room when there is no space to back up, while emphasizing the foreground. Wide angle lenses for the D80 range from about 20mm down to 10mm.

✦ **The urge to get closer:** Macro lenses are special optics with close-focusing capabilities that may bring you to subjects only an inch or two from the front of the lens. These lenses are available as fixed-focal-length (nonzooming) prime lenses, such as the 60mm and 105mm Micro-Nikkors, as well as in macro-zoom configurations.

✦ **The necessity of shooting in lower light, or with faster shutter speeds:** When light is dim, an f/4.5 maximum aperture may not allow you to use a shutter speed that's fast enough for handholding the camera. You can break out your tripod, switch to a lens with vibration reduction, boost the ISO of your camera to noise-inducing levels, or attach a lens with a faster maximum aperture (from f1.2 to f/2.8) to your D80. If you're shooting sports and need a fast shutter speed, you might find a faster lens useful even when there is plenty of light. The action-stopping capability of an f/2.8 lens at 1/500 second is much better than, say, that of an f/4.5 lens at 1/180 second.

✦ **The quest for a sharper image:** When it comes to sharpness, not all lenses are created equal. Some are simply sharper than others, and when you're taking pictures that are likely to be cropped significantly or enlarged for display, such as an 11-x-14-inch or larger print, you might want a lens that's sharper. Some lenses are better than others when used at large apertures; others perform more capably for macro photography; and some zooms do a better job at certain focal lengths than others. When sharpness is important to you, having a suitable lens available can save the day.

✦ **The lure of special features:** When the job at hand is specialized, a special lens might be available to do the job right. I've already mentioned the superior performance of macro lenses in close-up photography, and fast, large-aperture lenses in low light or when higher shutter speeds are desirable. Vibration reduction, which compensates for camera and photographer shake by shifting elements inside the lens as the picture is taken, is another special feature that's becoming relatively commonplace. Even so, there remain some exotic lenses with features that even the most jaded photographer considers special. These include optics with shifting elements that provide a certain amount of perspective control; and lenses like the Nikon DC (defocus control) series that let you adjust how the out-of-focus portions of an image appear (especially useful in portraiture). Other special lenses include fish-eye lenses, and ultraviolet lenses for scientific applications. If you need one of these unusual features, nothing else will do the job.

Choosing between Zoom and Fixed Focal Length

In the not-so-distant past, zoom lenses were big and heavy, expensive, didn't have large maximum apertures, and were not very sharp. Today you can still find zooms that are big and expensive, but, by and large, they are much sharper than their prehistoric predecessors, and are accompanied by other, more practical zooms that are small, light, and relatively inexpensive (but still slow in the maximum aperture department).

I once used a Nikon zoom that had a 50-300mm zoom range, weighed five pounds, was a foot long, and cost a month of my salary. Today, I'm better paid, but I was able to purchase a $350 28-200mm f/3.5-5.6G ED-IF AF Zoom-Nikkor for my D80 that measures 2.7 x 2.8 x 3 inches long, weighs 12.7 ounces, and outperforms its behemoth ancestor in every respect. Zoom lenses are suitable for just about every type of photography these days, provide excellent sharpness, and are eminently affordable.

Their chief limitation is maximum aperture and, with some of the longer zoom ranges, weight. These limitations are worse at one end of the zoom scale than at the other. For example, the 80-400mm f/4.5-5.6D ED AF VR Zoom-Nikkor makes a pretty good 400mm f/5.6 lens. Its vibration reduction can be especially useful for wildlife photography when you don't want to set up a tripod. But, when you're using this lens at the short end of its zoom range, it makes a rather unwieldy three-pound, 80mm f/4.5 lens. You can make similar comparisons with other zooms that tend to compromise

maximum aperture and size to give you a useful zoom range.

That's where fixed-focal-length (also known as *prime*) lenses come in. They are built to be used at only one focal length, and therefore can be more compact, have larger maximum apertures, and boast a little extra sharpness. They are a good choice when you have enough freedom of movement to move closer to or farther away from your subject as is required to fill the frame.

In recent years Nikon has offered f/1.4 lenses in fixed 28mm, 50mm, and 85mm focal lengths that are unmatched for speed and resolution (although Nikon seems to be phasing the 28mm f/1.4 out of the lineup). If you have deep pockets, you can buy 300mm and 400mm Nikkors with f/2.8 maximum apertures, and 500mm or 600mm f/4 super-telephotos. In contrast, even wide-angle and short telephoto zoom lenses from Nikon with f/2.8 maximum apertures tend to be very expensive.

5.7 A fast 85mm f/1.8 prime lens allowed me to take this concert photo using only available light.

Assessing Lens Compatibility

Until fairly recently, lens compatibility was almost a nonissue for Nikon users. You could mount any autofocus lens on any Nikon SLR camera — film or digital — and use it with full functionality. You could use manual focus lenses, too, with manual focusing, of course, and with the proviso that very old lenses (those made before 1977) needed to have a small adjustment made to ensure compatibility with newer cameras (those made in the last 30 years).

Until late 2006, the only real compatibility issue was with older, nonelectronic cameras that had to be used with lenses that included a real aperture ring. Modern G-type lenses (they include a G in their model name) don't have an aperture ring, and the camera must set the f-stop (see figure 5.8). All Nikon digital SLRs set the aperture electronically and can do this with both G-type lenses and other autofocus lenses that do have an aperture ring, as long as the ring is locked at the smallest f-stop. So, if you owned any Nikon dSLR, you could use virtually any autofocus lens with all of that lens's features and functions.

Unfortunately, this across-the-board compatibility changed with the introduction of the D80's "little" sibling, the Nikon D40. That camera's autofocus feature operates only with lenses that include an internal motor to handle focus. The Nikon version of these lenses are labeled AF-S or AF-I. Nikon dSLRs other than the D40 also have their own mechanism for focusing nonmotor autofocus lenses; they apply pressure to a pin on the rear surface of the lens mount. So, with the D40, Nikon rather unexpectedly introduced the element of lens incompatibility between the D40 and some fairly

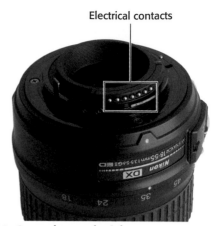

Electrical contacts

5.8 G-type lenses don't have an aperture ring at all; the camera communicates the lens opening required to the lens through these electrical contacts on the edge of the lens mount.

recent lenses, including those produced by a number of third-party lens vendors.

Because you own a D80, which does work with both AF and AF-S/AF-I lenses, you might think this new kink doesn't affect you. However it does, indirectly. If you have noncompatible lenses in your arsenal, or choose to acquire them in the future, you should be aware that you aren't able to autofocus with them if you decide to buy a D40 in the future as a backup to your D80. If someone in your family buys a D40, or you have a friend who owns one, you might not be able to share lenses as easily as you think. I'm glad Nikon has a lower-cost entry-level camera (I purchased a D40 myself), but am not pleased with the precedent-shattering lens incompatibility issue.

Other than the G-type aperture issue, the new D40 mismatch, and a few ancient fisheye and wide-angle lenses that require locking up the mirror before mounting, you can use just about any Nikon lens produced since 1959 with your D80. Nikon

lenses made prior to 1977 must have some simple machining done to remove portions of the lens mount that interfere with tabs and levers added to later models for functions such as autofocus, including the D80. Technician John White (www. aiconversions.com) can perform conversions for you for as little as $25 to $35.

You can't expect older lenses to offer the autofocus and autoexposure features built into the latest lenses, of course. For example, you must manually focus and meter older lenses when they are mounted on your D80. Even so, it's fun to be able to use inexpensive manual lenses that are sharp, available, and not even that inconvenient for many applications. I regularly use an old 55mm f/3.5 Micro-Nikkor for close-up photography. I manually focus macro images anyway, and it's no big deal to review an image on the LCD and then make an exposure adjustment if necessary. You can find many great old lenses on eBay or from other sources for less than $100.

Deciphering Nikon's Lens Naming Scheme

Before the electronic age, just about everything you wanted to know about a Nikon lens was readily discernable from its name. Most lenses were Auto-Nikkors (meaning the lens had an automatic diaphragm that stopped down to the taking aperture during the exposure). There were Micro-Nikkors for close-up work, and a few Zoom-Nikkors with variable focal lengths. Many lenses had a letter appended that indicated how many elements the lens had. If you knew Latin, you understood that a Nikkor-P lens had five elements (penta), a Nikkor-H lens had six

elements (hexa), and a Nikkor-S had seven (septa), and so forth.

Today, we have a virtual alphabet soup of designations, and you almost need a program to know what Roman number II is doing in the name of the latest 18-55mm f/3.5-5.6G II ED AF-S DX Zoom-Nikkor. (It means that it's the second lens in a series that otherwise has the same specifications.) The list that follows explains what various parts of the lens names signify:

✦ **AI, AI-S:** Nikkor lenses produced after 1977 have an *automatic indexing* (AI) feature and *automatic indexing-shutter* (AI-S) that eliminate the need to manually align the aperture ring on the camera. Nikon first included the letters AI or AI-S in the lens name to indicate that the lens had this feature, but eventually dropped the designation. In practice, all lenses introduced after 1977 are AI/AI-S– compatible and include automatic indexing, except for G-type lenses, which have no aperture ring at all.

✦ **E:** Nikon's E Series lenses are bargain-priced lenses with aluminum or plastic parts, which makes them a little less rugged than more expensive optics that use brass parts. However, the image quality is generally pretty good.

✦ **D:** The D Series lenses can relay focus distance information to the camera, used with 3D Matrix metering and flash exposure calculation.

✦ **G:** G-type lenses have no aperture ring, and you can use them at other than the maximum aperture only with electronic cameras like the D80 that set the aperture automatically or by using the sub-command dial.

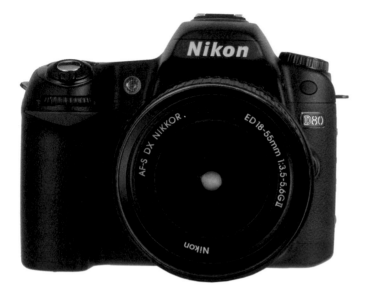

5.9 Most lenses have their vital statistics imprinted on the ring surrounding the front element.

✦ **AF, AF-D, AF-I, AF-S:** If you find AF in the lens name, the lens is an autofocus lens. The additional letter provides more information: D (it's a D-type lens), I (focus is through an internal motor), or S (internal focus with a *silent wave* motor; you can focus or fine-tune focus manually even with AF engaged).

✦ **DX:** The DX lenses are designed exclusively for use with digital cameras using the APS-C–sized sensor having the 1.5X crop factor, which at this writing includes every model from the D2Xs to D40. Their coverage circle isn't large enough to fill up a full 35mm frame. The digital-only design means that these lenses can be smaller and lighter than their full-frame counterparts. If Nikon comes out with a full-frame digital camera in the future,

I'd expect it to have an automatic crop mode that would crop the image to include only the APS-C–sized image area when a DX lens is mounted.

✦ **VR:** Nikon's expanding line of VR lenses, including the very afford-able 70-300mm and 18-200mm VR zooms, include vibration reduction technology, which shifts lens elements to counteract camera shake or movement and enables you to take photos without a tri-pod at slower shutter speeds.

✦ **ED:** The ED designation indicates that the lens has elements made of extra low dispersion glass, which tends to reduce chromatic aberration and other defects. Some lenses use an LD (low dispersion) or UD (ultralow dispersion) marking instead.

VR: Very Rewarding

Nikon's VR feature counters camera shake with lens elements that are shifted internally in response to the motion of the lens during handheld photography, countering the shakiness the camera and photographer produce and telephoto lenses magnify. (Although VR works well with wide-angle focal lengths, such as those found in Nikon's 18-200mm and 24-120mm VR lenses.)

VR provides the equivalent camera steadiness of at least two shutter speed increments, letting you shoot telephoto pictures at 1/250 second that might have required 1/1000 second without VR; or wide-angle photos at 1/15 second that would have mandated a 1/60 second shutter speed without VR. In some cases, VR can eliminate the need for a tripod. However, keep in mind that VR doesn't freeze action: You may still need that 1/1000 second shutter speed to stop sports action. Nikon's exceptional 105mm f/2.8G ED-IF AF-S VR Micro-Nikkor may enable you to shoot macro photos handheld — but it won't help you photograph outdoor blossoms that are wavering in the breeze. Nor does VR always work well when you're panning the camera. There are still many situations where a steady hand, a monopod, or a tripod does the best job for you.

✦ **Micro:** The term *micro* is Nikon's designation for a macro lens.

✦ **IF:** The IF code signifies that the lens has internal focusing, so the length of the lens doesn't increase or decrease as the lens is focused.

✦ **IX:** These lenses were produced for Nikon's Pronea APS film cameras. While you can use many standard Nikkor lenses on the Pronea 6i and Pronea S, the reverse is not true. You can't use these IX lenses on the D80. I include this designation only for the sake of completeness, and as a caveat for anyone who happens to spot an old IX Nikkor and wonder if it can be used with the D80.

✦ **DC:** The DC stands for *defocus control*, which is a way of changing the appearance of the out-of-focus portions of an image; this is especially useful for portraits or close-ups.

Understanding Automatic Focus

To take advantage of your Nikon D80's autofocus features, you must be using an autofocus lens, of course. Nikon autofocus lenses include an AF designation in their name. The company still has a limited number of manual focus lenses in its product line, all with the AI-S code in the lens name.

To activate autofocus, make sure the lever on the camera body next to the lens mount is set to AF (autofocus) rather than M (manual focus). If your lens has its own AF-M switch, it must be set to AF, too. The M setting on either the camera body or lens takes precedence: If you've selected manual focus in either case, then you must focus manually, regardless of whether AF is set or not on the camera or lens. Some lenses include an M/A-M switch. In the M/A position, autofocus is active, but you can override the camera's focus setting manually if you want.

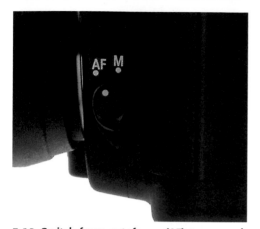

5.10 Switch from autofocus (AF) to manual focus (M) using the switch on the camera body.

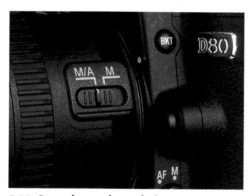

5.11 Some lenses have their own autofocus/manual switches.

If you do want to focus manually, just twist the focus ring on the lens, which is usually narrower than the lens's zoom ring. The focus ring may be either the innermost or outermost ring, depending on the lens itself. When you rotate the focus ring, you see the image pop in and out of focus as you peer through the viewfinder. If you press the shutter release down halfway, the information display at the bottom of the viewfinder appears, and the D80's green focus confirmation indicator lights up when correct focus is achieved.

In autofocus mode, partially depressing the shutter release button activates the focus mechanism. If your lens has an f/5.6 or larger maximum aperture, one or more of the nine brackets visible in the viewfinder illuminates in red to show you which areas of the image are calculating correct focus. When the lens has locked in autofocus, the green focus confirmation indicator glows.

The autofocus system works best under bright lighting conditions, with subjects that have lots of contrast. Some patterns and fine details, or areas with no details at all (such as the sky), can confuse the autofocus mechanism. If there are objects at widely different distances within the same focus zone (Nikon cites shooting through chain link fences as an example), the focus system may be unable to lock onto a specific subject.

When the light is dim or your subject's contrast is low, the D80's focus assist lamp illuminates. The lamp, which also flashes when the self-timer is used, is located on the front of the camera between the shutter release button and lens mount. External Nikon electronic flash units, such as the SB-800 speedlight and the Nikon SB-29 flash extension cable (which clips onto the flash accessory shoe on top of the camera), also have focus assist lights. If you find the focus assist feature distracting, you can disable it in the Custom Setting menu (CSM) using CSM 04.

Although the D80's autofocus system is smart enough to achieve sharp focus under most conditions, you can customize its operation, including specifying when and how the camera locks in focus, or which areas of the frame should be used to calculate focus.

Autofocus modes

The D80 has three autofocus modes to choose from, each suitable to a particular type of shooting situation. Press the AF button on top of the camera (to the right of the status LCD) to choose one of these modes. (You can't select an AF mode if the camera or lens is set to M for manual focus.)

✦ **Single autofocus (AF-S):** In this mode, the D80 locks in a focus point when you press the shutter button down halfway, and the focus confirmation light glows in the viewfinder. A beep sounds when sharp focus is achieved, except when you are using the Sports DVP/Scene mode.

(You can disable the beep sound in the Custom Setting menu with CSM 01.) The focus remains locked until you release the button or take the picture, and the shutter can only be released when the subject is in focus. (The D80 prevents you from taking an ill-focused photo.) If the camera is unable to achieve sharp focus, the focus confirmation light blinks. This mode is best when your subject is relatively motionless.

✦ **Continuous autofocus (AF-C):** In this mode, the D80 sets focus when you partially depress the shutter button, but continues to monitor the frame and refocuses if the camera or subject moves.

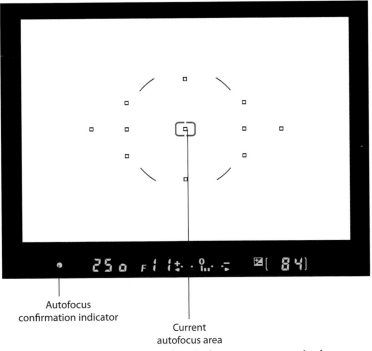

Autofocus confirmation indicator

Current autofocus area

5.12 The current focus area and an in-focus LED appear in the viewfinder.

This is a useful mode for photographing sports and other subjects in motion. The shutter releases even if the image is not currently in sharp focus.

✦ **Automatic autofocus (AF-A):** In this mode, which is the D80's default autofocus setting, the camera switches between AF-S and AF-C as appropriate. That is, it locks in a focus point when you partially depress the shutter button (AF-S), but switches automatically to AF-C if the subject begins to move. This mode is handy when photographing a subject, such as a child at quiet play, who might move unexpectedly. As with AF-S, the shutter releases only when the image is in focus.

Setting focus zones

The Nikon D80 uses 11 different focus areas to calculate correct focus. If you're using Auto, Portrait, Landscape, Night Scene, or Night Portrait DVP/Scene modes, the camera selects the focus zone automatically. In the other shooting modes, the camera can select the focus point automatically, or you can specify which focus point should be used.

To use manual focus area selection, follow these steps:

1. **If necessary, use the Custom Setting menu CSM 02 (AF-area mode) and choose either Single area or Dynamic area, as I explained in Chapter 3.** (With the Auto area setting, the D80 always chooses the focus zone for you.)

2. **Slide the focus selector lock to the unlocked position (see figure 5.13).**

5.13 Slide the focus area lock upward and use the multi-controller to choose the focus zone.

3. **While framing your image in the viewfinder, press the shutter release halfway to activate the autofocus system.**

4. **Use the directional buttons of the multi-controller to choose the focus area you want to use.** The selected focus area is highlighted in red.

5. **To fix the selected focus area, slide the focus selector lock to L.** The chosen focus zone is locked in until you unlock it and choose another zone, or switch to a focus mode in which the D80 chooses the focus zone for you.

6. **To lock in the focus area for the current picture only, hold down the AE-L/AF-L button.** The focus is now fixed, so you can reframe the photo if you want and retain the same focus setting (see figure 5.14).

Autofocus/Autoexposure lock

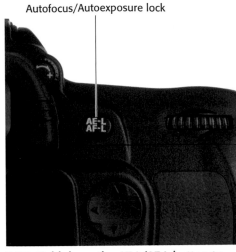

5.14 Hold down the AE-L/AF-L button to lock the current focus.

 You can learn how to change the behavior of the AE-L/AF-L button in Chapter 3 to lock only exposure or only focus, instead of both.

Working with Depth of Field

Depth of field is an important concept that you must understand to use the focusing capabilities of your D80 effectively. Broadly speaking, *depth of field* (DOF) is the distance range in a photograph in which all the included portions of the image are acceptably sharp. That sounds like a simple enough definition, except for the *acceptably sharp* qualification. What's acceptable and what is not acceptable in terms of sharpness can vary significantly depending on the viewing distance, amount of enlargement of an image, and even the person doing the viewing. Depth of field that looks fine in a 4-x-6-inch print viewed from 10 inches away might be intolerable in a 16-x-20-inch print viewed at a distance of 2 feet. And, what I think is acceptably sharp may not be acceptable to you.

In theory, only one plane of an image is actually in sharp focus for any given image. Everything else in the picture is, at the very least, a little bit out of focus. However, in practice, a much larger distance range of the image may be acceptably sharp, because the difference between perfect focus and almost-perfect focus is difficult for the eye to detect. Because our eyes have a poor memory for sharpness, good focus can be confusing.

5.15 Because depth of field is limited to a single plane at wide apertures, when the lens is focused on the battery at left (top image), the other two batteries are out of focus. Focusing on the center battery (bottom image), causes the two closer batteries to be out of focus.

F-Stop Foibles

Here are some things to understand about the lens aperture and its effect on focus and other aspects of your photographs:

✦ **Depth of field:** Larger openings (smaller numbers, such as f/2.8 or f/3.5) provide less depth of field at a given focal length. Smaller openings (larger numbers, such as f/16 or f/22) offer more depth of field. When you change exposure using the aperture, you also modify the range of your image that is in sharp focus, which you can use creatively to isolate a subject (with shallow depth of field) or capture a broad subject area (with extensive depth of field).

✦ **Sharpness:** Most lenses produce their sharpest image approximately two stops less than wide open. For example, if you're using a zoom lens with an f/4 maximum aperture, it probably has its best resolution and least distortion at roughly f/8.

✦ **Diffraction:** Stopping down further from the "optimum" aperture may create extra depth of field, but you also lose some sharpness due to a phenomenon known as *diffraction,* caused by interference with the light, around the edges of the diaphragm. You want to avoid f-stops like f/22 unless you must have the extra depth of field, or need the smaller f-stop so you can use a preferred shutter speed.

✦ **Focal length:** The effective f-stop of a zoom lens can vary depending on the focal length you use. That's why the D80's 18-55mm kit lens is described as an f/3.5-5.6 optic. At the 18mm position, the widest lens opening is equivalent to f/3.5; at 55mm, that same size opening passes 1.5 and stops less light, producing an effective f/5.6 aperture. At intermediate zoom settings, an intermediate effective f-value applies. Your D80's metering system compensates for these changes automatically, and as a practical matter, this factor affects your photography only when you need that widest opening.

✦ **Focus distance:** It's a minor point, but the effective f-stop of a lens can also vary depending on the focus distance. This is really a factor only when you're shooting close-ups. A close-focusing macro lens can lose a full effective f-stop when you double the magnification by moving the lens twice as far from the sensor. The selected aperture then "looks" half as large to the sensor, which accounts for the light loss. Your D80's exposure meter compensates for this, unless you're using gadgets like extension tubes, bellows, or other add-ons that preclude automatic exposure.

In fact, the term *circle of confusion* is applied to the slightly defocused points in an image that are large enough to appear to our eyes as fuzzy discs rather than points and, therefore, seem to be out of focus. The exact size of the circle of confusion varies, as I've noted, by the amount of enlargement, viewing distance (all of which make the circles seem larger to our eyes), and the discernment (or fussiness) of the viewer. Points that are smaller than the circle of confusion for a given image appear to be in

5.16 When the out-of-focus discs in the background are obvious, bokeh is said to be bad. Sometimes, changing the f-stop can provide less obtrusive bokeh.

sharp focus. Points that are larger make up the out-of-focus portions of the image. The range in which the apparently sharp points reside is that image's depth of field.

The approximate DOF range extends one-third in front of the plane of sharpest focus, and two-thirds behind it. So, assuming your depth of field at a particular aperture, focal length, and subject distance is 3 feet, everything 1 foot in front of the focus plane and objects 2 feet behind it should appear to be sharp.

We're not done yet. Some of the out-of-focus discs in an image are more noticeable than others because of the way they blend (or don't blend) together. This property, named for a variation of the Japanese word for blur, is *bokeh*. (It rhymes with *mocha*.) A lens's bokeh depends on things like the shape of its diaphragm (the more leaves in the diaphragm, the rounder and more pleasing the disc shapes it produces) and the evenness of the illumination of the blurry shapes created (see figure 5.16).

Lenses with good bokeh produce out-of-focus discs that fade at their edges, in some cases so smoothly that they don't produce circles at all. Lenses with intermediate bokeh qualities generate discs that are evenly shaded, or perhaps have some fade to darkness at their edges. The worst lenses from a bokeh standpoint create discs that are darker in the center and lighter on their edges.

Using Wide-Angle and Telephoto Lenses

From a theoretical photographic standpoint, the chief difference between wide-angle and telephoto lenses is their angle of view and how much they magnify the image. On a practical basis, there is a lot more to consider. Wide-angle and telephoto lenses are constructed differently, and are commonly

plagued by different kinds of optical problems, or *aberrations*, as well as various real or apparent types of distortion. These two classifications of lenses also offer very different perspectives on a subject and even, because of the relationship between the subject and distance, the amount of depth of field you have available. Close-up, or *macro*, lenses are special beasts, too, with characteristics of their own. This section explains some of those key differences.

Working with wide angles

There are six basic reasons for using wide-angle lenses/wide zoom settings, although there is no reason why you must choose just one of them for a particular image. Often, you will want to use more than one of the special properties of a wide lens setting as a compositional or creative tool in your images.

To give you more room to shoot

A wide-angle lens lets you shoot in tight surroundings, where you might not have room to back up in order to take in everything you want to include in the frame. Indoors, you might find yourself with your back up against a wall, and the alternative of going outside and shooting through an open window is either impractical or silly.

Outdoors, when you attempt to shoot a building, city street, landscape setting, or other scene, you may find an obstruction, such as a stand of trees, another building, or a looming precipice behind you that keeps you from backing up to take everything in. In other cases, there may be room to move back a little, but if you do so, the composition of the image just won't be the same. Perhaps you're standing in a queue outside

a trendy club and a noted jet-setter shows up. If you back up, you'd be lost in the crowd and not able to get the picture you want.

In all of these cases, a wide-angle lens enables you to stand your ground and shoot without the need to step back. When quarters are tight, the wider the lens you have available, the better.

To broaden your field of view

A wide-angle lens can increase your field of view when you're taking distant shots. Certainly, you could capture a sweeping panorama by taking multiple pictures and stitching them together in your image editor. But you might find it easier and faster to use a wider lens to grab that wide-angle view in a single shot, and then snip off the top and/or bottom of the frame to produce the wide-screen look you want.

To increase apparent depth of field

As a practical matter, wide-angle lenses offer more depth of field at a given aperture than a telephoto lens. Of course, the fields of view and perspective differ sharply, but if lots of depth of field is what you need, a wide-angle lens gives it to you.

Of course, strictly speaking, for the same *subject size*, depth of field is identical for both wide-angle and telephoto lenses. That is, if you took a photo of a friend standing 100 feet away with both a wide-angle and a telephoto lens, and then enlarged and cropped the wide-angle picture so your friend appeared to be the same size as in the telephoto shot, the depth of field would be identical (and your friend would seem a lot fuzzier in the extreme enlargement). But who would be crazy enough to do that? For real-world photography, it's enough to apply

the increased depth of field that results from taking a picture with a wide-angle lens.

To emphasize the foreground

The sweeping perspective of wide-angle lenses emphasizes the subjects that are closest to the camera (in the foreground) and makes subjects farther away appear to be much smaller in proportion. You can put that effect to good use when you *want* to place emphasis on the foreground. If your lawn looks better than your home, choose a wide-angle lens to fill most of your frame with that sweeping expanse of greenery. When photographing a landscape that includes a lake in the foreground, use the wide-angle lens to emphasize the water.

You can use this emphasis on the foreground as a creative tool, but you must also keep the emphasis in mind when shooting subjects that don't have an attractive foreground. In such cases, use a slightly less wide lens or zoom setting, step back (if you

can), and shoot. You'll find the field of view can end up the same, but there is less emphasis on the foreground in the shot taken with the slightly longer focal length.

To add creative distortion

Foreground emphasis, carried to the extreme, can result in outright distortion, where the objects closest to the camera are extraordinarily enlarged compared to subjects farther away. This distorted perspective can work for you if you use it intentionally.

To provide an interesting angle

Wide-angle lenses produce significantly different viewpoints when you use them at angles that are higher or lower than normal. Eye-level shooting tends to be the default for most photographers, but if you get down low and shoot up at your subject, or elevate yourself and shown down, you can find interesting new angles. Wide-angle lenses only emphasize those new perspectives.

5.17 A low angle provides an interesting perspective on these early-spring daffodils, and the emphasis on the foreground helps disguise the fact that the leaves haven't begun to bud on the trees.

Wide-Angle Pitfalls

For each reason that you might want to use a wide-angle lens, a potential pitfall that you might want to avoid exists. As with everything, there can be too much of a good thing, and even the best tool can be misused.

✦ **Tilting lines:** Wide-angle lenses tend to make horizontal and vertical lines more prominent. Avoid tilting or rotating the camera to produce off-kilter lines in your subject. If you lean back to take in the top of a tall building, you end up with a structure that appears to be falling backward.

✦ **Perspective distortion:** Wide-angles exaggerate the relative size of objects close to the camera, compared to those farther away. Although this property is a good creative tool, it can also be misused, particularly when you photograph people up close. Human subjects rarely are improved by making their noses (which are closest to the camera) appear huge in proportion to the rest of their faces.

✦ **Lens aberrations:** Wide angles may suffer from outwardly-curving lines at the edges of the frame (*barrel distortion*), or dark corners (*vignetting*). Sometimes you can improve these defects by using a smaller f-stop. In any case, you may want to keep important subject matter away from the edges and corners of your images.

✦ **Flash follies:** Electronic flash units, including the speedlight built into your D80, often provide coverage for wide-angle settings no wider than the 18mm position of the basic kit lenses. At wider angles, the flash might not cover the edges of the frame, or may cast shadows of the lens or lens hood on your subject. An external flash unit equipped with a diffusing panel can solve both problems by elevating the illumination high enough not to cast a shadow, and by providing broader flash coverage.

A new baby may get you down at floor level for the first time since childhood (or that time you lost a contact lens) and bring on a feeling of *déjà vu* as you recall what it was like to be a small person. You can find that same perspective to be a real winner from a photographic standpoint. Photograph a child and the child's world from the child's level to discover whole new creative angles for your photos.

Similarly, you see familiar subjects in a new light when you get up higher than normal and shoot down. Once you've explored these angles with a wide lens, you may find yourself reluctant to shoot from eye-level ever again.

Working with telephotos

There are six key reasons for using telephoto lenses and telephoto zoom settings, too. Not all of them involve sports or wildlife photography either. The important thing to remember about using telephoto lenses is that they tend to provide a flat perspective that isn't as varied as the one you get with wide-angle lenses. You can use that creatively or work extra hard to keep your flat

viewpoint from becoming boring. Here are the key reasons for using a telephoto lens.

To decrease distance

If getting closer to a distant subject isn't practical, a telephoto lens or telephoto zoom can help. Some subjects, such as the moon, are impossibly distant. Others, like erupting volcanoes, are impossibly dangerous. Frequently, it's just impractical to get closer to your subject. A telephoto lens can magnify distant objects so you can photograph them as if you were not so far away at all.

To isolate your subject

Because telephoto lenses tend to reduce the amount of depth of field in a given image, you can use them to isolate your subject through the magic of selective focus. Just focus carefully on the subject you want to separate from the foreground and background, and use a large enough f-stop to throw the rest of the image out of focus.

Indeed, depth of field with longer lenses is so shallow that you may be able to accomplish this feat even at smaller apertures, such as f/11 or f/16.

To grab sports action

Even indoor sports may be difficult to photograph up close. Certainly, you might be able to stand along the baseline at a high school basketball game, but other indoor sports, such as pro basketball, arena football, or indoor tennis may have you shooting from the stands where a telephoto lens comes in handy. Most outdoor sports are even more suitable for long lens photography, because even from the sidelines a lot of the action on a soccer field, baseball diamond, or football arena is 50 or more yards away.

Telephoto lenses — particularly telephoto zooms that let you zoom in and out as the action unfolds — can help you grab sports action without racing from place to place to keep pace with the players.

5.18 This hot air balloon was hundreds of feet in the air, but a long telephoto lens provided an interesting worm's eye view of the balloon's underside from below.

Telephoto Pitfalls

Telephoto lenses involve some special considerations of their own, some of which are the flip side of the concerns pertinent to using wide-angle lenses. Here's a summary:

✦ **Faster shutter speeds needed:** Because telephoto lenses magnify photographer and camera shake when the camera isn't mounted on a tripod, monopod, or other support, higher shutter speeds are mandated. There is a fairly useless rule of thumb that suggests using the reciprocal of the focal length of the lens (that is, 1/200 second with a 200mm lens) as the minimum shutter speed to be used with a handheld telephoto lens. This "rule" should be used as an absolute *minimum*, because it doesn't take into account the size and weight distribution of the lens, the ability of the photographer to hold the lens steady, and how much the image will be enlarged. In my own case, I find I must use at least 1/2000 second to successfully handhold a favorite zoom lens at 500mm; the suggested 1/500 second setting invariably produces blurred photos. If you can't use a sufficiently fast shutter speed with a telephoto lens, you really should consider a tripod or monopod (or springing for one of Nikon's cool VR lenses). It's too easy to lose a critical amount of sharpness through camera motion.

✦ **Reduced depth of field:** The reduced depth of field that results from longer focal lengths isn't imaginary. If you're using selective focus to isolate a subject in your photo, the shallow depth of field is a good thing. But, most of the time you want enough depth of field to allow all the important elements of your photo to remain in sharp focus simultaneously. Use a smaller f-stop as required, and use the D80's DOF preview button to estimate the approximate depth of field you can expect. (The DOF preview button dims the viewfinder image, so sometimes it's difficult to gauge depth of field accurately.)

✦ **Atmospheric haze and fog:** Unless you live in Southern California or a typical big-city area plagued with haze and smog, the diffusing effects of the atmosphere may not be part of your everyday life. Even so, haze and fog are present everywhere to some extent, even when you're hundreds of miles from civilization shooting that placid mountain vista. Dirt or moisture in the air reduces contrast and mutes colors, and the effect worsens as the focal length of your lens increases. Sometimes a haze filter on the front of your lens can help, but you still need to be prepared to increase the contrast and color saturation of your images, either using the D80's Optimize Image controls, or with your image editor.

✦ **Contrast-robbing flare:** Stray light bouncing around inside your lens reduces the contrast of your photos and can provide unattractive bright spots and flares. Because telephoto lenses often produce low-contrast images to begin with (see "Atmospheric haze and fog" above), you don't want any further contrast loss. Use the lens hood that came with your lens (or purchase one if a hood wasn't included).

✦ **Flash coverage (*redux*):** While wide-angle lenses sometimes cover more visual real estate than flash units can illuminate, with telephoto lenses the problem is more one of distance. That subject 50 feet from your camera may appear close at hand, but to your electronic flash, it's still 16-plus yards away. Your D80's built-in flash usually finds its limit at about 20 feet; for greater distances (say for nighttime wildlife photography or night sports), you need a more powerful flash. I recommend the Nikon SB-800 Speedlight, which has several times the power of the D80's built-in unit.

✦ **Squeeze plays:** Telephoto lenses compress the apparent distance between objects, making a row of columns that are separated by 20 to 30 feet appear to be only a few feet apart when you photograph them with a 500mm lens. Human faces tend to look flatter when you photograph them with longer telephoto lenses too. You can use the telephoto's compression effect as a creative tool if you want, but you should be aware of possible unwanted squeeze plays when you're not looking for a flattened look.

To capture wildlife in its native habitat

One of the most challenging things about photographing wildlife is that your quarry is, well, wild, and generally not inclined to approach your camera-wielding self and obligingly pose for a picture. Instead, you often need to quietly stalk your photo prey, get as close as you can, and capture your photo from a distance of 10 to 20 yards — frequently, much farther. Even zoo animals are difficult to photograph up close.

A telephoto lens can reach out and grab the photos you want without spooking the wild animals. Sometimes the distances aren't even all that great. You can photograph a skittish tree frog or squirrel from 10 feet with a telephoto, when a closer approach would send the creature running.

To create flattering portraits

Perhaps your family and friends aren't terrified of your camera and are willing to sit for an informal portrait or two. Still, a short telephoto lens (with an actual focal length of about 50-85mm) could serve you well.

Human beings photograph in a more flattering way with a slightly longer lens, as a wide-angle lens tends to make noses look huge and ears tiny in a frame-filling shot. A little extra telephoto distance also gives you room to arrange the lighting that illuminates your portrait subject, adding to the improved look that even a semiformal portrait session often has over a grin-and-grab candid snapshot.

To get up close — from afar

Macro photography is a third way of using the telephoto lens or telephoto zoom's magnification. The capability to focus close in isn't the only attribute of a macro lens that you need to pay attention to. The working distance can be even more important. Nikon's popular 60mm Micro-Nikkor lens brings you to within an inch or two of a tiny object, but that might be so close that the camera or lens itself casts a shadow on your subject. For that reason, telephoto macro lenses, like Nikon's 105mm f/2.8 VR Micro-Nikkor come in very handy. Armed with one of these, you can back up and still shoot close-up images.

Teleconverters

Teleconverters are magical devices that multiply the magnification of your lenses by 1.4X, 1.7X, 2X, or 3X, but at a price. Fit between your prime or zoom lens and the camera body, teleconverters include optics that magnify the image, changing a lens with a true focal length of 200mm into a 280mm, 340mm, 400mm, or 600mm lens. They also rob you of a little sharpness (with expensive Nikon converters) or a lot of sharpness (with some inexpensive third-party models). You also lose a half f-stop of illumination with a 1.4X model, and up to three full stops with a 3X converter. That's a double whammy, exacting a cost in the maximum aperture department (converting an f/2.8 lens into an f/8 lens with a 3X adapter), especially when you must use an even smaller aperture to regain some of the sharpness you lose. Because the D80's autofocus system requires the equivalent of at least f/5.6 worth of light, you can lose autofocus capabilities, too. Teleconverters are priced between $100 and $400, and work best when you use them with the vendor's own recommended lenses. Stick with the 1.4X and 1.7X models if possible. The "price" may be too high otherwise.

Working with Light

Your D80 can make light work for you. After all, it is light itself that is the medium we use to paint our images. The direction of light creates shapes and textures; the intensity and proportions control the contrast; and the colors of light establish the hues we see. Mastering the use of light — whether you work with the illumination as it already exists in a scene, or adjust it to suit your creative needs — is a key skill that separates snapshooters from avid photographers.

Light may bounce off opaque subjects, pass through translucent objects, or be emitted by things, like candles or campfires, that produce light on their own. The light you work with may be *continuous* (such as daylight, incandescent lamps, or fluorescent tubes) or occur in a quick *burst*, as is the case with electronic flash. (Such flash units are also called, variously, *strobes* or *speedlights.*)

In this chapter, I detail what you need to know about working with both existing light and electronic flash, giving special emphasis to using the Nikon D80's built-in, pop-up Speedlight.

Choosing between Continuous and Flash Illumination

It's a truism that you shoot with the light you have available. But, in that sense, *available light* means any source of illumination you can put at your disposal, whether it's existing light at the scene, supplementary incandescent or fluorescent lights you set up and adjust, electronic flash, or even existing or add-on lights that you redirect with the use of reflectors.

Of course, sometimes you want to use the existing light as-is, much as a photojournalist often (though not necessarily always) does, looking for the best angle and lighting conditions possible for the picture you have in mind. But when you do have a choice, you need to choose between continuous lighting—including daylight and artificial lighting of the lamp persuasion—and electronic flash, which can include your D80's built-in flash unit or external strobes.

Here are some advantages and disadvantages related to each type:

Ability to preview the lighting effect

Continuous lighting wins on this point. With constant illumination, the lighting effect you end up with is visible at all times. You know when you peer through the viewfinder how soft or how harsh the light may be. You can spot any undesirable shadows. If you're using multiple light sources, you can tell how they interact, and whether that second light sufficiently brightens the shadows cast by the main light, or whether you might need a little extra illumination on the background to separate your subject from its surroundings.

With electronic flash, the general effect you're going to see may be a total mystery unless you use the D80's built-in flash modeling light feature, which triggers an almost continuous series of reduced-power flashes for a few seconds. Once that preview burst is over, you must then keep the lighting relationships in your memory. Or, you might rely on your experience in shooting similar photos in the past, or need to review a test image on the D80's LCD, and then make some adjustments and shoot another test image until you get exactly the lighting look

you want. After all, that's exactly what studio photographers did with their Polaroid test shots in the olden days.

If you're planning on using subtle lighting effects, particularly those where the placement of shadows or highlights is important (see figure 6.1), continuous lighting is probably your best bet. Some types of shots that are simple with continuous illumination (say, you want to photograph a shiny piece of jewelry with a bright star highlight at a precise location) can be tricky to achieve with electronic flash.

6.1 Continuous illumination may be best when you want to preview the lighting effect before the shot.

Ease of exposure calculation

On the surface, calculating the exposure of continuous light sources seems like simplicity itself, because the illumination remains constant and can be easily measured. But, as you learned in Chapter 4, the only real stumbling blocks separating continuous light from perfect exposure are the use of the most important areas of the frame to figure the right exposure, and the necessity of exposing so that all tones (shadows, middle tones, and highlights) are accurately represented. Once you've mastered that aspect,

calculating exposure for continuous light sources is a snap.

Electronic flash exposures suffer from the same foibles, of course, but with an additional complication. How do you measure the correct exposure of a light source that may exist for only 1/1000 second? In a sense, the dilemma is similar to the problem of previewing lighting effects: With electronic flash, now you see it, now you don't. It should come as no surprise that with the Nikon D80, the solution is similar: an additional burst of light that is not used for the exposure itself. But while you can use a several-second modeling-light sequence to visualize lighting effects, calculating exposure requires only a brief preflash a fraction of a second before the picture is taken.

Using Nikon's through-the-lens (i-TTL) flash metering technology, the D80 is able to measure the amount of illumination that bounces off the subject back to the lens, and calculate the exposure based on that information (plus distance data supplied to the camera by a D-type lens). The i-TTL system is sophisticated enough that it even works when you're using multiple Nikon electronic flashes, such as the Nikon SB-600 and SB-800, which you can then trigger wirelessly using the D80's built-in Speedlight.

I should mention that you can also calculate flash exposure manually using a handheld electronic flash meter. Such a meter is particularly useful in multiple flash situations, because it's easy to measure the amount of light each of the strobes produces in a particular setup. Flash meters, although they can cost several hundred dollars, are worth the expense for those who need them, and are available in models that can read both flash and continuous illumination.

I reluctantly call the battle between the two types a tie: Continuous illumination should be theoretically easier and more convenient to meter, but the technology built into your D80 makes exposure with flash comparably fast and accurate.

Portability of add-on illumination

Daylight and other forms of existing illumination are always there for you, but may have insufficient intensity for the picture you want to take. At that point, it's time to roll out the add-on lighting, and from that standpoint, electronic flash usually comes out as the winner.

After all, your D80 has an electronic flash built in. If you need more flash power, external flash units that can fit in your camera bag are battery powered and easy to tote. Even fairly large studio-type strobes are available in battery-operated configurations that you can quickly transport from one location to another, even if they don't happen to be particularly small.

Add-on continuous light sources almost always involve AC-powered lamps, which can rival studio flash units in size and unwieldiness, even though some compact *hot lights* are available. Electronic flash is a clear winner in the portability department for most applications. By the time you move up to sophisticated multiple light sources with their umbrellas, reflectors, and light-stand supports, both flash and continuous lighting tend to be less portable. But, with their battery power options, electronic flash units are potentially more portable, even when it comes to studio-type rigs. (Plus you don't have to wait long periods for them to cool off before you can tear them down and pack up to go.)

Evenness of illumination

Some types of continuous light sources, particularly daylight, offer illumination that fills a scene, with lots of light for the foreground, background, and your subject. If there are shadows, you can use reflectors or fill-in light sources to even out the illumination further.

Electronic flash units, like all types of highly directional illumination, suffer most notably from the effects of the *inverse square law,* which dictates that as a light source's position increases from the subject, the amount of light reaching the subject falls off proportionately to the square of the distance. In plain English, that means that a flash or lamp that's 8 feet away from a subject provides only one-quarter as much illumination as a source that's 4 feet away (rather than half as much). This translates into relatively shallow depth of light.

So, if you're using an electronic flash to photograph a group that includes members who are 12 feet from the camera, a few standing just 6 feet away, and some distant participants milling about 18 feet or more from your shooting position, you may have problems. If the correct exposure for the main group is f/11, the subjects closer to the camera will be two stops overexposed (f/22 might be a better setting for those nearby subjects alone), while the stragglers at the periphery of the scene will be at least one stop underexposed. In terms of evenness of illumination, daylight and other forms of ambient illumination are clear winners. (Studio lamps also suffer the inverse square penalty, but electronic flash is much more commonly used.)

Action stopping ability

When it comes to the ability to freeze moving objects in their tracks, the advantage goes to electronic flash. The brief duration of electronic flash serves as a very high "shutter speed" when the flash is the main or only source of illumination for the photo. Your D80's shutter speed may be set for 1/200 second during a flash exposure, but if the flash illumination predominates, the *effective* exposure time is 1/1000 to 1/50,000 second or less duration of the flash you are using.

The variation in flash duration occurs because the flash adjusts the amount of light it produces by reducing the length of the burst. If the full power of the flash unit is required, all the energy stored in the Speedlight's capacitor "holding tank" is released at once, within about 1/1000 second. If less light is required, the flash can dump the excess during the actual exposure, producing a flash that may last 1/2000 second, 1/4000 second, or even briefer. The tiny slice of time carved out by an electronic flash is the champ when it comes to freezing action (see figure 6.2).

The motion stopping capabilities of a camera shooting under a continuous light source are completely dependent on the shutter speed. And those speeds are dependent on the amount of light available and your ISO sensitivity setting. For example, if you're shooting sports indoors, there probably isn't enough available light to allow you to use a 1/2000 second shutter speed, but applying that effective speed by using a flash unit is no problem at all.

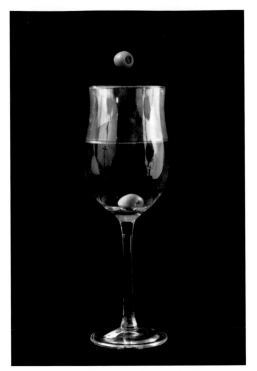

6.2 Electronic flash can freeze the fastest action.

Of course, any flash exposure is actually two exposures: one from the flash itself, and one from the ambient light admitted to the sensor by the shutter during its leisurely 1/200 second trip across the focal plane. If the ambient light levels are low, only the flash is used to make the image. But if the existing light levels are high, that additional exposure may produce a secondary ghost image in your picture. You can find more about this effect later in this chapter.

Syncing capability

Another consideration is the capability of a particular light source to synchronize with your camera's shutter, which is one you might not have thought of before.

Continuous lighting syncs at any speed; because it is continuous, the way in which the shutter travels across the focal plane has no effect on how that illumination is captured. (I explain this shutter operation later in the chapter.)

However, your D80's electronic flash is generally used at shutter speeds of 1/200 second or slower for a very good reason. Faster shutter speeds don't synchronize with the flash, which must burst when the shutter is fully open (and that's at 1/200 second or slower). At faster speeds, the shutter is only partially open, and flash photography produces only partially exposed frames, unless you use a special mode called High Speed Sync at reduced flash power. (I discuss Flash sync and High Speed Sync in more detail later in this chapter, too.)

Relative cost

No argument here: Incandescent lamps are generally much less expensive than electronic flash units, which can easily cost several hundred dollars. If you want to use more than one light source, the costs mount more quickly with flash. You can pay more than $300 for a Nikon SB-800 electronic flash unit, or $10 for a flexible-necked desk lamp that can double as a macro photography light source. And, of course, sunlight and existing room light is free!

Versatility

Of course, the adaptability and flexibility of a particular light source depends on what type of photography you're doing. If you consider the lighting effect preview question only, incandescent lamps are more versatile than electronic flash units that don't have a modeling light.

But, because incandescent lamps are not as bright as electronic flash, the slower shutter speeds they require mean that you may have to use a tripod more often, especially when shooting portraits or macro photographs. Electronic flash's action-freezing power enables you to work without a tripod, adding flexibility and speed when choosing angles and positions.

This one is almost a tie, depending, as I noted, on what kind of photography you do.

Mastering Continuous Lighting

For most types of photography, continuous lighting is much less complicated to use than flash. The key consideration you need to keep in mind is the illumination's *color temperature* and *white balance*, which are two terms used to describe the same attribute; that is, although light appears to our eyes as colorless, it actually has a color bias or color balance. The relative color of light is related to its color temperature, and how the digital camera uses white balance controls to adjust for this temperature.

Three types of continuous lighting

As I noted earlier, there are three main types of continuous lighting: daylight, incandescent/tungsten light, and fluorescent light. There are also some oddball light sources, such as sodium vapor illumination.

Daylight

The sun produces daylight even if you can't see the sun directly when it's hidden behind clouds. Direct sunlight can be bright and

harsh, causing inky shadows and shiny glare reflecting off some types of subjects. Daylight can also be soft when it's muted by overcast clouds, or diffused when it bounces off matte reflectors, walls, or other nonshiny objects.

Daylight's relative color varies widely, too, from relatively warm and reddish at sunrise and sunset (see figure 6.3), to quite blue at high noon. The temperature part of the equation comes not from the hotness or coolness of the photons themselves, but from the theoretical source of the illumination, an imaginary object called a *black body radiator.* The "black body" part comes from the object's capability to perfectly absorb all the light that strikes it. The "radiator" portion of the equation is derived from its capability to emit, or radiate, light when heated. At low temperatures, measured in degrees Kelvin, this radiated light is warm and orangeish, like an ember glowing in a fireplace. As the temperature rises, the object eventually reaches a blue-white fury that you might think of as "white hot."

The color temperature of daylight falls along this Kelvin scale. Starting an hour before dusk and an hour after sunrise, the sunlight, filtered by the particles in the air, can range from 4000K to 5000K (the term *degrees* is not used when referring to color temperature). As the day progresses, the color temperature ranges from 5500K to 6000K, peaking at high noon when the light is most direct and most "bluish."

Because one usually takes so many photos in daylight, you want to learn how to use, or compensate for, the brightness and contrast of sunlight, as well as how to deal with its color temperature. I provide some hints later in this chapter.

6.3 Early in the morning and late in the afternoon, daylight takes on a warm glow.

Incandescent/tungsten light

Incandescent or tungsten illumination comes from the direct descendents of Thomas Alva Edison's original electric lamp. This illumination consists of a glass bulb that contains a tungsten filament surrounded by vacuum or a halogen gas. The filament is heated by an electrical current, producing photons and heat. Although incandescent illumination isn't a perfect black body radiator, it's close enough that you can precisely calculate the color temperature of such lamps and use them for photography without concerns about color variation for most of the lamp's useful life. (Tungsten bulbs can change color as they age.)

Incandescent lighting generally has a color temperature of 3200K to 3400K. Indeed, before photoflood lamps were largely replaced by electronic flash for studio-type photography, it was possible to purchase bulbs with either 3200K or 3400K output, and films to match those specific color balances (as well as more familiar *daylight-balanced* films for 5500K illumination).

Fluorescent light

Fluorescent light is increasing in popularity for home illumination, generally because fluorescent bulbs and tubes have long lives and low power consumption. When installed in lamps, fluorescent lights may be rated for seven years or more of use, and provide the equivalent illumination of a 60-watt incandescent light in a thrifty 13-watt model. The odd colors and ghastly skin tones that caused homeowners to shy away from fluorescent lights for residential illumination are largely gone, thanks to the latest generation of *warm white* and other types of fluorescent bulbs.

However, digital sensors are less accommodating to variations in the colors present in light than the human eye, so fluorescent lights still can cause the same problems for digital photographers that they did for film photographers in decades past. Fortunately, though, digital cameras are more adept at correcting for the vagaries of this kind of illumination than film was.

Fluorescents generate light through an electro-chemical reaction that emits most of its energy as visible light, rather than heat, which is why the bulbs don't get as hot. The precise type and color of light produced varies depending on the phosphor coatings and kind of gas in the tube. Therefore, the illumination fluorescent bulbs produce can vary widely in its characteristics.

That's bad news for photographers. Different varieties of fluorescent lamps have different color temperatures that can't be precisely measured in degrees Kelvin, because the light isn't produced by heating. Worse, fluorescent lamps have a discontinuous spectrum of light that can have some colors missing entirely. A particular type of tube can lack certain shades of red or other colors, which is why fluorescent lamps and other alternative technologies such as sodium-vapor illumination can produce appalling human skin tones. Their spectra can lack the reddish tones we associate with healthy skin and emphasize the blues and greens best-suited for horror movies. Fortunately, you can tame the worst effects of most fluorescent lamps with your D80's white balance features.

Adjusting color temperature

You can use the white balance controls of your Nikon D80 to adjust the camera for the different types of illumination you'll encounter. I explained in Chapter 3 exactly how to adjust white balance, using the four different types of White Balance controls found in the Shooting menu. You may recall that you can choose a white balance preset value (such as Incandescent, Fluorescent, Daylight, Flash, Cloudy, or Shade), enter a specific color temperature in degrees Kelvin, select a custom white balance based on the

illumination of a particular scene, or even let the D80 choose white balance for you automatically.

All these choices are necessary because digital camera sensors can't always determine the color balance of illumination, although your D80 can make some pretty good guesses. For example, very bright light is almost always daylight; warmer indoor illumination often produces dim light. The colors the camera detects in the brightest areas of the image (which are supposedly white) can provide additional clues. And, of course, if the camera uses electronic flash to make an exposure, it knows that the electronic equivalent of daylight will provide the illumination.

The ability to change white balance after the shot is taken is one of the best reasons for shooting RAW or RAW+JPEG. When you import the image into Photoshop, Photoshop Elements, or another image editor, you can change the white balance from the "as shot" setting to any other setting you like (see figure 6.4). Although color-balancing filters that fit on the front of the lens still exist, today they are used primarily with film cameras, because the color balance of film — even color negative film — isn't as extensively adjustable as that of a digital sensor.

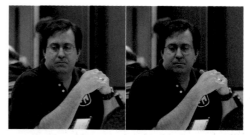

6.4 The greenish tones produced by uncorrected fluorescent lighting aren't flattering to human subjects (left). Fixing the color balance in an image editor produces a much better photo (right).

If you're not satisfied with the automatic white balance settings you're getting, you can select a manual setting. Use one of the camera's prepared values, or select a custom white balance setting, as I outline in Chapter 3. You should end up with a color setting that's close enough to fall within the range of the fine-tuning you can do in your image editor.

In that case, your biggest white balance problem is likely to occur with mixed light sources. For example, you might take a photo using the flattering soft daylight that filters indoors from a north-facing window and forget that the incandescent room lights are fairly bright, too. You'll end up with part of your subject illuminated with cool sunlight, and part with warm interior light.

That's not a good combination, unless you're looking for a special effect. In this case, you might want to turn off the lamps in the room. Consider using a piece of white cardboard or other reflector to bounce some of the daylight into the shadows that result when the lamps are turned off. (Professional photographers might put an orange filter sheet right over the window or perhaps replace the incandescent bulbs in the lamps with special *slave* electronic flash units that are produced as direct replacements.)

Both indoors and outdoors, you can encounter mixed lighting situations when the predominant light source is augmented by another fairly strong light source of a significantly different color. For example, suppose your subject is illuminated primarily by incandescent lamps indoors, but is standing rather near a bright green wall that's spot lit (perhaps to provide extra illumination for some artwork). The green of the wall can change the color of the shadows on the side of the subject closest to it, even if the wall itself does not appear in the photo.

Outdoors, you can find mixed light sources with scenes that include both incandescent lights and daylight (which might happen late in the day or on a cloudy day), as well as colors bounced into a scene from a brightly colored structure outside the frame, or even a blue expanse of sky.

Learn to identify mixed lighting situations and avoid them, or, perhaps, incorporate them into your image as a creative element.

Conquering Electronic Flash

Electronic flash was transformed from a laboratory tool to the ubiquitous photographic device we know today more than 70 years ago by Dr. Harold Edgerton, a professor of electrical engineering at Massachusetts Institute of Technology. His photographs of bullets piercing balloons and the coronets formed by splashing drops of milk helped his patented *stroboscope* gain popularity and evolve into the speedlights and strobes we use today.

Electronic flash illumination is produced by accumulating an electrical charge in a device such as a capacitor, and then directing that charge through a glass flash tube containing an electricity-absorbing gas to emit a bright flash of photons. Such a burst takes 1/1000 second or less and, with the D80's built-in flash, produces enough illumination to take a photo of a subject 8 feet away at f/8 and ISO 200. Indeed, distance, f-stop, and ISO setting are the three important factors that you or your camera must take into account when calculating a flash exposure.

If you're someone who enjoyed learning the multiplication tables even though you're never without a calculator, you should know

that you can figure flash exposure manually too. In the days before automatic electronic flash and TTL (through the lens) exposure metering, flash exposure was calculated using a value called a Guide Number (or GN), which lives on today as a way of rating the power of electronic flash units.

Your D80's built-in flash, for example, has a Guide Number of 42 at ISO 100 when the measurement is done using feet. If you're metrically inclined, the Guide Number is 13; you'll see why in a moment. To calculate the correct exposure for the D80's flash at full power and ISO 100, divide the GN by the distance to derive the f-stop. (You may recall from earlier in the chapter that the shutter speed doesn't matter; the flash's "shutter speed" is the duration of the flash.)

So, dividing 42 by 8 feet gives you 5.4, which is close enough to f/5.6 to make no difference. Doubling the ISO from 100 to 200 enables you to close down one stop to f/8, and ISO 400 would give you a proper exposure at f/11. (Just as a comparison, an external flash like the Nikon SB-800 has a GN of 125-184 at ISO 100, effectively three to four f-stops more powerful.)

Of course, you generally don't need to calculate flash exposure manually, as the D80 uses its 420-segment RGB viewfinder sensor to measure a preflash that's triggered just before the main burst. Assuming you're using a flash unit compatible with Nikon's i-TTL flash exposure system (as the D80's built-in flash and recent Nikon external flash are), the proper exposure is calculated and set for you. The camera varies the amount of the flash illumination by dumping some of the electrical energy before it reaches the flash tube. That reduces the power of the flash, and has the side benefit of making the duration of the flash shorter (as brief as 1/50,000 second with some units).

Because exposure when using a single flash is generally calculated automatically on your behalf, the number of things you have to worry about is sharply reduced. They boil down to three key areas: *light fall-off, flash-sync,* and an aspect related to flash sync, *ghost images.*

Understanding light fall-off

Earlier in this chapter, I mentioned concerns about evenness of illumination with electronic flash, produced as the result of the inverse square law. To recap, light diminishes with the square of the distance from the light source to the subject. An object that is 4 feet from the flash receives four times as much illumination as one that is twice as far, or 8 feet away. That's two full f-stops (see figure 6.5). Conversely, a subject that's twice as far from the flash receives one-quarter as much illumination.

Because the flash pictures you take are likely to have objects that are varying distances from the camera and flash, you need to take this effect into account. A photo of a group of people, as I described at the beginning of this chapter, can be well-exposed or poorly exposed, simply based on the arrangement of the group. Line them up in a row facing you from 10 feet away and they will all be well-exposed (assuming you're not using a wide-angle lens that provides a wider view than your flash's coverage can handle).

But if you have one of the group take a few steps backward to the 15-foot position, and another person step forward to a spot 5 feet away, and, with the same exposure, you'd end up with the closest person two stops overexposed and the farthest one stop underexposed.

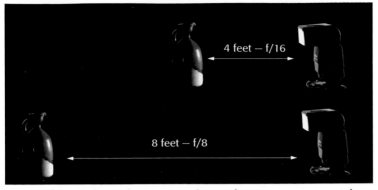

6.5 A subject twice as far away receives only one-quarter as much light.

You encounter the inverse square law in many other flash situations, such as when you use bounce flash to carom your flash off a ceiling and discover that the bald head of a 6'2" man is receiving a lot more light than his 4'8" daughter standing next to him. Because the gentleman's bald pate is so much closer to the source of illumination, it is too bright when the daughter is properly exposed.

When light fall-off bites you, your only recourse may be to rearrange your subjects or use supplemental illumination. But at least you've been warned and now know what to look out for.

Understanding flash sync

The near-instantaneous burst of the flash is supposed to take place only when the D80's shutter is fully open. Your camera's shutter consists of two "curtains" that chase each other across the focal plane at the instant of the exposure. First, the front curtain opens, exposing the leading edge of the sensor as it moves upward across the focal plane. When the front curtain reaches the other side of the sensor, the sensor is fully uncovered for an instant, and the flash goes off,

making the exposure. Then, a rear curtain begins to travel across the focal plane, covering up the sensor again.

To recap, the sequence at shutter speeds of less than 1/200 second is: Front curtain opens, pause, rear curtain closes. When shooting photos, the length of the pause determines the shutter speed for exposures from 30 seconds to 1/200 second. The rear curtain may pause for many seconds for longer exposures, and only a fraction of a second for shorter ones to 1/200 second. The electronic flash must be tripped during that pause.

For exposures shorter than 1/200 second, the rear curtain begins its travel before the front curtain has reached the other side of the sensor, so only a slit is exposed at any one instant — a fairly wide slit for a shutter speed like 1/400 second, and a very narrow one for a fast shutter speed, like the D80's 1/4000 second minimum speed. If the electronic flash is triggered when you're using a shutter speed briefer than 1/200 second, only the portion of the sensor revealed at that instant is exposed (with one exception that I describe shortly).

The D80 automatically keeps this from happening most of the time by switching back to 1/200 second when you're using flash, even if you've selected a higher shutter speed. The maximum speed that you can use when working with flash is called the camera's *sync speed.*

Figure 6.6 shows some conceptual diagrams (trust me, a focal plane shutter looks nothing like this) that may help you understand what happens. In Example A, the sensor begins to be uncovered as the front shutter curtain begins to travel upward. In Example B, the front shutter curtain has stopped, and the sensor is fully uncovered for the length of the exposure. In Example C, after the exposure is complete, the rear shutter curtain has moved up to cover the sensor once more. The curtains return to the positions shown in Example A to become ready for the next photograph.

These examples illustrate how the shutter operates for exposures at the flash sync speed (1/200 second) or slower. When faster shutter speeds are required, the front and rear curtains move simultaneously, exposing a slit of an appropriate size, as in Example D.

The sync speed impacts your picture taking in several different ways. For one thing, this limitation means that you can't generally use flash in some situations where it might be desirable. For example, when you're shooting outdoors in sunlight and would like to use the built-in flash to provide fill-in light to brighten shadows, you can only use exposure combinations that require a shutter speed of 1/200 second or slower. On a bright day, that might mean you're limited to 1/200 second at f/11 at ISO 100 (using a typical daylight exposure). If you'd rather switch to ISO 200 and shoot at 1/500 second at f/11, you must turn to neutral density filters, or else you're out of luck.

Another situation in which sync speed can be limiting is when shooting sports in brightly-lit arena. The flash's brief duration is great for freezing action, but if the ambient light levels are high, you can end up with *ghost* images (which I discuss in the next section). You might prefer to use a higher shutter speed to eliminate the secondary images, but you're stuck with 1/200 second.

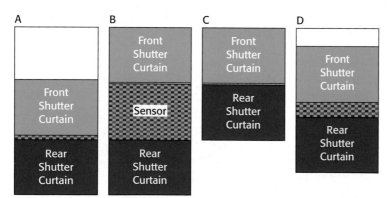

6.6 Front and rear shutter curtains expose the sensor to light for the required period of time.

The only exception to this rule is the Auto FP (focal plane) High Speed flash option available with some external flash units, specifically Nikon-dedicated Speedlights such as the SB-800 and SB-600. In this mode, the flash fires a series of bursts continually, exposing the sensor completely for the duration of the exposure, even though only a small portion of the sensor is uncovered at any particular instant. Unfortunately, spreading the total power of the flash over an extended period means that the effective output of the flash is sharply reduced, relegating this high-speed flash option to be useful chiefly for close-up photography.

If you need to use Auto FP mode, use the Custom Setting menu and CSM 25 to activate the feature.

Note *The multiple flashes produced in Auto FP High Speed Sync mode serve a different purpose from your D80's Repeating Flash mode (discussed in Chapter 3). When set to Repeat, the D80 produces multiple flash exposures at 1/200 second or slower (when the sensor is completely uncovered), producing multiple images on a single frame.*

Understanding sync modes, flash modes, and ghosts

The flash sync speed determines the maximum shutter speed you can use to provide a complete exposure with your flash. Your D80 also has several *sync modes* that determine how the flash is coordinated with the shutter speed. The three sync modes are called *front sync, rear sync,* and *slow sync.* You can select these sync modes, plus three other flash modes (Off, Red-Eye Reduction, and Auto Flash), by holding down the Flash

button on the left side (as you hold the camera) of the D80's pentaprism and rotating the command dial.

All six modes can easily confuse you, as some of them are available only when using certain shooting modes among the various Program (P), Aperture Priority (A), Shutter Priority (S), Manual (M), Auto, and DVP/Scene modes possible. I'm going to describe the sync modes, other flash modes, and their effects, and tell you when you are able to use each.

Front sync

This flash synchronization mode is the default mode for the D80. You don't really "select" it using the Flash button; when none of the other modes are active, front sync (also called *first curtain* or *front curtain sync*) is what the D80 uses.

Recall for a moment the flash sync sequence (front curtain, pause, rear curtain) I outlined earlier in the chapter. When front sync is active, the D80 fires the electronic flash as soon as the sensor is fully exposed, before the rear curtain begins its travel to recover the sensor. You can think of the sequence as front curtain, flash, pause, rear curtain. This is actually what happens most of the time.

However, if the light levels are high enough or the exposure is long enough to allow a secondary image (a ghost) to form from the ambient illumination, that second image is exposed after the flash picture. If the subject is moving, you end up with a sharp image (from the flash) and a ghost image in front of the subject in the direction of the movement. Usually that's not what we want. A race car shown chasing its own blurry ghost image is probably not what you think of when you think of motion. In such situations, you can use rear sync instead.

Rear sync

When you've chosen rear sync (also called *second curtain* or *rear curtain sync*), the exposure sequence changes. When you use rear sync, the flash is triggered just before the second curtain begins its travel, producing this sequence: front curtain, pause, flash, rear curtain. There is a pause, during which the ambient light, if it's strong enough, is able to produce an exposure. Then, the flash creates the main exposure. If the subject is moving, you end up with a ghost image that terminates with a sharp flash exposure in the direction of travel, which is more "realistic."

If you expect to have ghost images and want to incorporate them into your photograph, use rear sync to produce the kind of look that is expected from such dual exposures. Rear sync is available only when you're using Program, Aperture Priority, Shutter Priority, and Manual exposure modes.

Slow sync

Slow sync is not the same kind of sync mode as front sync and rear sync. Slow sync tells the D80 that you want to use slow shutter speeds to increase the chance of getting dual exposures: one with the flash, and a second one from the ambient light. You generally use this mode to allow light from the electronic flash to balance with background illumination, avoiding backgrounds that are completely black. (Remember the inverse square law: If the background is far behind the main subject, the background doesn't receive sufficient exposure.)

You should hold the camera very steady (I highly recommend a tripod) when using slow sync mode, to avoid turning the ambient exposure into a ghost image. When slow sync is active, the D80 can program exposures as long as 30 seconds.

6.7 Front sync (top) produces a ghost image ahead of a moving subject; rear sync (bottom) places the ghost image behind the moving subject.

Other flash modes

The other three flash modes available with the Flash button/command dial aren't sync modes, but, rather they perform other functions. They are Red-Eye Reduction, Flash Off, and Auto Flash.

✦ **Red-Eye Reduction:** This mode uses a preflash of the focus-assist lamp to decrease the chances of red-eye effects (see figure 6.8). Supposedly, the preflash causes a subject's pupils to contract and stifle some of the reflection.

6.8 If you get glowing red pupils in your subject's eyes like these, turn on your D80's Red-Eye Reduction mode.

✦ **Flash Off:** This mode disables the built-in flash entirely. Use it when you don't want to accidentally use the flash in situations where it is inappropriate or forbidden, such as museums or some concerts.

✦ **Auto Flash:** This mode is available with some DVP/Scene modes, and pops up the flash when you depress the shutter release halfway and the light is dim, or the subject is backlit and could benefit from some fill-in flash.

Flash mode availability

Not all flash modes are possible with all shooting modes, and the Nikon manual doesn't do a good job of explaining when you can use them. Here's a quick summary:

✦ **Front sync:** This mode is used whenever you haven't explicitly selected rear sync (as described next).

✦ **Rear sync:** You can select this mode only in S and M modes, or in combination with slow sync (rear curtain+slow sync) in P and A modes.

✦ **Slow sync:** You can choose this mode when using the Night Portrait DVP/Scene mode, as either Auto/slow sync or Auto/slow sync/Red-Eye Reduction. You can also select slow sync in P and A modes in three different combinations: slow sync (alone); slow sync/Red-Eye Reduction; and slow sync/rear curtain sync.

✦ **Red-Eye Reduction:** Red-Eye Reduction is available as an optional mode both for front-sync and slow-sync settings. In addition, in P and A modes, you can choose to combine slow sync with rear-curtain sync.

✦ **Flash Off:** You can disable the automatic (pop-up) flash feature in Auto, Portrait, Close-Up, and Night Portrait DVP/Scene modes. In all other modes, the flash does not pop up automatically and does not need to be disabled; you must push the flash button to manually elevate the flash in P, A, S, M, Landscape, Sports, and Night Scene modes.

✦ **Auto Flash:** If you do want the flash to pop up in Auto, Portrait, Close-Up, and Night Portrait DVP/Scene modes, choose Auto Flash mode. You can combine auto flash pop-up with slow sync (Auto+slow sync) and slow sync plus red-eye prevention (Auto+slow sync+Red-Eye Reduction) in Night Portrait mode. In Auto, Portrait, and Close-Up modes you can also choose Auto+Red-Eye Reduction.

When you've activated a flash mode, a symbol appears in the top panel LCD representing the active flash mode (see figure 6.9).

6.9 The current flash mode is shown on the top panel LCD.

To add or subtract exposure from the values calculated by the i-TTL flash system, hold down the Flash button on the left side (as you hold the camera) of the pentaprism and spin the sub-command dial. The exposure value (EV) changes that you specify, from +3 EV to −3 EV, appear on the top panel LCD and in the viewfinder (see figure 6.10). An indicator flashes in both places to remind you that you've adjusted the default flash exposure. To cancel flash EV changes, press the Flash button again and turn the sub-command dial until 0 EV appears on the top panel LCD.

Tip *You can program the D80's Func button to either of two flash-related functions in the Custom Settings menu CSM 16. Select either FV Lock to use the Func button to fix the current flash setting, or Flash Off to use the Func button to disable the built-in speedlight.*

Reviewing Key Flash Settings

I outline the various flash settings you can make in the menu system in Chapter 3, but I summarize some of the key options in this section.

Exposure compensation

If you find your flash exposures in a particular shooting situation are consistently over- or underexposed, or you want to dial in a little more fill flash to brighten shadows (or less fill to darken them dramatically), use the D80's Flash Exposure Compensation feature.

6.10 Adjust the amount of flash exposure using flash exposure compensation.

Flash shutter speed

This setting, available in the Custom Setting menu CSM 24, specifies the slowest shutter speed allowed for flash when you're using P or A modes, to prevent you from accidentally using a speed low enough to promote ghost images from ambient light. The default value is 1/60 second, but you can

choose a slower speed (say, you know there isn't much ambient light, or you are using a tripod and want ambient light to be captured), up to 30 seconds. In M or S modes, this setting has no effect; you can use flash at any shutter speed from 1/250 second down to 30 seconds.

Built-in flash features

Use Custom Settings menu CSM 22 to choose between various i-TTL modes, Manual flash (with an output level from full power down to 1/128 power), Repeating Flash, and Commander mode for wireless control of external electronic flash.

Modeling flash

Use Custom Setting menu CSM 26 to turn the D80's built-in flash's modeling feature on or off. This is a useful feature first introduced with the Nikon D200. It's great to have it available for an "amateur" camera like the D80.

Using External Flash

The more experience you gain with your D80, the more you can imagine photos you want to take that just can't be done with the built-in flash. At that point, you want to consider an external flash unit, like the Nikon SB-600 or SB-800.

The internal flash is nifty because it's part of your camera (and, thus, is always available), and it uses no additional batteries. The flip side of the coin is that you're stuck with any limitations the D80's flash has that add-on flash units might not have, and every time you use your flash, you are sucking power out of the camera's batteries that you might well need to take nonflash pictures later on.

Moreover, the internal flash isn't particularly powerful, it can't be swiveled for use as a bounce flash, and its location atop your camera can lead to shadows cast on your subject when you use wide-angle zoom settings, as well as contribute to red-eye problems.

External flash units, on the other hand, usually are more powerful. The Nikon SB-800 Speedlight, for example (see figure 6.11), allows an exposure of about f/14 at 10 feet with an ISO setting of 100, about three stops more light than the D80's built-in flash. The elevated position of external flash units (or their off-camera capabilities) can virtually eliminate red-eye problems and shadows. You can swivel them for bounce flash, and they include features that expand their flash coverage to better suit wide-angle lenses. You don't even have to connect some external flash units to the camera—you can use the SB-600, SB-800, SU-800, SB-R200, and R1 units in wireless Commander mode.

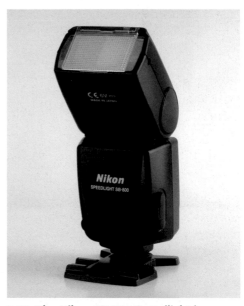

6.11 The Nikon SB-800 Speedlight is a more powerful external flash unit.

Many of the electronic flash's automated functions are available with non-Nikon external flash units as well. A few even support the Nikon i-TTL exposure system. However, not all Nikon flashes support all the features of the SB-600/SB-800 and other flash units in the Nikon line.

✦ **SB-400:** This new flash unit, introduced with the Nikon D40, is an inexpensive flash that costs about half as much as the more sophisticated Speedlights in the Nikon line. It operates on two AA batteries, can swivel in four steps up to 90 degrees for bounce flash, and requires an exposure of f/6.3 at ISO 100 for a subject 10 feet from the camera. You cannot use it wirelessly in Commander mode.

✦ **SB-600/SB-800:** These beefier flash units cost $250 to $350, but they have a full line-up of features, including wireless operation and hefty Guide Numbers. The SB-800 can serve as a commander for other external Nikon flash units, and requires an exposure of f/12.5 at ISO 100 for a subject 10 feet from the camera. The SB-600 is only a little less powerful, needing an exposure of f/9.8 at the same ISO and distance.

✦ **SB-R200:** This wireless remote Speedlight is triggered solely by the D80's built-in flash when in Commander mode or by another flash (such as the SB-800) set in Commander mode. It doesn't mount on the D80's flash accessory shoe and is used entirely as a remote slave flash that you can set on light stands or another support.

✦ **R1/R1C1 wireless close-up flash:** These close-up flash systems include a pair of Speedlights mounted on a ring on opposite sides of the lens. The R1 system uses the D80's built-in flash as the master, while the R1C1 system includes a Nikon SU-800 wireless commander that makes it compatible with strobe-less Nikon cameras, such as the D2xs. The close-up flash units have a guide number of 33, which is plenty for close-up work even at small apertures. A typical exposure would be f/22 at ISO 100 at distances of about 1.5 feet.

Photo Subjects

T here are four key ingredients that are essential when you're cooking up a successful photograph: an interesting subject, a creative photographer, an effective composition and execution, and the equipment needed to do a proper job.

In purchasing a Nikon D80, you've already satisfied the last requirement. Your camera includes just about every feature you could possibly need for most of the photographs your mind can concoct. Certainly, an extra lens or two can expand your creative options somewhat, and you can do additional things if you expand your equipment lineup with a new flash or some close-up accessories. But it would take a very long time to exhaust the possibilities open to you using just your D80 and a basic zoom lens.

I'm willing to bet you have a creative eye, one that you're eager to exercise to improve your skills. It's a safe bet because you purchased a D80 instead of a more limiting point-and-shoot camera, and invested in this book so you can get the most from your camera. At this point, all you need are some interesting subjects, a few tips on shooting techniques, and some guidelines for effective composition.

That's what you can get in this chapter. Here, you can find a refresher course in the "rules" of good composition, and advice on when to break those rules. You can also discover a series of recipes of typical – and atypical – shooting situations, with example photos, tips on getting the best from those photo subjects, and recommendations for lenses, lighting, and other aspects.

Basics of Composition

Good photos have good composition. You might be able to live with minor technical problems: a bit of overexposure here, or a little blurriness there. In fact, small technical glitches in your photographs can make them seem more natural or, in some cases, more urgent because it's obvious that you had to capture that instant right at that moment, without taking the time to think about precision or absolute control.

On the other hand, one expects to find pleasing compositions in the best photos, regardless of how quickly they were taken, because well-structured images do the best job of telling a story. So, even if you're snapping off a hurried photo with little time to check every last setting, you should try to compose the image as well as you can — by instinct or intuition if you have to. Alternatively, you can fine-tune the composition after you've taken the picture, using cropping or other tools in your image editor. But good composition is not something that's optional in a good photograph.

There are eight simple guidelines for composing photos effectively. I review each of them in this section.

Achieving simplicity

Reduce your picture to just the elements you need to illustrate your idea. Avoid extraneous subject matter, eliminate confusion, and draw attention to the most important part of your picture. Crop out unimportant objects by moving closer, stepping back, or using your D80's zoom lens.

Remember that a wide-angle look emphasizes the foreground, adds sky area in outdoor pictures, and increases the feeling of depth and space. Moving closer adds a feeling of intimacy while emphasizing the texture and details of your subject. A step back might be a good move for a scenic photo; a step forward might be a good move for a picture that includes a person.

Keep in mind that with a digital camera, careful cropping when you take the picture means less trimming in your photo editor, and less resolution lost to unnecessary enlargement. You want to waste as few of your D80's 10.2 megapixels as possible. But when you're eliminating "unimportant" aspects of a subject, make sure you truly don't need the portion you're cropping. For example, if you're cropping part of a boulder, make sure the part that remains is recognizable as a boulder and does not look like a lumpy glob that viewers waste time trying to identify. And cutting off the tops of your subjects can be just as objectionable when your subject is a mountain as when it is a person.

Centering interest

Decide on a single center of interest. It doesn't have to be the center of your photo, nor necessarily located in the foreground. But no matter where your center of interest is located, a viewer's eye shouldn't have to wander through your picture trying to locate something to focus on. You can actually have several centers of interest to add richness and encourage exploration of your image, but there should be only one main center that immediately attracts the eye.

The center of interest should be the most eye-catching object in the photograph. It can be the largest, the brightest, the most colorful, or the most unusual item within your frame; or it can be the one that is most active, as in figure 7.1. A photo of a deserted

7.1 Three softball players in the photo, and there's no question about where the center of interest resides.

beach may have no center of interest at all, but plop a bright yellow sports car on the sand, and you're guaranteed an eye-grabbing focal point. Conversely, if you want a certain subject to be the center of attention in your photograph, you should *not* include some competing subject that's larger, brighter, gaudier, or more unusual. If you're photographing your kids, make sure that a huge plaster pink elephant isn't lurking at the side of the frame. You should avoid having more than one center of attention. While other interesting things can be in the picture, they should be subordinate to the main subject.

Choosing an orientation

Beginners frequently shoot every photo holding the camera horizontally in a death grip. That's not a good idea from a compositional or technical standpoint. If you shoot a subject in that mode, you waste a lot of image area at either side. Vertical subjects, like trees or buildings (see figure 7.2), often look best when they're shot in a vertical orientation. Nikon offers the MB-D80 battery pack/vertical grip, which is configured to make the shutter release and command dials accessible when the cameras is rotated at a more comfortable vertical angle.

7.2 Some subjects just lend themselves to a vertical orientation.

Many subjects, particularly broad landscape vistas, look best in a horizontal view. A few types of subjects actually lend themselves to a square format (which otherwise tends to look a little static). With the D80, you can shoot a horizontal picture and crop the sides.

Applying the Rule of Thirds

I like to think of the Rule of Thirds as more of a guideline than a hard-and-fast rule. But it's true that placing objects of interest at a position located about one-third from the top, bottom, or either side of your picture makes your photographs more interesting than ones that place the center of attention dead center. Things that are centered in the frame tend to look fixed and static, while objects located to one side or the other

imply movement, because they have some-where in the frame to "move to."

To apply the Rule of Thirds, divide the frame with two horizontal lines and two vertical lines, each placed one-third of the distance from the borders of the image, as the Amish horse and buggy is positioned in figure 7.3. The intersections of these imaginary lines represent four different points where you might want to place your center of interest. The point you choose depends on your subject matter and how you want it portrayed. Secondary objects placed at any of the other three points are also arranged in a pleasing way. (Unfortunately, the D80's optional viewfinder grid can't be used for "Rule of Thirds" placement: It divides the frame into *quarters.*)

You can apply the Rule of Thirds by positioning specific subjects at any of the "hot points" in the image. Horizons are often best located at the upper third or lower third of the picture. Placing the horizon at the upper-third position emphasizes the foreground; at the lower third, it emphasizes the sky.

When applying this rule, remember that if your subject includes a person, an animal, a vehicle, or anything else that's mobile and has a definable "front end," it should be arranged in a horizontal composition so that the front of the person or object is facing into — or is at least visible — in the picture (as in figure 7.1.) If not, your viewer may wonder what your subject is looking at, or where the animal is going, and may not give your intended subject the attention you intended. Add some extra space in front of potentially fast-moving objects so it doesn't appear as if the thing is just about to dash from view.

It's less important to include this extra space for subjects that don't move, particularly in vertical compositions. A tree can butt right up to the top of an image with no problems. But if your picture shows a model rocket in flight, it would be best to position it a bit lower in the frame.

7.3 Place your center of interest at one of the intersections of the four imaginary lines.

Using lines

Viewers find an image more enjoyable if there is an easy path for their eyes to follow to the center of interest. Robust vertical lines lead the eye up and down through an image. Strong horizontal lines draw our eyes from side to side. Repetitive lines form interesting patterns. Diagonal lines conduct our gaze along a more gentle path, and curved lines are the most pleasing of all, as you can see in figure 7.4. Lines in your photograph can be obvious, such as fences or the horizon, or more subtle, such as a skyline or the curve of a flamingo's neck.

As you compose your images, you want to look for natural lines in your subject matter and take advantage of them. You can move around, change your viewpoint, or even relocate cooperative subjects somewhat to create the lines that enhance your photos. You can arrange lines into simple geometric shapes to create better compositions.

Achieving balance

Balance is the arrangement of shapes, colors, brightness, and darkness so they complement each other, giving the photograph an even, rather than lopsided, look. Balance can be equal, or symmetrical, with equivalent subject matter on each side of the image, or asymmetrical, with a larger, brighter, or more colorful object on one side balanced by a smaller, less bright, or less colorful object on the other.

Working with framing

Framing is a technique of using objects in the foreground to create an imaginary picture frame around the subject. A frame concentrates our gaze on the center of interest that it contains, plus adds a three-dimensional feeling. You can also use a frame to provide additional information about the subject, such as its surroundings or environment (see figure 7.5).

7.4 Curved lines lead the eye through the picture.

7.5 Surrounding trees form a frame around this structure.

Use your creativity to look around to find areas that you can use to frame your subject. Windows, doorways, trees, surrounding buildings, and arches are obvious frames. Frames don't have to be perfect or complete geometric shapes.

Avoiding fusion and mergers

Two-dimensional photographs tend to flatten the perspective of images we capture. So, although a tree behind the main subject didn't seem obtrusive to the eye, in the final picture, it may appear to be growing out of the roof of a barn. Or, perhaps you framed the image to trim off all of a tree except for one stray branch, and now that branch — detached from the tree that no longer appears in the photo — appears to grow out of the top of the picture.

Examine your subjects through the viewfinder carefully to make sure you haven't fused two objects that shouldn't be merged, and have provided a comfortable amount of separation between them. When you encounter this problem, correct it by changing your viewpoint, moving your subject, or using selective focus to blur that objectionable background.

Abstract and Pattern Photography

Images created from abstract compositions and patterns emphasize the internal form of the subject matter, rather than the subject itself. The pattern inlaid in gold on a Damascene dinner platter becomes the focus of an image like the one seen in figure 7.6; it doesn't matter whether the original object is a piece of dinnerware, an ornate ceiling, or a decorative vase (all of which sometimes have Moorish-influenced ornamentation of this type). It's the artistic content of the pattern itself that captures and holds the eye.

7.6 The intricate pattern of this gold inlaid Damascene decoration, photographed from inches away, creates an abstract pattern.

You can find abstract images in drops of water, the grain of wood, collections of rocks, or fine details of human-made objects. Such images don't need to be realistic or provide a good representation of the subject in which the pattern is found. In fact, if the eye can tell at first glance what the original subject is, then the image is probably not abstract enough. Abstract patterns can be totally nonrepresentational (that is, they don't resemble anything familiar), or they can contain the imagined shapes of real objects, as when you find the profile of a face in a collection of clouds in the sky. This kind of photography is particularly powerful because it depends so much on the imagination of the photographer and viewer.

Inspiration

That master of the abstract, Pablo Picasso, said, "There is no abstract art. You must always start with something. Afterward you can remove all traces of reality." Picasso's advice is particularly true when applied to digital photography, because photographers don't have a brush and canvas on which to create shapes and lines from scratch. Your abstractions must begin with a real-world object that you photograph in such a way as to remove the "reality" of your subject's complete image, and emphasize the form and color.

Figure 7.7 pictures the wind-catching panels of a decorative weathervane, captured from an angle that disguises the object's true nature. Only the concentric circles and alternating strips of red, white, and blue remain to create an image that's both realistic and abstract. You can see the individual parts of the object, but its true nature disappears into the pattern that results.

Look for abstract images in nature and human-made objects by isolating or emphasizing parts of those subjects. You can find

7.7 Repetitive shapes can form the foundation for an abstract image.

suitable patterns in plants, rocks, moving water, clouds, and simple household objects like salt shakers photographed from inches away.

Don't be shy about rearranging found objects in ways that create the patterns you seek. I've created abstract compositions from collections of seashells, piles of pasta, and layers of paper clips. You can photograph familiar objects in unfamiliar ways and unfamiliar subjects in ways that evoke more familiar shapes, winding up with abstract images that are interesting to look at and think about.

Abstract and pattern photography practice

7.8 An extreme close-up creates an abstract image from wood grain.

Table 7.1
Taking Abstract and Pattern Pictures

Setup	**Practice Picture:** While this 150-year-old privy was no longer "operational" when I discovered it on display at a county historical society, its weathered wood had an amazing texture. For figure 7.8, I attached my D80 to a sturdy tripod and photographed this opening carved into the side.
	On Your Own: Wonderful abstract images are hidden in common objects if you look hard enough. A tripod enables you to choose the best angle and distance, then lock the camera into position and focus without risk of losing sharpness from camera shake or unsteady autofocus.

Lighting

Practice Picture: I needed high-contrast lighting to emphasize the texture of the wood, so I took this image on a second visit to the historical society, which I timed for high noon, when I knew the light would be direct and bright.

On Your Own: If you're photographing a subject that calls for a softer look, you can use reflectors (a piece of white cardboard will do) to diffuse the light and bounce it into shadows.

Lens

Practice Picture: 105mm f/2.8D AF Micro-Nikkor. A macro lens is useful for getting close enough to capture fine details and abstract patterns in objects. The 60mm f/2.8D AF Micro-Nikkor would also have worked, but the slightly longer focal length of the lens I used made it possible to stand back further from the opening, avoiding any shadows that I or my camera might cast with the sun overhead and slightly behind my shooting position. The newer 105mm f/2.8G ED-IF AF-S VR Micro-Nikkor includes built-in vibration reduction, which might have partially eliminated the need for a tripod, but I still liked using a camera support to help me frame the image precisely and maintain absolute focus.

On Your Own: A macro lens isn't absolutely essential for this kind of photo. A macro-zoom lens that focuses close enough or even the 50mm f/1.8D AF Nikkor at that lens' minimum 18-inch focus distance might do the job.

Camera Settings

Practice Picture: RAW capture. Aperture Priority AE with white balance set to Daylight. Saturation set to Enhanced, and both Sharpness and Contrast set to High. Manual focus fine-tuned for the exact plane of the wood grain.

On Your Own: Aperture-priority AE mode lets you choose a small aperture and enables the camera to select a suitable slow shutter speed for the tripod-mounted D80. Extra saturation, sharpness, and contrast increase the abstract appearance at the expense of realism. You can also boost these values when converting the RAW image and processing it in your image editor.

Exposure

Practice Picture: ISO 100, f/32, 1/30 second.

On Your Own: A small lens aperture increases the depth of field so that the entire image is sharp. The long exposure means that the D80's best-quality ISO 100 sensitivity is sufficient.

Accessories

A tripod lets you lock down the camera once you've found an angle you like, and makes it possible to stop down to a small f-stop without worrying that the long shutter speeds that result is causing image blur. A Nikon ML-L3 wireless remote control or MC-DC1 wired remote cord are faster for releasing the shutter without jiggling the tripod, but you can also use the self-timer.

Abstract and pattern photography tips

✦ **Turn, turn, turn:** Rotate an image to provide an unfamiliar perspective on a familiar object. Changing the orientation alters the direction of the light as well as your viewpoint of the subject. Just turning the image 90 or 180 degrees might turn an everyday object into an abstract pattern.

✦ **Crop your image:** If you crop tightly or zoom in on your subject, you may find that a smaller portion of the object has abstract qualities that you didn't notice before.

✦ **Exaggerate colors:** Increase the saturation in your camera using the D80's Optimize Image options in the Shooting menu, or further enrich the colors in your image editor. Hue controls can shift colors from one shade to another. Exaggerated or modified colors can sometimes be enough to lift an image from the mundane to the abstract.

✦ **Carpe momentum:** Use a high shutter speed to freeze an instant in time to capture an abstract image from things that are ordinarily difficult to see, like the splash of a water drop, or the waves produced when a rock is tossed into a pond.

Action Photography

Action isn't just for sports any more! The Nikon D80's near-instant response when you press the shutter release, fast autofocus, and continuous shooting at three frames-per-second for up to 23 consecutive JPEG shots make it the perfect tool for capturing all kinds of fast-moving activities. You can put your camera to work photographing family and friends on the rides at amusement parks, diving off the high board at the pool, or unleashing a robust drive on the golf course. More traditional action events like football, baseball, basketball, and soccer games also provide excellent fodder for the photographer with an active lifestyle. If your subject moves—and the faster the better —you can get great action photos.

Your Nikon D80 simplifies action photography. You can have it powered up and ready to shoot at all times, bringing the exposure meters and autofocus instantly to life by pressing the shutter release down halfway. Once the camera is at eye level, the autofocus and autoexposure systems work so quickly that you can depress the release button the rest of the way and take a picture in an instant, without the frustrating shutter lag that plagues so many point-and-shoot digital cameras. And the D80's continuous shooting mode can squeeze off bursts of shots as quickly as three frames per second, so even if your timing is slightly off you can still improve your chances of grabbing the exact shot you want.

7.9 The view from the sidelines with even a short telephoto lens puts you right in the middle of the action.

Inspiration

The two main components of a good action photo (in addition to good composition!) are capturing the right subject at the right instant. A shot of a third-string sub running downfield and waiting for a pass in the waning moments of a football game is much less powerful than a picture of the winning score being pulled in by a tight end surrounded by defenders. (Unless the third-string sub is your child, of course!)

Similarly, a shot of an acrobatic aircraft (like the one in figure 7.10) executing a difficult stunt maneuver is a lot more exciting than an everyday photo of a plane touching down for a landing. When you're shooting action, it's always useful to have some understanding of what's going on that you can anticipate just where the most exciting moments will take place; this way you're ready to snap the shutter at the perfect instant. With that much preparation, your D80's action-ready features handle the rest of the job for you.

Action photography freezes a moment in time, capturing a critical instant that sums up the excitement of the sport or activity. But that's not to say that every action photo has to be razor sharp, with all subject motion at an absolutely standstill. Indeed, a little blur can add a feeling of urgency and realism. A shutter speed that's fast — but not too fast — freezes a helicopter in flight, but allows its rotors to blur enough that we know the aircraft hasn't stalled in flight. On the other hand, a shot of a motocross racer with wheels frozen in time looks as if the motorcycle is parked; blurry tires and a bit of mud being kicked up makes for a more exciting photograph.

7.10 A peak moment, like this stunt plane at the top of its loop, is the perfect instant to capture an exciting action photo.

Action photography practice

7.11 A combination of a seat next to the visitors' dugout, a long lens, and the D80's continuous shooting mode produced this shot of a runner sliding safely into third base.

Table 7.2 Taking Action Pictures	
Setup	**Practice Picture:** I mounted my long lens on a monopod, sat in the first row next to the visitors' dugout, and was able to cover home plate, first base, the pitcher's mound, and third base for the whole game.
	On Your Own: Knowing where to stand or sit is half the battle. If you can't get a spot behind the baseline, you can cover basketball games from a floor or second-row seat, especially one near the bench. Most of the action at a soccer game takes place near the net. At football games, don't stand at the line of scrimmage: Position yourself 10 yards in front of or behind the line to catch a receiver snaring a pass, a runner breaking through, or a quarterback dropping back to throw.
Lighting	**Practice Picture:** Daylight, mixed with some occasional overcast that softened shadows, was perfect for this afternoon baseball game.
	On Your Own: Whether shooting outdoors or indoors, you usually have to work with the light you have. You may have to increase the ISO slightly to allow high enough shutter speeds, and indoors use settings as high as ISO 1600 in very poor illumination.

Lens	**Practice Picture:** Sigma 170-500mm F5-6.3 APO Aspherical AutoFocus Telephoto Zoom Lens at 500mm.
	On Your Own: Outdoor sports often call for lenses with 300mm to 500mm focal lengths if you're in a fixed position far from the action. But if you have some mobility, a 28–200mm or 70–200mm zoom lens may be better. Indoor action may require wider lenses to take everything in or faster lenses to allow higher shutter speeds. An 85mm f/1.8 lens can be perfect for some kinds of indoor activities.
Camera Settings	**Practice Picture:** JPEG Fine. Shutter Priority AE and continuous shooting mode.
	On Your Own: The D80 stores JPEG Fine images more quickly than RAW format images, so when you're take photos quickly and continuously, you gain some shooting speed with very little quality loss by choosing Fine. Using Shutter Priority mode allows you to choose the highest appropriate shutter speed when you want to stop action. Under reduced light levels, you want to drop down to a slower shutter speed or boost the ISO setting.
Exposure	**Practice Picture:** ISO 400, f/11, 1/1000 second.
	On Your Own: At 400mm, the f/11 aperture allowed the people in the stands to blur, and 1/1000 second was fast enough to freeze the runner sliding into the bag under the third baseman. Noise isn't a problem with the D80 at ISO 400.
Accessories	A tripod isn't usually a good choice for action photography, because it reduces your mobility and may even make you a hazard to the participants if you're standing along the sidelines. A compact monopod can steady a long lens and produce sharper results. If you do a lot of action photography, look at lightweight monopods made of carbon fiber or magnesium.

Action photography tips

✦ **Lock focus:** One trick sports photographers use is to redefine the AE-L/AF-L button on the back of the camera to AF-ON operation. (See Chapter 3 for instructions on how to do that.) Then, set the D80 to AF-C (continuous autofocus). It continually refocuses when the shutter release is partially depressed as your framing or the subject moves. When you want to lock focus, press the AE-L/AF-L button with your thumb to lock the focus at that point. It's like having AF-C and AF-S switching available at the press of a button (and a better choice in these situations than AF-A).

✦ **Ready, aim, fire:** Most types of action have a definite flow. Pay attention to the rhythm and be ready to press the shutter release at recurring peak moments to capture the decisive instant when a race car rounds a turn and heads for the straightaway, a quarterback pumps before unleashing a pass, or a high jumper leaves the ground to clear a hurdle.

✦ **Freeze oncoming action:** Any movement that's coming directly toward the camera can be frozen at a slower shutter speed than action that's across the width of the frame. Instead of using the D80's highest shutter speeds (from 1/1000 to 1/4000 second) at large apertures, stop down to an f-stop with more depth of field, use a shutter speed like 1/500 second, and freeze oncoming action instead.

Animal Photography

In the United States alone there are 90 million cats and 73 million dogs. If you like your fauna on the small side, there are 360,000 different species of beetles. It's possible for a photographer to specialize in photographing nothing but living creatures of the non-human variety, and many do.

If you don't want to occupy your time shooting landscapes, photographing flowers, or capturing portraits of your friends, colleagues, and family, opportunities abound for photo creativity when taking pictures of animals. You can travel on a "safari" to a local zoo, where you can find exotic animals from all over the world. Or, you can visit Africa on a real safari armed only with a camera and accompanied by a local guide. Such trips are, in fact, the dream of many avid photographers.

But you don't need to travel far to take interesting photographs of animals. The park down the street probably teems with squirrels, chipmunks, frogs, and other creatures. The rural area close to home may shelter deer or rabbits. You may even find a patient dog, cat, ferret, or pet bird in your own home who would make a perfect photographic subject. Home may even be the best place to photograph an animal; you can wait patiently until your pet does something interesting, then snap a picture that sums up your companion animal's personality and habits (see figure 7.12).

7.12 This photograph captures the alertness of the cat, who keeps patient watch over something outside the frame, and is ready to move.

Inspiration

The key to attractive photos of animals is to picture them in natural-looking surroundings, whether they are wild animals, pets at home, or animals being showcased in a zoo exhibit. Nobody particularly cares for pictures of animals in cages or with other unnatural surroundings. A photograph of a deer that's wandered into your backyard may be mildly interesting because of the incongruity, but if you're able to use the patch of woods that borders your property as a backdrop instead, the image will seem more natural and compelling.

Similarly, you should photograph a zoo animal as if it were in its natural habitat, with nary a bar or moat in sight. Those who view your photographs probably won't think you traveled to some exotic place to take the picture, but the natural surroundings encourage them to suspend their disbelief and enjoy the photo on its own merits.

The quest for natural appearance extends to the animals' behavior, too. Once you've selected and tracked down your quarry, wait until the creature is engaged in behavior that's both typical and revealing. Cats sleep a lot, but they also crouch and lie in wait, their attention focused and unwavering until they leap into action with a pounce. Dogs may display curious behavior; monkeys may groom one another or look at human observers quizzically. Timid animals may act nervous; aggressive animals may try to intimidate you. Be patient and you'll be rewarded with a great animal picture.

7.13 Domesticated animals like this dog usually sit contentedly while you take their photo.

Animal photography practice

7.14 A long lens brought this wild bird up close for an impromptu portrait.

Table 7.3
Taking Animal Pictures

Setup	**Practice Picture:** Perched near a watering hole frequented by large birds, I set up my D80 with a long lens on a tripod and waited for the chance to capture the cooperative avian shown in figure 7.14.
	On Your Own: Patience is its own reward when photographing animals. In the wild, you might want to set up a blind to hide in wait near a watering place. Food or salt blocks can attract wild creatures. At zoos, spend the morning when the animals are most active observing and taking pictures, and return at late evening or feeding times, if necessary, when the creatures are active again.
Lighting	**Practice Picture:** The bright sunlight was perfect for showing off the bird's plumage.
	On Your Own: You work with the available light most of the time, although some photographers have been known to set up flash units with remote wireless triggers for photographing animals in the late evening or nighttime.

Lens	**Practice Picture:** Sigma 170–500mm F5-6.3 APO Aspherical AutoFocus Telephoto Zoom Lens at 400mm.
	On Your Own: You can use a long lens to shoot close-up photos of animals that won't come closer to you than 20 or 30 yards. Wide-angle lenses aren't much use for wildlife photos, but longer lenses — either zooms or prime lenses with focal lengths of 300mm or more — will do the job. If you shoot under dimmer light (say, in the woods), a fixed focal-length lens with a large maximum aperture, such as f/4 or f/2.8 will be better than a slower zoom lens.
Camera Settings	**Practice Picture:** RAW capture. Shutter Priority AE. Saturation set to Enhanced.
	On Your Own: Shooting in RAW format enables you to adjust the exposure when importing the picture in your image editor. Shutter Priority mode enables you to specify a fast shutter speed to freeze a fast-moving or skittish animal.
Exposure	**Practice Picture:** ISO 200, f/8, 1/1000 second.
	On Your Own: Using a fast shutter speed serves a triple purpose: the high speed minimizes camera shake (in case you're not using a tripod), reduces the amount of vibration that a typical long lens produces, and lets you work with a fairly large aperture so a distracting background is out of focus.
Accessories	Carry a tripod or monopod when using a long lens. A rain poncho and umbrella can come in handy if the weather turns bad and you're far from your transportation.

Animal photography tips

✦ **Early to rise:** Whether you're going to the zoo or venturing out into the boonies, get up early and arrive when the animals are active. By noon, they're ready for a nap.

✦ **Go outdoors:** Even domestic animals look their best outdoors, so take your pets outside to your yard or to a nearby park for their portraits. In zoos, if the animals have gone inside to feed, wait until they emerge again to shoot them against a more natural outdoor backdrop.

✦ **Shoot low:** Humans are taller than most wild animals, and so the tendency is to photograph them from an unnatural standing position. Get down low and take pictures of wildlife from their own vantage point for a more natural photograph.

✦ **Accentuate the habitat:** If you're photographing in a zoo, use a long lens and wide aperture to throw the bars or fence (if present) out of focus. Scant depth of field can disguise those walls and fake rocks in the background, too. If you're forced to shoot through glass, take your pictures at an angle to avoid reflections.

Architectural Photography

Architectural photography is a highly specialized pursuit, and one of the last bastions of film, particularly in medium and larger formats. But there's no reason why an amateur photographer can't capture the beauty of well-designed buildings and structures.

Photography of building interiors is particularly challenging for owners of digital SLRs like the Nikon D80, because the lighting aspects can be complex, extremely wide (and extremely expensive) lenses are sometimes needed, and indoor shots frequently require the kind of perspective adjustments that are easiest with specialized cameras and equipment.

That doesn't mean you can't attempt indoor architectural photography—only that you may find photographing exteriors less frustrating and more rewarding. You can start out with simple projects, like the photograph of the church shown in figure 7.15. (Just to show you the different things that can be done, I'm including a quite different view of this same structure in the Infrared Photography section later in this chapter.)

Inspiration

You can use architectural photography to capture the designer's art, to create abstract patterns from a section of a complex structure, to record construction progress, or to show how an historic building has changed during the years. You can take architectural photos at virtually any time and in any weather. Indeed, some of the most interesting photos are taken in the rain or after a snowfall, or at night when interior and exterior illumination combine to show off the building. I have some favorite structures that

7.15 Choosing the best angle shows both the building and its surroundings without a distracting background.

I return to over and over, months and years apart, and I always come away with a new image and new perspective.

For example, figure 7.16 shows a tower built 40 years ago to house an 18th century clock that once was mounted atop a Western Reserve county courthouse. I've photographed the tower and clock on several occasions, and decided to take a black-and-white photo through a red filter, which lightened the brick and darkened the sky behind the clouds (you can find more black-and-white photography later in this chapter). In this case, the image doesn't even show the clock itself, but emphasizes the tower.

7.16 This black-and-white photo of a tower housing an historic clock uses black-and-white photography to reduce the image to its basic form.

Architectural photography practice

7.17 Only a section of this ultra-modern, aluminum-clad building is needed to capture the power of its curves.

Table 7.4
Taking Architectural Pictures

Setup	**Practice Picture:** Although I live not far from the National Inventors Hall of Fame, I've been inside only three times; but I've returned to this interesting building on a dozen occasions to photograph its exterior from many angles. On this visit, I concentrated on the curving metal façade that was shining brilliantly in the winter sunlight, as shown in figure 7.17.
	On Your Own: If you're not shooting a detail of a structure, you need to find a location that enables you to photograph the entire building without obstructions and with a clean background.
Lighting	**Practice Picture:** It was midday and the brilliant sunlight accentuated the sheen of the curving sheets of metal.
	On Your Own: In most cases you want to avoid harsh shadows, so slight cloud cover might be desirable to provide slightly more diffuse illumination.
Lens	**Practice Picture:** 12–24mm f/4G ED-IF AF-S DX Zoom-Nikkor set to 12mm to exaggerate the foreground and make the curving wall seem to recede into the distance.
	On Your Own: The best lens depends on whether you are able to back away from the building enough to take in the entire structure without tilting the camera back and introducing perspective distortion. Very wide-angle lenses like the 14mm f/2.8D ED AF Nikkor are quite expensive, however. A more reasonably priced alternative is the 10.5mm f/2.8G ED AF DX Fisheye-Nikkor, which produces a curved view that can be straightened out in Nikon Capture NX.
Camera Settings	**Practice Picture:** RAW capture. Shutter Priority AE. Saturation set to Enhanced and Sharpening set to Medium High.
	On Your Own: Outdoors in bright sun, you can usually use Shutter Priority to specify a speed that nullify camera shake, and let the camera choose the appropriate aperture.
Exposure	**Practice Picture:** ISO 200, f/16, 1/500 second.
	On Your Own: Center-weighted or spot metering can help ensure that the exposure is made for the building itself and not any bright surroundings such as sky or snow.
Accessories	A tripod can be helpful to enable you to carefully compose your photo. I like to remove the camera after the shot and take a picture of where the tripod was set up, so I can repeat the picture from that position on a visit on a different day and different time of year.

Architectural photography tips

✦ **Do your architectural planning.** Walk around a location to choose the best position for a shot. If the weather isn't ideal, plan to come back at a better time — but take a few test shots you can use to map out what you're going to do.

✦ **Choose the best time.** For buildings in urban settings, Sunday mornings are often the best time to shoot a structure without the intrusion of automobile or foot traffic. Other buildings might look their best at sunrise or sunset.

✦ **Avoid perspective distortion.** You don't want to end up with that tipping-over look that results when the camera is tilted back, unless

you plan to use the effect as part of your image, as I did in figures 7.16 and 7.17. Instead, step back as far as you can, using the widest lens you have available. Sometimes shooting from a slight elevation will enable you to take in the entire structure without needing to tip the camera back.

✦ **Ask permission.** In these security-conscious days, it's often a good idea to ask permission to shoot a particular building, especially government edifices and commercial structures. The laws of most states don't require getting permission to shoot and use photographs of buildings that are clearly visible from public areas, but doing so can avoid potential problems.

Black-and-White Photography

For photographers who grew up in the age of color, black-and-white photography is a new way of seeing, a way to strip an image down to its essentials, and a method for concentrating on the tones, play of light and shadows, and texture rather than the hues in an image.

While Kodak actually marketed a black-and-white digital camera for awhile, modern dSLRs like the Nikon D80 are full-color pixel grabbers, with plentiful controls for tweaking the color balance and hues. But the D80 also gives you tools for exploring the world of

black-and-white photography. The Optimize Image menu has a black-and-white mode, and there are choices for simulating the grayscale effects produced when you shoot with color filters, too, so you can shoot pictures like the one shown in figure 7.18 right in the camera. You can convert a color image into a black-and-white picture using Nikon Capture NX or another RAW converter like Adobe Camera Raw, and every image editor includes tools for removing the color from images and choosing or mixing color channels down into a grayscale version.

If you're willing to explore photography at a new level, black-and-white photography can add excitement and new creative options to your work.

7.18 Using black-and-white gives a period look to this modern photograph.

We've come a long way since then! Today, many digital photographers have never taken a black-and-white picture, and, thanks to full color imaging, often fret more about getting just the right colors than about capturing a rich tonal scale. And yet, the range of tones is one of the most important aspects of a good picture: The amount of detail in the shadows, midtones, and highlights is just as important with a color photograph as it is for a black-and-white picture. Monochrome photography makes it possible to explore tonal relationships without the distraction of color.

Black-and-white photography can even "correct" difficult color, as in figure 7.19, which was not originally shot in monochrome. A mixture of green-tinged fluorescent lighting and blue-soaked daylight provided a bizarre color rendition. In black-and-white, it shows the fellow who sold me my D80 in a thoughtful moment.

Inspiration

Until the 1950s, monochrome images dominated movies, television, advertisements, and even publications like *Life Magazine* that featured photojournalism. Until *USA Today* launched in 1982, black-and-white photos were the rule in our daily newspapers, too. Affordable desktop scanners introduced late in that decade were monochrome only, and the first image editing programs I worked with in the late 1980s could handle only black-and-white.

7.19 Black-and-white photography strips away distracting color to provide a simpler image.

Black-and-white photography practice

7.20 Antique autos seem especially appropriate for a black-and-white/sepia photographic treatment.

Table 7.5
Taking Black-and-White Pictures

Setup	**Practice Picture:** Parked in front of a residence in New York City, the old-time automobile shown in figure 7.20 could be waiting for Laurel and Hardy to climb in for a chase scene. I used the D80's sepia mode to enhance the 1930s flavor of the image. **On Your Own:** Train your eye to look for subjects that would look especially good in black-and-white. In addition to historical objects and scenes, any subject with strong interplay of light and shadows has great possibilities, as well as high contrast scenes with pure whites and blacks.

Lighting	**Practice Picture:** Bright daylight with a dappling of shade from trees on the other side of the street provided enough contrast to show the texture of the old car's body, without excessive harshness.
	On Your Own: Black-and-white photography is your chance to experiment with light. Use the existing lighting, or add your own (including bounce light from reflectors or fill flash), to manipulate the highlights and shadows for the tonal rendition you want.
Lens	**Practice Picture:** 18–55mm f/3.5–5.6G ED II AF-S DX Zoom-Nikkor at 25mm.
	On Your Own: The particular lens you choose for black-and-white photography has no effect on the monochrome rendition itself; select your lens to best suit the subject matter, whether you're shooting a portrait, landscape photo, or close-up.
Camera Settings	**Practice Picture:** RAW+JPEG Fine. Aperture Priority AE with white balance set for Daylight.
	On Your Own: Using RAW+JPEG Fine gives you the best of both worlds. When you play back the image, the black-and-white version appears on the D80's LCD so you can judge exposure and tonal rendition. You can further manipulate the image — or even convert it back to color — when you import the RAW version into your image editor.
Exposure	**Practice Picture:** ISO 200, f/11, 1/500 second.
	On Your Own: Because color isn't available to provide tonal separation, if you want to isolate a black-and-white subject from its background you need to use a large lens opening; if you want the foreground, subject, and background all in focus, use a smaller f-stop.
Accessories	Black-and-white photography can be contemplative (think Ansel Adams) or fast-moving photojournalism (think Eddie Adams). So, your accessories might range from a sturdy tripod to a photojournalist's vest with pockets for lenses, flash, and other gear.

Black-and-white photography tips

✦ **Watch for unintended fusion and mergers.** While your D80 captures images in black-and-white, you can still see the scene through the viewfinder in full color. Unless you're careful, you may miss mergers of tones that are similar in brightness and texture, but differ in color. Until you learn to "see" in black-and-white, check your shots on the LCD to make sure that what you end up with is what you intended.

✦ **Look for a moment.** Black-and-white photography is a great tool for capturing the essence of a moment. You may discover that if your snapshot captures an interesting moment, viewers don't care if the exposure or focus isn't absolutely perfect, and a few imperfections might even make the photo appear to be more natural.

✦ **Tell a story.** Traditionally, some of the best black-and-white photos have been photojournalist-style images that tell a story about the people and their activities in the urban area you picture.

✦ **Travel light.** The purity of black-and-white photography often lends itself to working simply, sometimes with a single camera or lens. That's especially true of street photography in cities, when youre on foot much of the time, scooting between locations by bus or taxi. You don't want to be lugging every lens and accessory around with you. Decide in advance what sort of pictures you're looking for, and take only your D80 and a few suitable lenses and accessories.

Concert and Theatre Photography

Even though DVDs and audio CDs can bring us live concerts and stage performances with vivid realism and flawless sound, people still love to attend concerts and go to the theatre. Live music and stage productions have a lot of visual excitement that you don't get from canned performances, and they make perfect venues for photography as well. It doesn't matter whether you're attending a concert by an internationally known artist or enjoying the earnest efforts of a high school musical. Your Nikon D80 is up to the task of capturing the scene in photographs.

There's one challenge that every concert or theatre event presents: getting close enough to take pictures that show the performers clearly. In large auditoriums or arenas, you're probably seated so far back that you'd need a long telephoto to capture single figures or "two shots" (of a pair of musicians/actors). But even proximity is no advantage at more active venues where a lot of boogy-ing or moshing is going on in front of the stage.

Instead, you want to concentrate on shows at smaller theaters and clubs, with a good second- or third-row seat, located far enough to the side to provide an excellent view of the performers, but not so close that all you get is a view of the underside of their chins. That happened to be the case for the image shown in figure 7.21, but the angle happened to work out for that particular shot. A whole concert captured from that angle wouldn't have enough variety to be pleasing.

7.21 Low angles can provide an interesting perspective for an occasional shot.

Inspiration

Plays are an unfolding story that you can capture in photographs, and it's sometimes useful to think of concerts in the same way. For example, just as plays start off with a lively act, then segue into intense scenes as the story builds, concerts also begin with a rousing tune or two, then ease into ballads or acoustic numbers. Both finish with crowd-pleasing final acts and finales.

As the performance develops, you want to capture each of these stages, perhaps including a few shots of the venue, its setting, and the crowd/audience itself. There is always a moment about halfway through that embodies the whole performance. Sometimes it's a pivotal moment in a play (like the one shown in figure 7.22) or the performance of the musicians' signature tune. Capture that moment, and you transport the viewer right to the event itself.

The key to successful photography of concerts and plays is planning. Pack light so you're not burdened by equipment, taking along a wide-angle lens and a short telephoto (or a zoom or two that cover both ranges). Use lenses with a large maximum aperture if you have a choice, to better photograph using existing light. If flash is permitted, take one along, but refrain from using it as much as possible, as it can be distracting to both the audience and performers. But if you see that fans (or parents of the performers) are regularly popping off flash pictures, there's no harm in flipping up your D80's flash unit and experimenting with a few flash photos yourself. If you are allowed to use a monopod, one would be helpful for steadying your camera for slightly longer exposures under available light. Dress rehearsals can be a nonstressful venue for photography of dramatic performances.

7.22 Look for a pivotal scene in a play for a good photo that tells a story of its own.

Concert and theatre photography practice

7.23 A jazz violinist concentrates on his solo in this live concert shot.

Table 7.6
Taking Pictures at Concerts and Theatre Pictures

Setup	**Practice Picture:** A second-row aisle seat on the right side of the stage is my favorite perch at the theatre where I took the picture shown in figure 7.23. I had a good view of all the performers in the folk/jazz group, including the virtuoso violinist who punctuated his playing with fiery solos.
	On Your Own: A close vantage point at a concert or play provides a good perspective, but it is usually too low. Back up a little and use a slightly longer lens so you can isolate one performer at a time.
Lighting	**Practice Picture:** For this picture, I needed only the stage lighting used at the concert, which is invariably more natural looking than direct flash. In this case, the spotlight had a slightly reddish cast.
	On Your Own: Lighting at concerts and plays is varied throughout the performance to best suit the mood, ranging from big bright lights to more subdued illumination with colored gels to create a particular effect. Regardless of the intensity, however, the lighting generally has high contrast.

Lens	**Practice Picture:** I used an 85mm f/1.8D AF Nikkor at f/11.
	On Your Own: You can use a zoom lens at stage productions that have bright lighting, but you often get better results with fast fixed focal length lenses that you can use almost wide open to allow faster shutter speeds when you're not going for the blurry effect I was looking for in the practice picture. Vibration-reduction lenses like the 18-200mm f/3.5-5.6 G ED-IF AF-S VR DX Zoom-Nikkor are also a good choice if you can't use a monopod to steady your camera.
Camera Settings	**Practice Picture:** I used Shutter Priority AE mode. I set the white balance to tungsten. By controlling the shutter speed, I was able to set a 1/30 second speed that allowed the violinist's hands and bow to blur. His face remained sharp because only his hands and arms were in motion, and I mounted the D80 on a monopod to prevent camera shake.
	On Your Own: Usually, you want to control the depth of field, so switch to Aperture Priority AE mode, select the f-stop you want to use, and set the white balance to the type of light in the scene. If the light is low, switch to Shutter Priority AE mode and specify the slowest shutter speed you feel comfortable with.
Exposure	**Practice Picture:** ISO 400, f/11, 1/30 second.
	On Your Own: Concerts usually call for higher ISO ratings, and the D80 provides decent results at ISO 400 to ISO 800. You might need ISO 1600 in very low light or when you're using a longer lens and want a higher shutter speed. Use slower shutter speeds to allow musicians' hands to blur slightly, as in the practice photo. Experiment with different shutter speeds to get different looks.
Accessories	If monopods are permitted, take one along to help steady your camera for exposures that are longer than 1/200 second — or even for faster shutter speeds with longer lenses.

Concert and theatre photography tips

✦ **Arrive early.** Even if you have a backstage pass, security can be tight at some concerts. Show up when the equipment is being unloaded to scout the area (and become one of the "gang," which makes it easier to blend in during the actual performance).

✦ **Arrive very early.** You might be able to show up the day before a performance. Sometimes I am able to attend a dress rehearsal of a play, and use the opportunity to take photos from a variety of angles without worrying about disturbing and audience. Then, I come back for an actual performance, better equipped to know when crucial moments of the play or musical will take place.

✦ **Change your angles.** Don't plant yourself right in front of the stage. Move around and take shots from high vantage points and unusual angles.

✦ **Use center-weighted or spot metering.** Your D80 may do a better job if you switch from matrix metering to center-weighted or spot metering, and lock in exposure on your subjects.

✦ **Watch for light changes.** It's very common for the light to change dramatically during the course of a show, from bright white spotlights to blue or red key lights to set a mood. Each individual performer may be lit differently, too, perhaps with a stronger light on a musician performing a solo, and lights at a lower level or of a different color on the other performers. Even if you're using automatic exposure, be prepared to adjust your settings as the evening goes on.

Event Photography

Special events are great fun on two levels. County fairs, parades, festivals like Mardi Gras, classic car exhibitions, wedding celebrations, and air shows always have a lot going on that is fun to participate in. But for the photographer, these events offer a cornucopia of photo opportunities, concentrated in a few hours, spread over a day or two, or even lasting a week for the larger festivities.

But these events don't have to be mammoth extravaganzas. Your company's annual picnic at a local amusement park, a tailgate party before the biggest football game of the year, or even a traveling art exhibit can be a special event worth of photo coverage. There is color, maybe some costumes, exhibits, participants and spectators, and probably some great opportunities such as demolition derbies or livestock exhibits. You get the chance to photograph exotic automobiles or aircraft, too, up close and from unusual angles, as shown in figure 7.24.

7.24 Air shows provide the opportunity to photograph impressive aircraft up close and from unusual angles.

Try to take photos that capture the theme of the special event. Show the overall event and its environment; picture the people, capture an awards ceremony, and get close-ups of the automobiles, airplanes, or crafts on display. Your photos should tell a story and help the viewer understand the event itself. Most daylong (or longer) events have a schedule, often available from the promoter's Web site, that you can use to plan which things you want to see, and map out the logistics for seeing them.

Inspiration

7.25 A 12–24mm zoom lens at its widest focal length offered this distorted — but interesting — view of a classic automobile.

Try to come up with new uses for your event photos. Create slide shows, albums, Web pages with event pictures on display, or historical collections showing the same event over a period of years. Many events have such broad appeal that you'll find a broad audience for your photos if you use a little imagination in developing ways to distribute them.

Indeed, event photos become even more interesting as the years pass, because they document our life and times, preserving details that we might not notice now, but which become precious memories in the future. Outdoor musical performances today are dramatically different from those in the late 1960s, as are the clothing worn by the performers and spectators. Photos you take today may capture the equivalent of leisure suits or disco attire from 30 years ago. You can capture your event photos today, but they'll be preserved for posterity and appreciation when you're older, or for sharing with your children or grandkids.

You may find that others want to share your event photos, too — even people you don't even know. A whole mini-industry of "event photography" has developed, with enterprising photographers setting up laptops and portable photo printers at specific affairs such as weddings, class reunions, or (with the permission of the performers) stage productions. Photos taken on the spot can be downloaded to the laptop, printed, and distributed immediately. Consider providing this service gratis to family or friends, or even try making a few bucks. If you like sharing your photos, event photography is a dream situation.

Event photography practice

7.26 This ride at a county fair took on a mystical air after dark, and its bright lighting and colorful decorations were dramatic.

Table 7.7
Taking Event Pictures

Setup	**Practice Picture:** The huge Pharaoh's Rocking Ship ride, shown in close-up in figure 7.26, was somehow trucked in a county fair near me. After dark, its festive lights and colorful decoration took on a mystical quality. I was seated at a table next to an elephant-ears food trailer when the ride paused and I shot this photo from 50 feet away. I waited until the ride had stopped, because there wasn't enough light to use a fast shutter speed.
	On Your Own: If a particular outdoor event has activities extending from full daylight to after dark, you'll be rewarded if you stick around for the late-evening happenings. Interesting displays, rides, or things like a county fair's midway are transformed when the sun goes down and the lights come on.

Lighting

Practice Picture: The illumination that bedecked the pharaoh's head provided most of the light required for this photo, but there was enough light spilling into the scene from the surrounding midway to fill in the shadows just a little.

On Your Own: The natural lighting at most events provides a look that's consistent with the event itself, especially after dark when the illumination is sometimes garish and filled with color. You wouldn't like that kind of lighting when shooting a portrait, but it's perfect for gala outdoor events.

Lens

Practice Picture: 28–200mm f/3.5–5.6G ED-IF AF Zoom-Nikkor set to 200mm.

On Your Own: Travel light at most events, so a single lens that has a variety of focal lengths from wide to medium-long can eliminate a lot of lens swapping. The 18–135mm f/3.5–5.6G ED-IF AF-S DX Zoom-Nikkor or 18–200mm f/3.5–5.6 G ED-IF AF-S VR DX Zoom-Nikkor with vibration reduction are also good choices.

Camera Settings

Practice Picture: Shutter Priority AE mode. The white balance was set to tungsten. This exposure mode let me use the slowest shutter speed I felt I could use with my D80 steadied by a monopod, thereby improving the depth of field.

On Your Own: If you want to control the depth of field tightly, switch to Aperture Priority AE mode and set the white balance to the type of light in the scene. If the light is low, switch to Shutter Priority AE mode, as I did.

Exposure

Practice Picture: ISO 800, f5.6 1/30 second

On Your Own: Nighttime events usually call for higher ISO ratings, and the D80 does provide acceptable images at settings as high as ISO 800. Don't rule out ISO 1600 in very low light or when you need faster shutter speeds. A monopod, like the one I used, can steady the camera to make it possible to use slower shutter speeds.

Accessories

A tripod isn't practical at most events, because the events are crowded, you move around a lot, and there may be scant space to set up a three-legged camera support. On the other hand, a monopod is compact and has a very small "footprint" while shooting and is extremely portable. You might have some limited use for flash, either as the main illumination or for fill flash during the day, so either use the D80's built-in strobe or bring along a detachable external flash unit.

Event photography tips

✦ **Ask for permission before photographing adults or children at most events.** A smile and a gesture or a nod is usually all you need to gain the confidence of your photo subject. But it's always best to explicitly ask for permission from a parent or guardian before photographing a child.

✦ **Get there early.** As with concerts and plays, do yourself a favor by showing up early enough to scout around, get the lay of the land, and locate the best spots for photography. Just don't get in the way of event workers who are setting up equipment or displays, or making last-minute touch-ups on their automobiles or aircraft.

✦ **Most events look best photographed from a variety of angles.** Don't waste your time in the front row of a performance; you can take the most interesting photos at the sides of any stage. Nor should you remain stuck at street-level for a parade, or around the barbeque grill at a tailgate party. Roam around. Shoot from higher vantage points and from down low. Use both wide-angle and telephoto lenses.

✦ **For outdoor events, plan for changing light conditions.** Bright sunlight at high noon calls for positioning yourself to avoid glare and squinting visitors. Late afternoon through sunset is a great time for more dramatic photos. Night pictures can be interesting, too, if you've brought along a tripod or monopod, or can use flash.

Fireworks Photography

The Chinese invented fireworks more than 2,000 years ago as a way of frightening evil spirits, and the country ships more than 6 million cases of pyrotechnic devices to the United States annually. Fireworks exhibitions abound every Fourth of July, just as they were used to celebrate the very first Independence Day. If you want to photograph fireworks, you don't need to wait for July, however. They're frequently set off on New Year's Eve, at the close of many amusement parks, and after baseball games during summer "fireworks" nights.

While you can easily photograph fireworks at any time of year, summer is often the best time to shoot them, because the warm weather makes the outdoor wait for the display a comfortable and pleasurable experience, and the summertime exhibitions are usually longer, larger, and more colorful.

It might not have occurred to you, but fireworks are a special kind of photographic subject, because they not only create the light for the exposure, but also they are the subject itself. As fireworks explode, the points of light they create are the only thing bright enough to register with your sensor during an exposure of several seconds, so the display creates an interesting kind of light trail. (You can find more on photographing other types of light trails later in this chapter.)

The only thing you need to photograph fireworks is your D80, a tripod for steadiness, and, if you want to eliminate possible camera

shake, either the ML-L3 wireless infrared remote control or the MC-DC1 wired remote. Find a good place to stand, set up, and you can take interesting photographs of bursts like the one shown in figure 7.27.

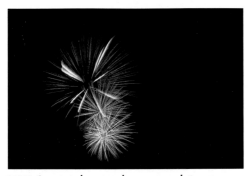

7.27 A several-second exposure lets you capture multiple bursts in a single shot.

Inspiration

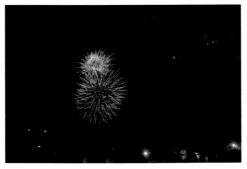

7.28 Using a slightly wider focal length made it possible to capture the fireworks, the crescent moon (upper right), and the spectators (bottom).

Shooting fireworks is an exercise in contrast and colors, with the vivid bursts appearing especially dramatic against the dark night sky. Mix up your images; take a few of just one or two exploding skyrockets (so you can combine them later in your image editor) and leave your shutter open for a longer period to capture multiple cascading bursts in one shot.

You usually don't have time to move to a different location once the show begins, so scout around for a good spot early. Take along a folding chair for each member of your party or perhaps a blanket to sit on. It helps if you've viewed fireworks at a particular location in previous years; I have a few favorite spots for local displays, but tend to relocate to a slightly better position each year based on my experiences the year before.

Once you've got the camera positioned to take in the area of the sky where the displays appear, you don't have to change the focal length of the lens or focus, other than making a few small adjustments in framing after the first few shots. Monitor your exposures on the D80's LCD, too, so you can make manual adjustments if your initial exposure guess was off. Make sure long exposure noise reduction is turned off: Noise itself doesn't detract much from these shots, and the processing delay while the camera applies this extra step might cause you to miss a burst or two.

I've found that once I've set up the camera properly, all I have to do is trigger the shutter using the wired remote, and I can sit back and enjoy the actual fireworks display rather than see it through a viewfinder.

Fireworks photography practice

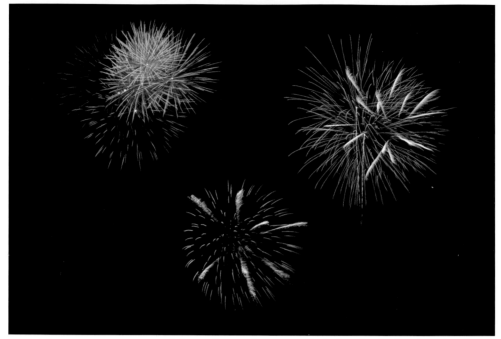

7.29 A long exposure captured the outbursts that erupted during the finale of a July 4th fireworks extravaganza.

<table>
<tr><td colspan="2" align="center">Table 7.8
Taking Fireworks Pictures</td></tr>
<tr><td>Setup</td><td>**Practice Picture:** I intentionally arrived at a fireworks display an hour early so I could choose a prime location on a small hill at the edge of a stand of trees. I was elevated over the crowd for a perfect view, and didn't have to worry about obstructing the view of anyone seated behind me as I took the image in figure 7.29.</td></tr>
</table>

Setup	**Practice Picture:** I intentionally arrived at a fireworks display an hour early so I could choose a prime location on a small hill at the edge of a stand of trees. I was elevated over the crowd for a perfect view, and didn't have to worry about obstructing the view of anyone seated behind me as I took the image in figure 7.29.
	On Your Own: There are many different "best" locations for shooting fireworks. You can position yourself fairly close to where the fireworks are launched, so you can point the camera straight up and capture the streaks and flares with a wide-angle lens setting. Or, you can locate yourself a half-mile away, and capture the show with a telephoto setting. If your location provides an interesting foreground (a city skyline, a river, trees, or other scenic marvel) so much the better.

Lighting	**Practice Picture:** The fireworks themselves provide the illumination.
	On Your Own: Avoid getting streetlights, lights from buildings or parking lots, and other distracting illumination in your photo. Extra lighting can cause flare in your images.
Lens	**Practice Picture:** 28–200mm f/3.5–5.6G ED-IF AF Zoom-Nikkor set to 28mm.
	On Your Own: Unless you're very far away, you usually need a wide-angle lens to catch the area of the sky that's exploding with light and color. You can even use a fish-eye lens to interesting effect.
Camera Settings	**Practice Picture:** RAW capture. Manual exposure, with both shutter speed and aperture set by hand. Manual focus on infinity. Saturation set to Enhanced.
	On Your Own: Depth of field and action stopping are not considerations. As I mentioned earlier, be sure to turn off Long Exposure Noise Reduction; the extra time the reduction step takes can cause you to miss some shots.
Exposure	**Practice Picture:** ISO 200, f/11, 30 seconds.
	On Your Own: Don't try to rely on any auto exposure mode. Your best bet is to try a few manual exposure settings and adjust as necessary.
Accessories	A steady tripod is a must. Use an infrared remote control or wired remote to trip the shutter. You also should have a penlight so you can locate the control buttons in the dark! Carry an umbrella so your camera doesn't get drenched if it rains unexpectedly. I have a small camera bag with a "raincoat" that unfolds from the back and securely shields its contents from even the worst downpours. Regardless of the expected weather, all my camera bags have compact emergency disposable rain ponchos, no larger than a folded handkerchief, which I buy for less than a dollar from the camping department of a local discount store.

Fireworks photography tips

✦ **Don't forget the tripod.** A mono-pod won't work, as fireworks expo-sures usually require at least a second or two to make. Set up the tripod and point the camera at the part of the sky where you expect the fireworks to unfold, and be ready to trip the shutter.

✦ **Do a quick review.** Check your first few shots on the D80's LCD to see if the fireworks are too light, too dark, or in proper focus (set your lens to infinity). Decrease the initial f-stop if the colored streaks appear too washed out, or increase the exposure if the display appears too dark. Experiment with different exposure times to capture more or fewer streaks in one picture

✦ **Visually track the skyrockets.** Watch the fireworks in flight so you can start your exposure just before they reach the top of their arc and explode. At the right instant, trip the shutter for an exposure of one to four seconds for single displays, or longer exposures for a series of bursts.

✦ **Use your camera settings creatively.** Lower ISO settings allow longer exposures and provide the best image quality. But, you can also use higher sensitivity settings for smaller f-stops. If there are other lights in the image (such as lights on buildings in a skyline) the smaller f-stop can create a star effect that's interesting.

Flower and Plant Photography

Flower photography is a year-round endeavor that many Nikon D80 owners find especially rewarding. There are thousands of different varieties of flowers, and each bloom has its own special qualities of shape and color. Flowers and plants can be photographed from many different angles, and, unlike human subjects, they wait patiently as you set up your camera and adjust lights. Flowers and plants come in many colors, too, so you can mix and match different species to create a colorful rainbow of hues.

You can find suitable subjects anywhere: In your own backyard, in public parks, or even in a nearby pond, where you might find lily pads floating on the surface of the water.

Although some photographers specialize in flower photography, many of us turn to shooting blossoms when we have nothing else to inspire us or need a creative spark. Certainly, the fresh flowers of springtime, the mature blooming plants of summer, and the last bursts of color in the fall can be invigorating, but there's no need to eschew flower photography in the dead of winter. You can drop by your local florist and purchase a bouquet, a blooming plant, or selected individual flowers to brighten your home as well as your photographic efforts.

Public gardens, greenhouses, and herbariums are also open year round. If you read your newspaper, you can find dates for exhibits and flower shows that are an opportunity to shoot digital portraits of some of the most beautiful living things.

Inspiration

You can exercise your creative talents to the utmost when using flowers as your subjects. You can apply the compositional techniques I describe at the beginning of this chapter — using shapes, lines, balance, framing, placement, and other techniques — successfully to flower photography. You can use creative lighting, photograph individual blooms, or collect several of them together in a group portrait.

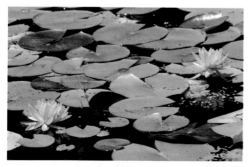

7.30 You can find wildflowers everywhere, including floating on the surface of a rural pond.

Extreme close-ups can produce abstract images, or reveal intimate aspects of blos-

soms that can't be seen with the unaided eye. You can photograph several flowers together with just about any lens, or resort to a close-focusing macro lens or add close-up attachments to your existing optics to capture fine detail.

Flower photography has its own set of challenges. Outdoors, the most vexing obstacles are gusts of wind. You carefully focus on a particular blossom, start to press the shutter release button the rest of the way, and find that a sudden breeze has spoiled your composition and changed the plane of focus. Although there are wind shields you can buy for flower photography, you can just as easily make your own out of rigid foamcore board. Leave one side white (which makes it possible to use the board as a reflector to add a little kick of light to your subjects) and, if you like, paint the other side black or dark gray when you want to block the wind, but don't want to add light to the shadows.

7.31 The vivid crimson hues make this blossom stand out.

You may want to work with a tripod, too, to help you lock in your composition and focus, and free your hands to arrange or re-arrange the blossoms in your photos. A tripod also allows you to work with slower shutter speeds and smaller lens openings to increase depth of field (assuming you've got the breeze problem licked).

Flower and plant photography practice

7.32 Flowers themselves can make a great background for your photos, if you allow the blooms behind your main subjects to go out of focus.

Table 7.9
Taking Flower and Plant Pictures

Setup	**Practice Picture:** I wanted to show off a lush flower bed, so I positioned the camera on a tripod above these blooms, focusing on the flower at center-right in figure 7.32. The flowers behind served as a backdrop.
	On Your Own: It's tempting to shoot down on flowers, to better capture those opulent blooms (as in this case). But you can also get interesting views by getting down and looking at the plant from its own level, or by shooting upward to include a contrasting blue sky in the image. Don't be locked into one position, and thus limit your creative possibilities.
Lighting	**Practice Picture:** I waited for a slightly overcast day with no breeze, so I could capture these flowers in a softer light.
	On Your Own: Full sunlight brings out the brightest colors and adds contrast that highlights detail, but also produces dark shadows. You may need reflectors to soften the light, or fill flash to illuminate the shadows. Use the diffuse light of overcast days for a softer look, but keep in mind that the colors will be muted. You might need to adjust the saturation in the D80 or your image editor.
Lens	**Practice Picture:** 105mm f/2.8D AF Micro-Nikkor.
	On Your Own: Although I used the older model of Nikon's telephoto macro lens, the newer 105mm f/2.8G ED-IF AF-S VR Micro-Nikkor has some significant advantages, including its vibration reduction feature that reduces the need for a tripod. Unlike shorter focal length lenses (like the 60mm f/2.8D AF Micro-Nikkor), which exaggerate the proportions of parts of the flower closest to the lens, a telephoto macro lens lets you step back, and throws the background out of focus. A close-focusing telephoto in the 100mm range also works well.
Camera Settings	**Practice Picture:** Aperture Priority AE. The white balance was set to Auto. Color saturation set to Enhanced. Manual focus used to prevent camera from locking in on foreground flowers at the bottom and left of the frame.
	On Your Own: For all types of close-up photography, you usually want to select the aperture yourself, either to control depth of field for selective focus effects, or to increase it to bring more of the frame into sharp focus.
Exposure	**Practice Picture:** ISO 100, f/5.6, 1/200 second.
	On Your Own: A sensitivity setting of ISO 100 is a good starting point for most outdoor lighting conditions. You can increase the setting if you find you need a faster shutter speed or more depth of field. To blur the background, start with an f/5.6 aperture. For more generous depth of field, use an f/8 or f/11 aperture.
Accessories	In addition to a tripod, you want to have either the Nikon ML-L3 wireless remote control or MC-DC1 wired remote cord to release the shutter without shaking the camera. You can also use the D80's self-timer.

Flower and plant photography tips

✦ **Rely on manual focus.** Autofocus is great, but your D80 isn't smart enough to know exactly what portion of a flower you want to focus on. There are situations where you want to focus on the center of a blossom, and the camera might tend to focus on the closest petal instead. You can manually select the autofocus area, of course, but with a nonmoving subject, it's usually quicker to switch into manual focus mode and set your plane of focus by hand.

✦ **Use the depth-of-field preview.** Hand-in-hand with setting focus manually is using the DOF (depth-of-field) button to preview the range of focus before you take the photo. At macro focusing distances, what you see through the viewfinder (with the lens wide open) can be dramatically different from what you get with the lens stopped down (using the DOF preview).

✦ **Increase saturation.** Boost the richness of the colors by visiting the Shooting menu and setting the saturation to Enhanced under Optimize Image. If the sky appears in your photos, use a polarizing filter to add saturation to the flowers and sky.

✦ **Experiment with lighting.** Simply changing your position can alter the lighting dramatically. You can use reflectors and (indoors) lights of your own. Backlighting can be especially interesting to show off translucent petals and leaves.

Infrared Photography

Infrared (IR) photography is an amazing way of taking eerie, other-worldly photos that show objects in a new light — literally. IR photography with the Nikon D80 uses a special filter to emphasize the *near infrared* portion of the spectrum (although some visible light sneaks through) when making exposures.

Subjects are reproduced with tones that depend on how much IR illumination they reflect, which create images with very light foliage, dark skies with fluffy white clouds, and other effects. The strange images result from the tendency of plant life to reflect IR light extremely well, while the sky doesn't reflect much IR at all.

Because of the stunning effects it creates in landscape images, IR photography is most often used for scenic pictures. Filtering out most of the visible light also means that you need to shoot IR pictures with the D80 mounted on a tripod, and, for the most part, shoot blind. That's a hefty price to pay, but one that is well worth it once you see the unusual images you end up with.

IR photography requires a bit of technical skill, and tweaking of the D80's white balance controls. For example, your shots will have a reddish cast to them (see figure 7.33), but you can eliminate that by converting the picture to grayscale or by isolating the red channel in your image editor, or by changing to a preset white balance as I describe in Chapter 3.

7.33 With the white balance set to daylight, IR photos typically display a strong reddish cast.

You don't need a lot of special equipment. An IR filter is required, such as a Hoya R72 or Wratten #89B, and you must use a tripod for the long exposures (frequently four seconds or more) that IR photos call for.

Inspiration

Landscape photos are traditional fodder for IR photography, because such images are static and call for setting up the tripod, composing the image through the viewfinder, and then attaching the IR filter (which makes D80's viewfinder appear totally black). However, there are plenty of other subjects for IR photography, including architecture, portraits (IR photography tends to smooth out complexions), and pictures taken by candlelight.

Compare figure 7.34 with another shot of the same structure in figure 7.15 to see the difference between IR photography and traditional full color imaging. For figure 7.34, I adjusted white balance by pointing the D80 at the grass and using the preset white-balance facility (described in Chapter 3) to eliminate the reddish cast and create a more off-beat color-but-not-color IR picture. You can also reduce IR pictures to straight grayscale images if you like, or capture false-color IR pictures with *channel swapping* in your image editor (as detailed later in this section).

IR photography can be especially interesting as a photojournalism tool because its grainy look, black-and-white tones, and motion blur add an artful look. With the odd tonal shifts, common subjects take on unusual looks that you can use creatively. Some things appear to be darker in an IR photo than you might expect, while others are lighter.

7.34 The church originally pictured in figure 7.15 assumes a more metaphysical aspect in this IR photo.

Infrared photography practice

7.35 Interesting IR pictures can be as close as your backyard, as you can see in this false-color IR photo.

Table 7.10
Taking Infrared Pictures

Setup	**Practice Picture:** I wandered out into my own backyard one late summer day when wispy clouds formed patterns in the sky as shown in figure 7.35. I set the camera up on a tripod, carefully composed my image, and then mounted my Hoya #72 IR filter.
	On Your Own: Find subjects outdoors with a lot of foliage and grass to make the most of the dramatic pale look that IR photography provides.
Lighting	**Practice Picture:** Daylight illumination.
	On Your Own: Brightly lit days are best for outdoor IR photography, but you can also get good results on slightly foggy days, too, because IR illumination cuts right through the haze.

Continued

Table 7.10 *(continued)*

Lens	**Practice Picture:** 12–24mm f/4G ED-IF AF-S DX Zoom-Nikkor set to 12mm to exaggerate the foreground, making the yard (which is about an acre in size) look even larger.
	On Your Own: Unfortunately, you may find your choices of lenses limited by the need to have an IR filter for each lens. The Nikon 12–24mm zoom uses an expensive 77mm filter, but many other Nikkors accept 52mm, 62mm, or 67mm filters. You can buy a single 67mm filter for, say, the 18–135mm f/3.5–5.6G ED-IF AF-S DX Zoom-Nikkor and use it with a step-down ring or two (available at camera stores for about $10) so it can be mounted on lenses that use the smaller 62mm or 52mm filter size. If you can live with using just one lens, the 18–55mm f/3.5–5.6G ED II AF-S DX Zoom-Nikkor uses relatively inexpensive 52mm filters.
Camera Settings	**Practice Picture:** I used RAW capture and manual exposure. I set white balance manually using the D80's Preset capability. Instead of pointing the camera at a neutral gray or white subject, use the grass or trees.
	On Your Own: Manual exposure and manual bracketing (use several different exposures, such as one second, two seconds, and four seconds) make it easier to get the correct settings. Review your images on the D80's LCD, and then adjust for subsequent exposures.
Exposure	**Practice Picture:** ISO 200, f/11, 8 seconds.
	On Your Own: Increase the ISO setting to allow shutter speeds within a range of a few seconds. Otherwise, moving objects such as tree branches or clouds can blur.
Accessories	A tripod is essential for IR photos.

Infrared photography tips

✦ **Use channel swapping for false color infrared.** It's easy. In Photoshop, use the Channel Mixer to set the Red Channel's Red value to 0 percent and its Blue value slider to 100 percent. Then switch to the Blue channel and set the Red slider to 100 percent and the Blue slider to 0 percent. That's all you need to do.

✦ **Bracket exposures.** Even small exposure increments can change an IR photo dramatically. Set your basic exposure, say f/11 at 4 seconds, then shoot additional pictures at 1, 2, 8, and 12 seconds.

✦ **Use motion blur creatively.** The long exposures needed for infrared photos can be used creatively. Waterfalls take on a satiny texture with exposures of one second or longer. People walking and vehicles driving past blur in an interesting way. Use a small f-stop and a very long exposure (perhaps 30 seconds), and those moving subjects may vanish entirely, turning your urban IR scene into a ghost town!

Lighthouse Photography

I love lighthouses. You can find these beacons for navigation on every coast where ships sail, including the shores of the Great Lakes in the United States. If you don't happen to live within driving distance of a lighthouse, they are usually worth a special trip, because they are one of the most emblematic and iconic structures in existence. Many businesses, including the Scripps Howard News Service, use a lighthouse in their logo. A photo of a lighthouse automatically invokes a maritime experience, even if the structure itself happens to reside on a tall hill a hundred yards away from the sea, as it does in figure 7.36.

I've photographed lighthouses all over the world, including the Tower of Hercules, a second-century Roman lighthouse on the shores of the Atlantic Ocean in A Coruña, Galicia, Spain. The Spanish word for lighthouse is *faro*, from the ancient Lighthouse of Alexandria (Egypt) on the island of Pharos. The study of them even has a name: *pharology*.

Today, these worthy subjects come in all shapes, sizes, and heights. Some are ancient, some have been built more recently, and all share one common aspect: At night they produce a brilliant light that ships can see for many miles. In the United States, lighthouses still in operation are maintained by the U.S. Coast Guard. Many historic lighthouses are open for tours by the public.

It's easy to fall into photographing lighthouses as a hobby, trying to take pictures of as many different beacons as possible, from many different angles, and during many different times of year.

7.36 This 69-foot sandstone lighthouse dates back to the Civil War and stands on a hill overlooking Lake Erie.

Inspiration

7.37 This more recent lighthouse was built in 1925 and stands at the end of a break wall.

You may be lucky enough to live near historical lighthouses and not know it. There are 17 along the shores of Lake Erie alone, stretching from Detroit, Michigan, through Pennsylvania and into New York State. Along the East and West coasts of the United States, as well as the Gulf Coast in the South, there are dozens more.

If you set out to capture a memorable lighthouse photo, Google is your best friend. You can use the search engine to locate potential beacons for your photography, with many links to Web sites specifically set up

for these shore-side attractions. A little research is important, because some lighthouses are of recent vintage and not particularly photogenic, others are not open to the public, and a few have seasonal or limited hours.

I actually try to visit some of the more historic lighthouses when they are closed because that is the best time to capture them without swarms of tourists clustered around their bases or gawking from the look-out railings at the very top. My usual plan is to visit the tower mid-week late in the afternoon before it closes for the day, so I can climb to the top (if permitted) and shoot pictures from the viewing area. Then, when the lighthouse is locked up tight and most of the visitors leave, I set up and photograph the structure from a variety of angles.

In Northern climes, I find there are several times of year when it's best to photograph lighthouses. Mid-September, when the kids have gone back to school but before the leaves have begun to change colors, is good for summery-looking photos. Two or three weeks later, it's usually possible to photograph a lighthouse surrounded by the hues of fall (if it's positioned in a leafy locale). Spring is also good. At these times of year, the sun sets a few hours earlier than in the summer, so by 6 or 7 p.m. the crowds have left and the lighting is most dramatic.

Lighthouse photography practice

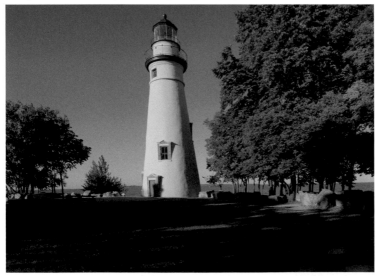

7.38 Built in 1821, this is the oldest continuously operating lighthouse on the Great Lakes.

Table 7.11
Taking Lighthouse Pictures

Setup	**Practice Picture:** After taking photos of a Civil War reenactment during the first week of October, I jumped in my car and drove 40 miles to this historic lighthouse, arriving just in time to see most of the visitors depart. I set up a tripod and timed my photos for periods when the remaining stragglers walked around to the other side of the structure or were otherwise not visible in the picture, and took the image shown in figure 7.38.
	On Your Own: Explore all sides of a lighthouse to find the best angle, which is usually one that shows the ocean, sea, or lake in the background. But don't overlook less obvious vantage points, including those from the caretaker's home (which is often a short distance from the lighthouse), from down on the shore itself, or even from the top of the tower.
Lighting	**Practice Picture:** I intentionally waited for early evening to shoot this picture because I wanted the dramatic lighting and shadows of late in the day.
	On Your Own: Earlier in the day the lighting may be too bland, especially in summer. You usually want to avoid overcast days because the shadows and shading of the direct sunlight add to the dramatic look.
Lens	**Practice Picture:** 12–24mm f/4G ED-IF AF-S DX Zoom-Nikkor set to 24mm to exaggerate the foreground.
	On Your Own: Lighthouses that are surrounded by other structures may require a wide-angle lens so you can take in the tower itself without other distracting elements. Avoid tilting the camera back to take in the top of the tower, or you can expect a little perspective distortion, which is visible in the practice photo even though I stood back 60 feet from the lighthouse.
Camera Settings	**Practice Picture:** RAW capture. Aperture Priority AE exposure. Saturation set to Enhanced.
	On Your Own: You can shoot lighthouses with the D80 handheld, but if you prefer a tripod for scenic photos, as I do, select Aperture Priority mode and choose your lens's sharpest f-stop to preserve details. Then let the D80's exposure system adjust the shutter speed as appropriate. The tripod assures a shake-free, tack-sharp image regardless of the shutter speed you choose.
Exposure	**Practice Picture:** ISO 100, f11, 1/200 second.
	On Your Own: Lighthouses are often light in color, so make sure you expose for the tower itself to preserve detail. That allows less-illuminated surroundings to register as slightly darker, producing a framing effect.
Accessories	A tripod is certainly optional in bright daylight, but by late afternoon a camera support can give you an edge when you're shooting this type of scenic or any landscape-style photograph. A polarizing filter is a good accessory to have to help darken the sky and reduce reflections.

Lighthouse photography tips

✦ **Learn to use your image editor's perspective correction tools.** It's almost impossible to avoid that tilting-back look if you must shoot from fairly near the lighthouse. If you can step back some distance, you can sometimes take pictures with the back of the camera held parallel to the tower. If not, use your image editor's perspective controls to straighten out the lighthouse.

✦ **Use windy days and rough seas.** If you're going to include the surrounding water in your photos, rough seas (for lighthouses on ocean shores) or windy days (for beacons located on the Great Lakes) add some motion to your "oceans." Just remember that rough weather often follows rough water.

✦ **Explore the lighthouse keeper's residence, and other perspectives, too.** Not all your lighthouse photos have to be of the lighthouse itself. You can find some interesting photos at the lighthouse keeper's residence (which might be open to the public at historic lighthouses, because most no longer have a resident keeper) and even inside the lighthouse itself.

Light Trails Photography

Light trails are especially fun to capture, because you never quite know what you are going to get. You can point your camera at just about any subject with its own illumination, take a photograph at an exposure of anywhere from 1/30 second to a minute or more, and then examine your results. If the picture looks good, you can save it and tell everyone "I meant to do that!" and congratulate yourself on your artistic sensibilities.

Indeed, I recently mounted a fish-eye lens on my D80 while riding home from a shopping mall. I put the camera on a monopod to provide a degree of steadiness, set the shutter speed for several seconds, and snapped photos out of the car window. I took shots of the taillights of the cars ahead of us, some of oncoming headlights, and more than a few out the side window, producing colorful streaks like you see in figure 7.39. In the course of 30 minutes, I took several hundred pictures, and ended up with a dozen that I thought were interesting.

The cool thing about light trail photography is that the light itself becomes your subject. Every point of illumination writes its own "path" on the sensor. You can lock down the camera on a tripod and shoot a fixed scene (say, a town's Main Street after dark) with only the lights of moving cars forming trails. Or, you can move the camera itself to create trails from a stationary light source.

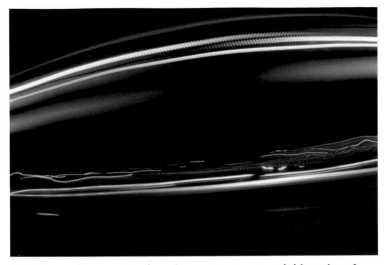

7.39 As we drove past a shopping center, I captured this series of light streaks with a four-second exposure, with the D80 on a monopod to provide a modicum of steadiness.

Inspiration

Let your imagination run free in transforming any type of illumination into your own personal drawing-with-light tool. All you need is a dark background and either a moving camera, moving lights, or both, to produce interesting light trails.

For example, you can mount the camera on a tripod, focus sharply on some interesting lights (a neon sign, holiday lights, or the lights of a building), choose an exposure of several seconds, and then press the shutter release down fully. Allow the image to record for about 25 to 50 percent of the full exposure (I count off one-Mississippi, two-Mississippi ...), then carefully rotate the zoom ring. You get different results when you start the zoom at the maximum focal length, and then zoom in, than when you shoot the picture using the reverse strategy. Try both.

Another favorite technique of mine is to point the camera at a busy street, use a low ISO setting (such as ISO 100), a small f-stop,

and set the exposure for 30 seconds. All sorts of interesting and unpredictable photos result. If traffic lights are in the frame, you can end up with a picture showing red, yellow, and green lenses illuminated on two sides facing the camera. Automobiles that stop for a red light appear in the photo more clearly than those that were just passing through. Pedestrians might be entirely invisible, unless they stopped moving during the exposure long enough to register.

7.40 I mounted the camera on a tripod and zoomed during the long exposure to create this moving image.

Light trails photography practice

7.41 A rotating amusement ride at a county fair created this interesting trail of lights.

Table 7.12 Taking Light Trail Pictures	
Setup	**Practice Picture:** After the demolition derby was finished at our county fair, the rides on the midway really got into swing, and I realized that the "rotor" type ride shown in figure 7.41 would produce some excellent light trail images. I have a lightweight tripod that's not especially sturdy, but it is compact enough to drag along almost anywhere, so I broke it out, set it up, and began taking photos of the light-bedecked amusements.
	On Your Own: A tripod is essential for light trail photography only if you want to exclude camera shake from your light trails. Some kinds of trails are just as interesting — or more so — when it's the camera that's moving.
Lighting	**Practice Picture:** The lights on the ride themselves provided all the light the illumination needed.
	On Your Own: This is another type of photography that doesn't require you to make many lighting decisions.

Lens	**Practice Picture:** 85mm f/1.8D AF Nikkor.
	On Your Own: The lens you use depends on the distance between you and your subject, and whether you want to use distortion (produced by, say, a fish-eye lens) as a creative element. I was working with a fast prime telephoto lens while roaming the county fair, and had enough room between me and the ride to use it for the practice picture. In general, though, light trails pictures don't require a fast aperture, because long exposures will be part of your shooting technique.
Camera Settings	**Practice Picture:** RAW capture. Manual exposure, with both shutter speed and aperture set by hand. Saturation set to Enhanced.
	On Your Own: Depth of field and action stopping are not generally considerations for light trails photography.
Exposure	**Practice Picture:** ISO 200, f/11, 4 seconds.
	On Your Own: Don't use autoexposure with light trails pictures; make the settings yourself and adjust them after a few test shots. You can get very different effects by shortening or lengthening the exposure time, so be sure to experiment.
Accessories	For smooth trails of moving lights, a steady tripod is essential. As with fireworks photography (another kind of light trails picture-taking), you want to have a penlight so you can locate your D80's control buttons and dials in the dark.

Light trails photography tips

✦ **Drawing with light.** Set your D80 on a tripod, aim the camera at a very dark area (with no lights or illuminated objects in the background), and then open the shutter for a 30-second time exposure. Then, you or a helper armed with a penlight can move into the camera's field of view and draw light trails of your own devising. You can even write in midair during the exposure, using script letters. Your writing is reversed in the final image, of course, but you can simply flop it in your image editor so that it reads properly.

✦ **Creating suspended animation.** Now tie the penlight on a piece of long cord, suspend it from an overhead tree branch, and place the D80 on the ground, pointing upwards. Start the penlight swinging back and forth, pendulum-fashion, in a pattern. Open the shutter for a few seconds. This records a regular design. When using this or the previous technique, experiment with passing pieces of colored plastic in front of the lens to create multicolored streaks of light.

✦ **Skip noise reduction.** Although you'll take pictures using exposures as long as 30 seconds, don't bother with the D80's Long Exposure Noise Reduction feature. You can work faster, and the noise won't show up once you start adjusting the brightness and contrast in your image editor.

Macro Photography

Want to make it big in photography? Try close-up or macro photography for an opportunity to take small things and make them appear huge, through the magical expedient of magnification. I enjoy macro photography all year round (I have a close-up table set up in one corner of my home studio), but it's especially fun to turn to as a rainy-day activity or during winter when taking photos outdoors is best accomplished in small doses.

One of the best things about macro photography is that you can use just about anything as a subject. Spilled table salt, a crystal vase, a spider web, a hand-worked piece of jewelry, or a common rock can become great objects for photography when you photograph them from inches or a fraction of an inch away. If you have a stamp or coin collection, or like to accumulate pewter soldiers, macro photography can be useful for documentation or insurance purposes, too. Something as mundane as a plant (see figure 7.42) can transform into a mysterious subject when it's photographed from a fraction of an inch away.

You need some special equipment for the most flexibility in shooting macros, but you should not have to spend a great deal of money. Your current lens might focus close enough for macro photos. If not, the 50mm f/1.8D AF Nikkor costs about $100, and you can outfit it with extension tubes or a lens reversing ring that let you focus to within a few inches of your subject with great results. (It's a very sharp lens, too.) You can fit inexpensive filter-like close-up lenses (despite the name, these are not stand-alone optics themselves) to the front of your existing lens. If you really enjoy macro photography and have a few hundred dollars to spend, you can purchase a macro lens, such as the 60mm f/2.8D AF Micro-Nikkor.

7.42 This plant becomes an abstract object when photographed up close.

Inspiration

7.43 Small creatures, many of them less than an inch long, are popular subjects for macro photography.

It's important to keep in mind that magnification, not focusing distance, is paramount in macro photography. That's because the size of the subject in the finished photo is key, not how far you were away when the picture was taken. For example, you might be able to fill the frame with a postage stamp using a 60mm macro lens at a distance of two inches, or take virtually the same picture using a 105mm macro lens from five inches away.

Indeed, macro lenses are often described using the magnification they produce at their closest focusing distance. For example, a lens capable of creating a 1:1 (also known as 1X magnification) image would produce an image that's *life-size*; that is, a subject measuring one-half-inch across would be one-half-inch wide on the sensor. A 1:2 magnification (1/2X) would create an image that's half life-size, and so on.

For flat objects, you probably can't tell which lens or focal length was used. That's not the case with three-dimensional subjects, because the closer you get, the more those parts of the subject that are closer to the lens appear disproportionately large compared to more distant parts of the subject. You might find a longer focal length (say, 105mm instead of 60mm) preferable to avoid this distortion. Plus a longer focal length gives you a greater working distance and more elbow room to light the subject, both of which can be important if you're photographing living creatures.

Macro photography practice

7.44 This doughnut proved to be a patient subject that let me experiment with different lighting schemes. Plus, when I was done shooting, I got to eat it.

Table 7.13
Taking Macro Pictures

Setup

Practice Picture: I swiped my macro subject from the breakfast provisions to produce the close-up photo shown in figure 7.44. When you want to experiment with macro photography, any objects you have lying around, from car keys to edibles, are fair game. I set the doughnut on a piece of seamless white cardboard.

On Your Own: You can use poster board, fabric, or other backgrounds to isolate your macro subjects, and pose them on a tabletop or other flat surface.

Lighting

Practice Picture: I used a pair of Nikon SB-800 electronic flash units, bounced off umbrellas, and triggered by the D80's built-in flash in wireless Commander mode.

On Your Own: You can also use desk lamps to light small setups, with reflectors to fill in the shadows.

Lens

Practice Picture: 105mm f/2.8D AF Micro-Nikkor.

On Your Own: Any macro lens, close-focusing prime or zoom lens, or an ordinary lens on extension tubes or outfitted with close-up attachments can do the job.

Camera Settings

Practice Picture: RAW capture. Manual exposure. Although Nikon's Creative Lighting System and i-TTL flash exposure could have adjusted the flash output automatically, it was just as much fun to set the flash units' output manually and experiment.

On Your Own: If you're using incandescent illumination, use Aperture Priority AE mode and allow the D80 to choose the right shutter speed appropriate for the f-stop you select.

Exposure

Practice Picture: ISO 100, f3/2, 1/200 second.

On Your Own: For maximum depth of field, chose a small aperture such as f1/6 to f/22. If you want to blur the background, choose a wider aperture such as f/8 to f/11. Use ISO 100 for maximum sharpness and the least amount of noise. You don't need higher ISOs when your camera is mounted on a tripod.

Accessories

Use a tripod for macro photography. The Nikon ML-L3 infrared remote or MC-DC1 wired remote cord helps prevent camera shake, but you can also use the self-timer. Set the self-timer for a two-second delay to avoid a longer wait.

Macro photography tips

✦ **Close-up attachments are cheap.** Filter-like close-up attachments that screw onto the front of a lens provide additional magnification and can cost about $50. They do come with a sharpness penalty and, unlike extension tubes, only work with a lens that has a matching filter thread size. If you want to use close-up attachments with lenses having different filter sizes, you'll need step-up or step-down rings, available from your camera supplier.

✦ **Buy some automatic extension tubes.** I use the Kenko brand that preserve the D80's autofocus and autoexposure exposure features. You can purchase them individually for as little as $50, in sizes ranging from about 12mm to 36mm in length, or in sets of three for about $150. Combine tubes to achieve longer extensions.

✦ **Always review your first shots.** That's especially important when you're taking photos using electronic flash that don't have modeling lights that let you preview your close-ups. It takes a long time to set up a close-up photo, so you want to get it right the first time rather than have to set up everything again later.

Night Scene Photography

There's not much to see after dark—but there's a lot to photograph. The same inky blackness that's illuminated by artificial lights or moonlight offers lots of possibilities if you look carefully enough. At night and during the early evening, the reduced illumination serves to cloak some of your surroundings in darkness, while further accentuating the scene that remains.

Add-on light sources, particularly flash, may not always be the answer, because artificial light makes night scenes seem ... artificial. It's often best to work with the illumination that's naturally there, as was done for the image shown in figure 7.45. It was taken an hour before dawn, when the night sky was beginning to lighten, and there was enough illumination to brighten the façade of the building. The interior lights were just beginning to come on as the first to work began their day's activities.

7.45 An hour before dawn there was enough skylight to photograph the façade of this castle, accented by a few interior lights.

Night and evening photography is challenging technically, because a combination of slow shutter speeds, higher-than-normal ISO sensitivity settings, the potential for using camera supports like tripods, and, as a last resort, auxiliary lighting, can pose a complex puzzle to solve. Those hurdles make night photography that much more satisfying when you do a good job.

Inspiration

7.46 This flagpole on the grounds of a county seat's courthouse lawn towers skyward in a night-time shot.

Getting good exposures at night is the most significant technical challenge you need to tackle. There's simply not enough light to use the best f-stop at a low ISO setting with a shutter speed that's fast enough to prevent blurry pictures from camera shake. You often need to make compromises in one or all three of these settings. Here are some possible solutions:

✦ **Use fast lenses.** The typical zoom lens has a maximum aperture of f/3.5 to f/4.5. More expensive zoom lenses might have f/2.8 as their largest f-stop. Nikon makes several fixed focal length (prime) lenses with maximum apertures of f/1.8 or faster, including a very affordable 50mm f/1.8 optic, a medium-priced 85mm f/1.8 lens, and more costly 50mm and 85mm f/1.4 lenses. (At the time of this

writing, Nikon's 28mm f/1.4 lens has been discontinued.) Any of these can let you shoot at night without using oppressively slow shutter speeds (1/30 second or longer) or especially noisy ISO settings (ISO 800 and higher).

✦ **Use vibration reduction.** Although some people claim to be able to handhold exposures with wide-angle lenses at 1/30 second or even longer, few can actually pull it off. But lenses with built-in vibration reduction, such as the 24–120mm f/3.7-f/5.6 VR Zoom-Nikkor or 18–200mm f/3.5-5.6 G ED-IF AF-S VR DX Zoom-Nikkor can be reliably handheld for exposures of 1/15 second or longer.

✦ **Use a tripod, monopod, or other support.** Brace your camera well enough, and you can take sharp photos with exposures of several seconds to 30 seconds or longer.

✦ **Use ISO settings wisely.** You can boost your D80's sensor's response to light by increasing the ISO value, but at the cost of additional visual noise in your photos. If image quality is important, use ISO increases as a last resort, and use the D80's long exposure/high ISO noise reduction features when appropriate. Use the ISO Auto function, described in Chapter 3, to intelligently rein in the automatic application of ISO increases.

Night scene photography practice

7.47 Exactly 2,500 American flags made up this 9/11 commemorative display, photographed at night by the spotlights used to illuminate the memorial.

Table 7.14
Taking Night Scene Pictures

Setup	**Practice Picture:** On the weekend of the last 9/11 commemoration, 2,500 American flags were erected in a public park by volunteers, with each flag designated in the name of a fallen soldier. The flags were on display, attended by an honor guard of soldiers, 24 hours a day until the evening of September 11. I showed up at 11 p.m. to shoot the photo shown in figure 7.47. At that late hour, there were still many visitors and I had to time my shots for moments when none of them was in my field of view.
	On Your Own: Although I used one, you don't necessarily need a tripod for night scenes. Rest your camera on an available object to steady it. If your scene is relatively unmoving, use the self-timer to trigger the shot and avoid shaking the camera with your trigger finger.
Lighting	**Practice Picture:** Giant cranes with attached floodlights ringed the display and provided all the light for my pictures.
	On Your Own: Try to work with the available light at night. If you must use supplementary illumination, bounce it off reflectors and try not to overpower the existing light. Use your extra light as fill for dark shadows, which can be helpful when the available light is overhead and high in contrast.
Lens	**Practice Picture:** 16mm f/2.8D AF Fisheye-Nikkor.
	On Your Own: Wide-angle lenses and zooms at their wide-angle settings generally afford the fastest f-stop available. Even short telephoto lenses saddle you with a double penalty: A smaller maximum aperture and the need for a faster shutter speed to minimize camera shake.
Camera Settings	**Practice Picture:** RAW+JPEG Fine capture. Manual exposure with Optimize Image set to Vivid and white balance set to tungsten.
	On Your Own: As your exposures approach one second or longer, manual mode and some minor tweaking of shutter speed between shots yield the most accurate exposures.
Exposure	**Practice Picture:** ISO 200, f/16, 20 seconds. It was a quiet night with no breezes about, so the long exposure wasn't spoiled by flags rustling in the wind, and the small f-stop ensured that the whole line of banners would be in sharp focus.
	On Your Own: For exposures longer than about 1/30 second, your D80's matrix metering system does a good job with most night scenes; you might want to bracket exposures to get different looks.
Accessories	A tripod, monopod, a clamp with a camera tripod mount attached, or even a beanbag, can serve as a support for your camera during long nighttime exposures.

Night scene photography tips

✦ **Slow Sync helps dark backgrounds.** If you use flash, the D80's Slow Sync mode is available when using the Night Scene and Night Portrait DVP/scene modes, or Program or Aperture Priority modes. It allows the use of longer shutter speeds with flash so that existing light in a scene can supplement the flash illumination in the background areas.

✦ **Twilight: The other nighttime.** If you shoot at twilight, you get a nighttime look, but will have the remaining illumination from the setting sun to fill in your scene, reducing the inky blackness. A full moon can also provide a little fill light when you're shooting exposures of one second or longer.

✦ **Readjust or bracket.** Whether you're estimating exposure, using histograms to zero in, or letting your D80 choose the night exposure for you, it's a smart idea to review your shots and make adjustments, or to use the camera's bracketing feature to automatically create overexposures and underexposures that might later turn out to be spot on when you get the photo into your image editor.

Scenic Photography

Landscape and scenic photography is one photographic pursuit that many serious Nikon D80 owners like to specialize in. Nature provides an endless bounty of beautiful locations, many of them still unspoiled by human interference, and all ready for you to capture with your imagination and your camera.

All the elements are there. You can experience the thrill of tracking down perfect locations, whether they are well-known and much-photographed, or remote scenes that might not have been seen before by the eye of a camera. You can choose an angle, select the time of day best suited to the image you want to capture, and decide what lens and settings are appropriate for your creative vision. Scenic photographs can be breath-taking panoramas, simple vistas, or scenes that combine nature with human-made additions, such as rustic barns, covered bridges, or the cornfield shown in figure 7.48.

7.48 Human intervention doesn't necessarily detract from landscape images, as this tall, healthy cornfield demonstrates.

Landscapes are a dynamic subject, and you can photograph the same scene in spring, summer, winter, or fall and achieve an entirely different photograph on each picture-taking expedition.

Inspiration

Finding the right place and time to take a scenic photo is half the fun. You can get a good start by photographing the landscapes around your home area. If you don't live close to majestic mountains or a the thunderous surf of an ocean, you still can find good locations among forests, lakes, deserts, or even swamps (they're called *wetlands* these days) near your home.

When you travel outside your home base, you can get good tips on scenic locations from the staff of a camping or sporting goods store, or from the friendly folks who operate a fishing tackle shop. Buy a map or make another small purchase, and then get the real dope on hiking trails or scenic fishing spots from the local experts.

At locations near the sea coast, newspapers always have listings of high and low tides, and a schedule of sunrises and sunsets, so you know when the beaches might be at their best, and what times the sun is lower in the sky and better able to emphasize the texture of the scenery. I very rarely photograph landscapes at high noon; more often I'm out there shooting in the two or three hours before sunset, and a couple hours after sunrise.

It's easy to get lost in unfamiliar territory, so carry a compass. Better yet, use the compass with sunrise/sunset tables to determine exactly where the sun disappears in the evening and reappears in the morning, so you can be positioned to catch it illuminating a mountain, lake, or other scenic feature.

7.49 In spring, this old covered bridge nestles among brilliant greenery, including tall trees that were planted around the time the bridge was built in the nineteenth century.

Scenic photography practice

7.50 Rural vistas often include human-made features, such as this barn, which is one of the last remaining "advertising" barns in my state.

Table 7.15
Taking Scenic Pictures

Setup	**Practice Picture:** The itinerant painters who plastered ads on the side of farmers' barns as they freshened up their coats of paint have largely retired, so I've made a regular practice of shooting one of the last remaining "ad" barns in my state during different seasons of the year. This last winter produced the picture shown in figure 7.50.
	On Your Own: You don't need to find a remote location to find unspoiled wilderness. Even sites close to home can make attractive scenic photos if the signs of civilization are rustic and/or historic.
Lighting	**Practice Picture:** Winter days are frequently overcast and dreary here, so I set out shooting on the first bright day after a snowfall. The midday sun was acceptable because I had no way of knowing whether the fluffy clouds pictured would be visible closer to sundown.
	On Your Own: You don't have a lot of control over the available illumination when shooting scenics. Your best bet is to choose your time and place, and take your shots when the light is best for the kind of photography you want to capture.

Continued

Table 7.15 *(continued)*

Lens	**Practice Picture:** 28–200mm f/3.5–5.6G ED-IF AF Zoom-Nikkor set to 100mm. **On Your Own:** While you can use a wide-angle lens to take in a broad view, you should remember that the foreground will be emphasized. If you're far enough from your chosen scene, as I was for the practice photo, a telephoto lens can capture more of the landscape, and less of the foreground.
Camera Settings	**Practice Picture:** RAW capture. Shutter Priority AE, with Saturation set to Enhanced. **On Your Own:** Shutter Priority mode lets you set a high enough shutter speed to freeze your landscape and counteract any camera or photographer shake if you're not using a tripod.
Exposure	**Practice Picture:** ISO 200, f11, 1/500 second. Slight underexposure helped make the colors appear even richer. **On Your Own:** This early in the day, an ISO setting of 200 was enough to allow an appropriately higher shutter speed.
Accessories	I like to use a tripod for scenic photographs whenever possible. A camera support helps you steady the camera and make it easy to fine-tune your composition. Use a quick-release plate so you can experiment with various angles and views and then lock down the camera on the tripod only when you've decided on a basic composition. A circular polarizer and an umbrella and raincoat might be handy, too, if you're caught far from your transportation or other shelter.

Scenic photography tips

✦ **Bracket your exposures.** It may be a long time before you're back at the same location for a reshoot, so expend the effort to shoot several different exposures to increase your odds that one is exactly right. A given scene can look different when you photograph it with a half-stop to a full-stop (or more) extra exposure, or with a similar amount of underexposure. An ordinary dusk scene can turn into a dramatic silhouette.

✦ **Learn to use your filters.** Landscape photographers have two favorite filters. One is a split-density filter that you can orient so the top half of the image receives a stop or two less exposure than the bottom half. That lets you reduce the exposure of the sky, so clouds appear more readily, without causing the foreground to darken too much. The other favored filter is a polarizer, which can remove reflections from the water, reduce haze when you're photographing distant scenes, and boost color saturation.

✦ **Be prepared for the weather.**
Scenic photos often involve a bit of hiking, and it's easy to find yourself a mile or two from your car when an unexpected shower becomes a downpour. Carry an umbrella, a rain poncho, gloves, or other protective gear even if you think you don't need them.

Seasonal Photography

I feel bad for those who don't live in areas that have the full range of seasonal transitions, from winter to spring to summer and fall. That was one of the reasons I moved some time ago back to the Midwest from Rochester, New York (which has nine months of winter, and three months of bad skiing). It's a joy to record the varied weather, the changes in wildlife and moods, and the other changes as the seasons progress.

Each new season has new activities, as people celebrate the rebirth of spring, the freedom of summer, the changes of fall, and the beauty of new-fallen snow. These seasons all present a wonderful array of photo opportunities, and even if you've seen dozens of seasonal changes in your lifetime, each new transition is bound to get your creative ideas flowing.

Something as simple as a decorated Christmas tree can inspire you to try new things. We didn't have much of a snowfall in my area during the early part of last winter, so when I visited our community's tree on the courthouse lawn, I decided to get up close and concentrate on the lights. I used a small f-stop to maximize depth of field, but found that the tiny aperture had an added bonus: It turned each of the lights on the tree into a miniature star, without the need for a special star filter, as you can see in figure 7.51.

7.51 A small f-stop added star-like points to the twinkling lights on this Christmas tree.

Inspiration

7.52 Summer activities are always fun to photograph, even if you, the photographer, aren't quite daring enough to engage in them personally.

Each new season presents its own roster of opportunities. Here are some idea-starters to think about:

Winter

Each year kicks off in the dead of winter, and it might seem like a good idea to stay indoors and take macro photographs of your hobby collection or flowers purchased from the florist shop. That's especially true on dreary days filled with more slush and rain than snow. So, when the snow does arrive, it's time to get out and take photos of snowy landscapes, tree branches caked with ice, and fields buried under a blanket of white. You can take some of the best shots at sunset, with its dramatic colors contrasting with the monochrome landscape. It may be chilly in winter, but you can go out, take a few sunset photos, and still be home in time for dinner.

Winter is also a good time to shoot wildlife photos, because the tracks in the snow make it easier to discover where deer, rabbits, and other hardy species congregate.

Dress warmly, and you can have more fun than you expect. Just remember to protect your D80 from the elements; cold weather depletes battery power quickly.

If you happen to be a winter sports enthusiast (in Rochester, it was almost mandatory to be a lover of ice skating, skiing, hockey, or shoveling snow), you can combine your interest in outdoor activities with your affection for photography.

Winter is a good time for traveling light, because it's never fun to change lenses or lug around a lot of equipment when the weather is cold. Decide on one "walking around lens" and, perhaps an alternate, and stick to that, if possible.

Spring

I always get excited when spring approaches, because by March or April I've taken about as many winter pictures as I care to, and am eager to photograph something that's not white. Emerging greenery can be invigorating.

It's easy to jump the gun. I'm usually out there photographing crocuses and other spring flowers the instant they poke their petals above the snow. Eventually, though, the flowers emerge, leaves reappear on the trees, and you can find lots of vibrant colors for your photography. You can find lots of new plants and wildlife emerging from hibernation or restricted activity, ready for capturing with your camera.

Just remember that, as in the fall, weather can be fickle throughout the springtime. March may come in like a lion, and may very well go out like one too, with a bit of raging lasting long into April and beyond. Carry protective rain and wind gear for yourself and your camera and dress in layers so you can add or remove clothing to keep warm or cool as required.

During your spring shooting, it may be more convenient to carry along a bit of additional gear, giving yourself a full complement of lenses, flash units, tripods, and other essentials to choose from.

Summer

Summers are great, as long as they're not too hot; I don't even mind the heat because I like to concentrate my outdoor shooting to early morning or late evening hours anyway because the light is better. Summer days are longer, so you do have more time to shoot.

There's always a lot going on in summer, including swimming, baseball, motor sports, outdoor plays and musicals, as well as active animal life both in the wild and in zoos (if you're smart like the animals and avoid the heat of midday). There are always tempting shots of sunsets, water activities, and rich landscapes full of mature plant life.

Fall

Many photographers find fall to be their favorite time of year. The weather is cooler, but still summer-like at the tail end of September. Indeed, last September, shortly after I purchased my D80, I found myself shooting photos at a professional baseball game and a high school football game in the same week, then two weeks later photographing fall colors in a nearby national park.

Of course, the fall foliage, as it changes from green to vivid reds, oranges, and yellows is always the main attraction during autumn. It's a great time for a road trip, since the colors change as you travel from north to south, or even just from one state to another. Check with tourist boards in most areas to pinpoint when each area's fall colors are at their peak. Set your D80's saturation level to Enhanced or Vivid during this time of year to get the most of the rich colors.

Every other year, I like to spend a couple weeks in the fall on photo safaris to Europe, as October is absolutely the best time to visit many countries. Most of the tourists have gone home, but the weather is still warm and comfortable, and most of the attractions and monuments maintain their summer schedules for a few weeks more.

When planning your fall shooting activities, don't forget the key autumn holidays, including Halloween and Thanksgiving, and the activities that accompany them.

Seasonal photography practice

7.53 Winter is a great time for photographing hardy plant life.

Table 7.16
Taking Seasonal Pictures

Setup	**Practice Picture:** Halfway through the warmest winter on record, the Midwest was surprised by an unexpected snowfall that buried the evergreen trees near my home. Seeing this as my chance to try out a new 10–17mm fish-eye zoom I'd just acquired, I ventured out in the cold to take the photograph shown in figure 7.53, getting down low to include the sky.
	On Your Own: Your own seasonal photography can include fireworks in the summer, snow scenes in the winter, and the rich colors of changing leaves in the fall. It's a challenge to find seasonal themes that haven't been done to death, but you can rise to the challenge by emphasizing good composition, color, or distinctive patterns.
Lighting	**Practice Picture:** Midday sunlight.
	On Your Own: Learn to work with outdoor lighting, or to supplement it with fill flash or a bit of brightening up with reflectors.
Lens	**Practice Picture:** Tokina 10–17mm AT-X 107 AF DX fish-eye set to 10mm.
	On Your Own: Wide-angle lenses are very popular for seasonal landscape photos. You need a telephoto to pull in distant views or for sports photos.
Camera Settings	**Practice Picture:** Aperture Priority AE mode with white balance set to Daylight.
	On Your Own: In bright daylight, your shutter speed is likely to be short enough to freeze movement, so you can use Aperture Priority AE mode to select a suitable f-stop. If the light is low, switch to Shutter Priority AE mode. Be sure to set the white balance to match the type of light in the scene.
Exposure	**Practice Picture:** ISO 200, f/16, 1/200 second.
	On Your Own: Outdoors during the day, ISO settings of 100 or 200 should be sufficient for most seasonal photographs. Choose f/8 or f/11 to give you enough depth of field (DOF), or stop down to f/16 when you need extra DOF for a close-up photo. As the light wanes, switch to Shutter Priority and select a speed no slower than 1/60 second.
Accessories	Use a tripod or monopod for longer exposures. Carry reflectors with you to fill in dark shadows.

Seasonal photography tips

✦ **In the winter:** During snowfalls, use slower shutter speeds so the flakes appear as white streaks.

✦ **In the spring:** Search for new plant life on dewy mornings that's still covered with moisture, and possibly surrounded by mist and fog.

✦ **In the summer:** In bright daylight you can find contrast-y scenes that must be compensated for with careful exposure. Reflectors can fill in shadows, but for scenic photos you might be better off with a split-density filter to darken the sky and balance it with the foreground.

✦ **In the fall:** Capture colors at their most brilliant by shooting late in the day.

Sunset and Sunrise Photography

It's no accident that this chapter is packed with photo subjects that relate to landscape and scenic photography in some way. Sunsets and sunrises are classic sub-genres of the larger landscape photography arena, and especially beloved by photographers for some very good reasons.

One of those reasons is that it's very difficult to shoot a bad sunset or sunrise. The most mundane sunset is gorgeous, and any sunrise is likely to be stunning just on the basis of its rich colors and the broad strokes from nature's palette on the skies. Sunsets can survive a wide range of overexposures and underexposures, and each and every day provides one of each in an infinite variety. You can shoot a sunset from a single location five evenings in a row and come up with a different picture every time. During a ten-day visit in Toledo, Spain, recently, I made a point of getting up before sunrise and remaining active at sunset so I could shoot from a different location at the edge of town each day. None of my shots resembles any of the others.

Sunsets and sunrises can be dressed up, too. You can shoot them with nothing but the sky and horizon, or include foreground objects, such as mountains, lakes, or even buildings in a city skyline, as in figure 7.54.

7.54 This dawn shot shows the sun, already raised above the horizon, starting to peek above the clouds.

Inspiration

7.55 Sunsets can be incredibly rich in colors, and also incorporate other subject matter, such as the boats shown in this photo.

The late Galen Rowell, a master photographer who produced some fabulous photos of sunsets, once noted that each day has just one sunset and one sunrise, and we shouldn't waste any of them. That's especially true because these natural wonders are so beautiful, they make even an average photographer seem brilliant.

Sunsets and sunrises tend to resemble each other a great deal, but there are some small differences. Dawn in the early morning occurs after the cool of the night, so there may be haze or mist in the distance as the sun comes up. Sunsets take place after the heat of the day, so mist may be replaced by smog if you're near an urban area. The differences are likely to be important only to those who live on the East and West Coasts, where, if you want to picture the sun at the horizon over water, you generally must take your photos in the morning (in the East) or at dusk (in the West). Those of us who live along the Great Lakes can often position ourselves to capture both sunrises and sunsets above our respective bodies of water.

Sunset and sunrise photography practice

7.56 Although the sun was low in the sky on this crisp fall day, it was still an hour from sunset. I created a dusk photo by underexposing the picture by three f-stops.

Table 7.17
Taking Sunset and Sunrise Pictures

Setup	**Practice Picture:** I pass by the lake shown in figure 7.56 often, and have photographed it at sunset frequently, but this day the sun was still an hour away from sunset. I decided the composition would work better as a sunset silhouette.
	On Your Own: If you can't come back to a locale when the lighting is perfect, you can frequently use underexposure to simulate a sunset when the real thing won't happen in time to suit your schedule. But, if you can, wait until the time is perfect, or, alternatively, come back another day to capture the sunrise or sunset properly.
Lighting	**Practice Picture:** I found a spot where the sun would silhouette the trees.
	On Your Own: Taking a few steps to the left or right can dramatically change the composition of the photo and allow foreground objects to frame a sunset or sunrise in an interesting way.
Lens	**Practice Picture:** 18–70mm f/3.5–4.5G ED-IF AF-S DX Zoom Nikkor at 50mm.
	On Your Own: Wide-angle lenses are excellent if you want to take in a large area of sky. A telephoto setting is a better choice to emphasize the sun and exclude more of the foreground.
Camera Settings	**Practice Picture:** RAW capture. Shutter Priority AE.
	On Your Own: Use a high shutter speed to minimize camera shake, and a small f-stop at least two or three stops under the correct exposure to underexpose the foreground in a silhouette.
Exposure	**Practice Picture:** ISO 200, f/16, 1/800 second.
	On Your Own: Underexpose by two f/-stops or more to create your silhouette effect.
Accessories	Carry along your tripod, and a selection of filters, such as a polarizer, star filter, and split density filter.

Sunset and sunrise photography tips

✦ **Use underexposure creatively.** Silhouettes consist of black outlines against a bright background, so you usually have to underexpose from what the D80 considers the ideal exposure. Use the Exposure Value compensation to reduce exposure by two stops or more.

✦ **Shoot sharp.** Silhouettes usually look best when the outlined subject is sharp, so watch your focus, locking it in, or use manual focus.

✦ **Vary your composition.** Sunsets and sunrises don't have to be shot in a horizontal format. Actively look for vertical compositions to create an unusual-looking dusk or dawn image.

✦ **Experiment with filters.** You can apply diffraction grating filters (which split the light into rainbows), split-density filters, polarizers, and colored filters to sunset and sunrise images creatively.

Water Scene Photography

The final landscape subject in this chapter is water scenes, which can include seascapes, waterfalls, and pictures taken along rivers or alongside lakes. Water makes a great photographic subject because of its purity and the interesting reflections that result when nearby objects are mirrored in the water itself.

Photographers either live near an ocean or are willing to travel to one expressly for the photographic opportunities. A seashore, with its marine life, the beach, and the relentless lapping of the waves, provides picture opportunities nearly as varied as those offered by sunsets.

Lakes can be interesting subjects, too, because they are, in some ways, gentler on the environment surrounding them, so you can find a greater variety of trees, forests, swampland, and other habitats next to their shores.

Rivers and waterfalls have their own charms, because the water is livelier and ever-changing. Heraclitus of Ephesus has been quoted, in paraphrase, to have said, "No man ever steps in the same river twice, for it's not the same river, and he's not the same man." (What he actually said was, "We both step and do not step in the same rivers. We are and are not." But that sounds too much like Yoda.) These dynamic bodies of water can be pictured in a variety of ways, as you can see in figure 7.57

7.57 With the camera secured on a tripod, and an 8X neutral density filter mounted on the lens, a three-second exposure allowed the water in the falls to blur mystically as it fell across the river shelf.

Inspiration

As with other types of scenic photography, sea, lake, and river photos are often at their best when the human touch is not obviously present. If you can find a spot without people, structures (other than, perhaps, the rustic cabin or seaside grass hut or two) and other artifacts, your photograph can be viewed through rose-colored glasses that might suggest an uncharted desert isle or a remote mountain stream. You may have to take a short trek to provide such a vista, or confine your visit to the early morning or late evening hours, but it should be worth it. I like to visit such areas after the tourist season has ended.

In a sense, most waterside photos have already been done to death, so you have to use your ingenuity to come up with new angles and perspectives. For example, you can shoot from offshore looking toward the beach, rather than from the beach looking seaward. Fishing piers or boats can provide good vantage points.

Or, shoot from overhead. Photographer Felix Hug, who contributed several exceptional photos to my book *Digital Travel Photography Digital Field Guide*, provided a couple of excellent ocean pictures taken from high vantage points, looking down into crystal-clear water. Alternatively, you can get down low, almost at water level to emphasize the watery foreground and/or beach. (Keep your camera dry, or consider renting a waterproof housing for your camera.)

Use long shutter speeds (a neutral density filter might be necessary) to allow waves to merge, or a waterfall to blur. Mix in some wildlife of the non-human variety: Seagulls, crabs, or other natural creatures in their own environment don't detract from your waterside nirvana.

7.58 This lakeside view is only two miles from a public beach; the trek was worth it to capture the solitude of nature.

Water scene photography practice

7.59 The crashing waves contrasted with the placid sailboat off in the distance, so I decided to juxtapose them in this photo.

Table 7.18
Taking Water Scene Pictures

Setup	**Practice Picture:** I was looking for something out of the ordinary when I encountered the waves crashing ashore while a sailboat placidly moved past at the horizon. I decided that this was a perfect opportunity to check out my D80's sepia image mode for the image shown in figure 7.59.
	On Your Own: You may have to do some exploring to find suitable waterside scenes to shoot. Rough-looking roads and trails leading off the main highway often dead end at scenic overlooks and interesting hiking routes right on an ocean, lake, or river.
Lighting	**Practice Picture:** It was late in the day, skies were clear, and the sunlight was perfect for this photo.
	On Your Own: As with other types of landscape photography, you usually can't choose your lighting, but you can choose to wait until the illumination looks good. Sometimes you have to come back a different day, but when the lighting is just right, you'll know that being patient was worth it.
Lens	**Practice Picture:** 12–24mm f/4G ED-IF AF-S DX Zoom-Nikkor set to 24mm.
	On Your Own: Wide-angle lenses work well with seascapes, and a zoom is handy to have if your photographic perch makes it difficult to move closer or farther away from your favored vista. You need a telephoto zoom only to pull in distant views.
Camera Settings	**Practice Picture:** RAW+JPEG Fine capture, with Optimize Image set for Sepia toning. Shutter Priority AE.
	On Your Own: Choose a shutter speed that counters camera/photographer shake and let the exposure system choose the f-stop.
Exposure	**Practice Picture:** ISO 200, f/8, 1/400 second.
	On Your Own: Your D80 usually does a good job of calculating the exposure for you, but be prepared to use the EV compensation feature to add or subtract a little exposure if the metering system is misled by bright water or extra dark surroundings. Switch to center-weighted or spot metering if necessary.
Accessories	You should have some sort of waterproof bag to carry your equipment, as splashing water is one of the dangers inherent in photographing water scenes. In hot weather, have a cooler in your vehicle to protect your camera from high temperatures. Digital cameras don't have film that can be spoiled by heat, but a hot sensor is a noisy sensor.

Water scene photography tips

✦ **Watch the horizon.** It's easy to tilt the camera slightly, and you must fix a sloping horizon in an image editor, probably wasting pixels, and perhaps forcing you to crop out some portion of your image that you didn't want to part with.

✦ **Watch your environment.** Water scenes are fraught with sand, which can play havoc with the delicate mirror and shutter mechanism of your camera should a few grains sneak in during lens swaps. Water, especially salt water, is not good for your D80, either, which isn't weather sealed to the extent of its D200 and D2X siblings. If you keep splashes and sprays of sand from your camera, and are careful when changing lenses, you should be okay.

✦ **Follow the tides.** For ocean pictures, you want to track the tides and remember that a high tide cleans the beach, and a low tide exposes a treasure-trove of picturesque seashells, seaweed, scrambling sea creatures, and a few old shoes, tires, and soda cans. You'll soon learn which times of day provide the best and most photogenic seashore for your photographic endeavors.

Downloading and Editing Pictures

Because this book is intended as a field guide, I've concentrated on showing you ways to get great pictures in your camera rather than emphasizing what you can do in an image editor to fix goofs that needn't have existed at all if you knew what you were doing. Even so, working with various software applications and utilities is often necessary after you take a shot. You need to download your images to your computer, organize them for display, prep them for printing, and perhaps do a little cropping and resizing. Beyond that, many pictures can benefit from a little judicious editing to tweak unanticipated defects.

This chapter introduces you to the most common applications that are put to work after your picture has already been taken, including Nikon PictureProject, which is furnished with the D80, and more sophisticated tools such as Nikon Capture NX and Nikon Camera Capture Pro. Don't expect extensive instructions on how to use any of these programs: This is still a field guide, and unless you normally carry a laptop with you when you venture out to shoot pictures, you probably won't fire up this software until you're back in your home or office.

Starting with Nikon PictureProject

If you aren't currently heavily involved in photo editing and organizing, Nikon PictureProject is a good place to start. Packaged right in the box with your D80 camera, it offers an easy-to-use set of basic functions for importing your photos to your computer, organizing them into albums, and doing simple image editing. Even if you intend to graduate to another

application, PictureProject enables you to perform the most common functions without the need to spend hours learning to use a new program. If you're new to digital cameras or image editing, PictureProject gives you a quick way to perform many of the basic functions involved in importing, touching up, and organizing your photos.

The basic functions of PictureProject are image transfer, organization of photos into albums, basic image editing, and the capability to share images as prints, slide shows, e-mails, or other forms. PictureProject also includes a button that links the program to the extra-cost Nikon Camera Control Pro, which enables the camera to operate remotely, downloading photos immediately as they are shot, and uploading camera settings files to the D80.

PictureProject is furnished with the Nikon D80 on two CDs: one disc for the application, and a second one for the user manual. The two discs also contain Nikon Fotoshare, a photo sharing program, and a trial version of Nikon Capture NX.

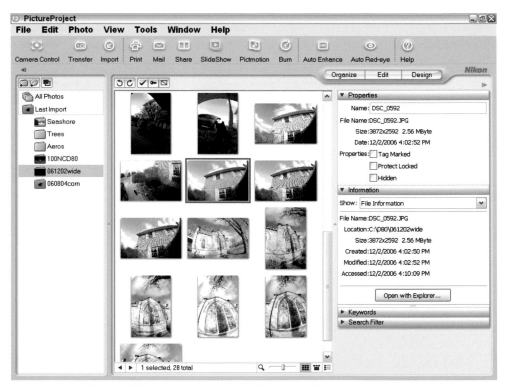

8.1 PictureProject enables easy organization of photos without having to learn a complex program.

Transferring pictures

PictureProject can transfer images directly from your D80 to your computer using the USB cable. The program also recognizes when a memory card has been inserted in your card reader, and pops up to offer to transfer those photos too. You can specify PictureProject as your default photo importing utility, or choose to work with another program, such as Adobe Photoshop Elements' Photo Downloader, or the facilities built into Microsoft Windows XP, Microsoft Windows Vista, or Mac OS X's iPhoto.

If you decide to rely on one of the other image transfer options, you can prevent PictureProject from popping up when a camera or memory card is detected by choosing Tools ➪ Options in the PictureProject main screen. In the Auto Launch area of the dialog box, uncheck the Auto launch PictureProject when a camera or memory card is connected box. You can still use PictureProject Transfer at any time by launching the application manually and then clicking the Transfer button in the toolbar. Whether the transfer utility is started automatically or manually, the PictureProject Transfer wizard shown in figure 8.2 appears.

Click the Show thumbnails button in the transfer wizard's toolbar to inspect miniature views of each picture in the dialog box's main pane. Choose which images you want

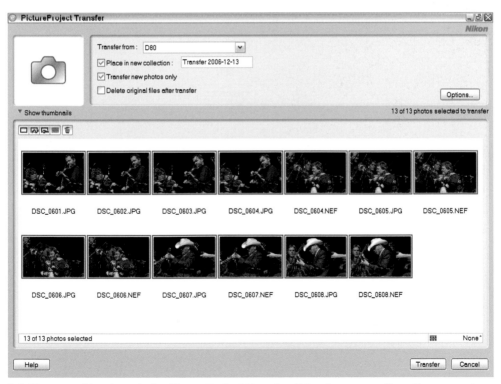

8.2 You can either launch the PictureProject Transfer dialog box manually or the computer can do it automatically.

to transfer by clicking to select individual photos, Ctrl/cmd+clicking to add additional photos or to remove them from the selection, or clicking the Select All button to choose all the thumbnails the wizard detects.

A check box is available to enable you to place the imported photos in a new collection (album) with a name of your choice, or to append the new images to an existing album you specify. You can also choose to import only new images from the camera or memory card, ignoring those that were imported earlier. If you want, the PictureProject Transfer wizard can erase the photos from the camera or memory card after they've been copied. Click the Options button to select additional choices (described next). When you've returned from the Options dialog boxes, click the Transfer button in the lower-right corner of the dialog box to initiate importation of your photos.

Knowing your transfer options

The PictureProject Transfer wizard has options of its own. Click the Options button at the upper right of the screen to view the Transfer Options dialog box with four tabs for General, Transfer Destination, Rename Photos, and Pictmotion choices. (Pictmotion is available only with Windows and is not used with the D80. Why does it appear? Go figure.)

✦ **General:** This tab includes options for copying hidden files, embedding the color profile information in the file, adding a preview to RAW Nikon Electronic File (NEF) images, rotating images shot in vertical orientation (if you've selected that option in the camera), and synchronizing your camera to the computer's clock (only when the camera is connected via

the USB cable). You can also elect to copy the photos into a single new collection (album) on your hard disk, separate them based on the folders you've created for images on your memory card, or segregate them by the date the images were shot.

8.3 The General parameters tab helps you transfer and collect images.

✦ **Transfer Destination:** Here you specify the names of the folders used to store the transferred pictures on your computer. You can tell PictureProject Transfer to create a new folder each time photos are transferred, which can make it simpler to organize the fruits of your various shooting sessions. The utility can also use the folder names created in your camera (in case you've stored images in more than one user-named folder). You can specify the prefix used to create

the folder names, too. For example, with travel photography, you might want to use prefixes like Paris, New York, or Geauga Lake. You can also append a sequential number to folders and apply a suffix to the end of folder names.

Transfer Options

General | Transfer Destination | Rename Photos | Pictmotion

Transfer destination folder:

C:\D80 Browse...

☑ Create a new subfolder for each transfer

☑ Copy folder names from camera

Sample Name: GeaugaLake2006-12-13

Prefix

Text ▾ | GeaugaLake

Index

Transfer date ▾

Date separator: - | yyyy-mm-dd

Number separator: - | yyyy-mm-dd-nn

Suffix

No Suffix ▾

OK | Cancel

8.4 Specify the file destination with this tab.

✦ **Rename Photos:** This tab gives you a lot of flexibility when you create new descriptive names for your image files as they are copied — or you can retain the name applied by the camera. Here you tell PictureProject Transfer whether to use the filename the camera created, or to rename each photo using a name you specify. Filenames can begin with a text label you specify, include a numbering scheme with one to nine digits, and begin the numbering at a value you enter. You can also add a suffix to renamed files.

Transfer Options

General | Transfer Destination | Rename Photos | Pictmotion

☑ Rename photos during transfer

Sample Name: [Original Name]0001

Prefix

Original name ▾ | [Original Name]

Index

Sequential Number ▾

Start numbering at: 1

☐ Reset to 1 before each transfer

Number of digits: 4 ↕

Suffix

No Suffix ▾

OK | Cancel

8.5 Specify the filename here.

✦ **Pictmotion:** Windows users who own Nikon point-and-shoot digital cameras that support Pictmotion can have PictureProject Transfer assemble copied photos into a minimovie of stills, using either Windows Media Video (WMV) or MPEG1 (MPG) formats. Several quality levels are available, as well as resolutions from 160 x 120 pixels up to 640 x 480 pixels (which is near TV quality). The D80 doesn't support this function, but I describe it for completeness.

Organizing and viewing pictures

PictureProject's album functions enable you to create album-like collections, and then organize images by filename, date, or keywords that you enter to classify your shots. You can drag and drop images to organize your album collections. Preview your

images as thumbnails, thumbnails with an enlarged image of the current frame, or thumbnails with photo information. You can click one of the icons at the bottom of the preview pane to switch views.

PictureProject lets you examine individual images, organize them into collections, or view a series of photos in a slideshow:

✦ **Picture collections:** The left side of the PictureProject window shows a list of available picture collections. Just click a collection name to view all the images in that collection in a scrolling thumbnail panel in the center of the PictureProject window. Click the All Photos or Last Import buttons to see all the images in all your collections, or only the most recently-imported images.

✦ **Thumbnail area:** A zoom slider at the bottom of the preview area enables you to change the size of the thumbnails, and you can choose whether to view thumbnails only, view a larger preview of a selected image below the thumbnails in addition, or see thumbnails accompanied by shooting information for those images.

✦ **Information area:** At the right side of the screen are expandable/collapsible panels that show more information about a selected photo, and search boxes for finding specific images using the filename, a

keyword you've previously entered, or the date when the image was taken. Click the Information and Properties bars (shown collapsed in the top right-hand corner of figure 8.6) to see additional data about a selected image.

✦ **SlideShow button:** Select a collection or folder of images and click the SlideShow button in the PictureProject toolbar to view a series of selected images one after another.

✦ **Import button:** Although PictureProject automatically loads the pictures it transfers into collections, you can also add photos already residing on your hard drive by clicking the Import button in the top tool bar.

Retouching pictures

PictureProject has some limited picture-retouching features that you can use when you don't want to work on your images in a more advanced image editor. Editing changes are always applied to a duplicate image instead of the original, so if you change your mind you can always return to the original photo. Click the Edit button at the right side just below the tool bar or the Auto Enhance button in the tool bar itself.

To edit in PictureProject, double-click any photo in a collection, or select a photo and click the Edit button. You can choose from the following functions:

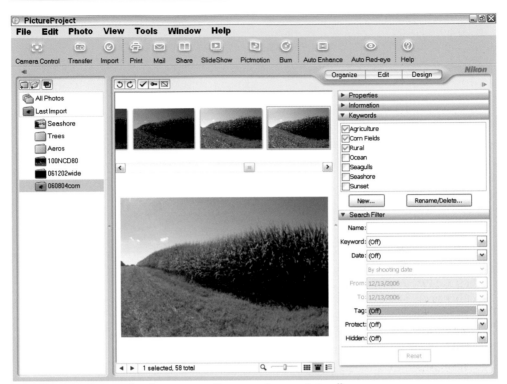

8.6 PictureProject makes it easy to collect your images into albums.

✦ **Auto Enhance button:**
PictureProject makes its best effort
to automatically fix the brightness,
color saturation (under the option
Color Booster), and sharpening for
the image.

✦ **Auto Red-eye button:**
PictureProject automatically
removes glowing red eyes from
pictures of humans. This tool does-
n't work on the eyes of animals,
which usually glow yellow or
green.

✦ **Photo Enhance section:** Click the
Brightness, D-Lighting HS (a
shadow brightener), Color Booster

(for saturation), Photo Effects,
Sharpening, or Straighten boxes,
and then use the slider and/or
options offered for each to make
the adjustments manually.

✦ **Tool buttons:** These are located
above and to the right of the edit-
ing preview window itself. Six but-
tons appear immediately above the
editing preview window. They
enable you to rotate the image
counterclockwise or clockwise,
move it around, zoom in or out,
crop, or remove red eye.

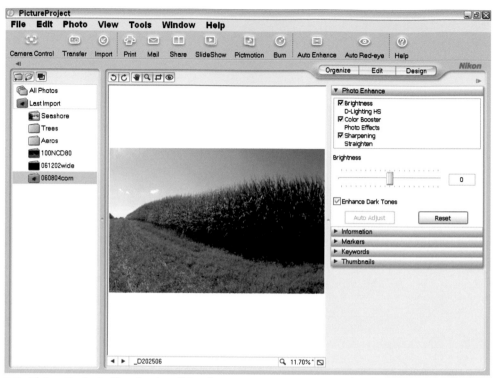

8.7. PictureProject offers basic editing features you can use to make simple modifications to your JPEG images.

Sharing pictures

PictureProject also includes functions you can use to share your photos through PictureProject InTouch. You need to create an account with the PictureProject InTouch Web site, but it's free, and you can set it up the first time you use PictureProject InTouch. To use the feature, click the Share button in the tool bar and wait for the program to launch. PictureProject InTouch enables you to do the following:

✦ **Print:** Output one photo, or a selection of them, from a collection.

✦ **E-mail:** Send one or more photos by e-mail using Outlook, Outlook Express, or Eudora (Windows); or Entourage X, Mail, or Eudora (Macintosh).

✦ **Organize:** Arrange photos into a layout to print or e-mail.

✦ **Share:** Send album collections with friends, using up to 50MB of free Web space provided to you by Nikon each week. After two weeks, your photos are deleted from the Nikon Web site, freeing up space for additional images.

8.8 You can use PictureProject InTouch to print, e-mail, and share your best photos.

Nikon Capture NX

Nikon Capture NX replaces the earlier product Nikon Capture and is not so much an upgrade from the previous program as a completely new application built from the ground up with much more sophisticated editing features and lots of new capabilities. The original Nikon Capture was a useful tool for manipulating Nikon NEF (RAW) image files, converting files in batches, uploading/downloading and transferring images, as well as controlling the camera remotely through a USB cable (for time-lapse photography and other kinds of remote shooting). Capture NX gives you much more powerful editing tools that you can use for *nondestructive* modifications (meaning that

you can always return to the original picture) of selected regions of the picture you can isolate using *control points*.

If this all sounds complex, it is. Capture NX is definitely a highly optional tool for Nikon D80 tools. That is so true that Nikon has unbundled one of the most-used portions of the old Nikon Capture program, the camera communication facility, and now provides it as yet another optional utility under the name Camera Capture Pro (CCP). This utility works with both PictureProject and Capture NX, so you can purchase it (about $70) and use it without needing to make the hefty $169 investment in Capture NX itself (you can try it out for 30 days for free before you have to buy it.)

If you do need the advanced features of Capture NX, they are impressive. Developed using technologies from Nikon partner Nik Software, Capture NX features new Brush, Lasso, and Marquee selection tools, advanced layering features, and the aforementioned U Point control points so that you can modify color, dynamic range, and other parameters only in selected areas. This new program has improved tools for correcting aberrations such as barrel distortion, vignetting, and fisheye distortions found in Nikkor lenses. The new Edit List provides better control over image processing workflow by listing each manipulation as it is applied, and allowing individual steps to be undone in any order. Also included is a new Capture NX Browser for labeling and sorting images, and applying settings to batches of photos.

Advanced photographers will like the color management controls that aid printing images that more closely match what you saw through the camera and on the display screen, and new, sophisticated noise reduction algorithms.

Nikon Capture NX users can import RAW/NEF images and save them in a standard format such as TIFF, either using the original settings from the camera file or fine-tuned settings for things such as sharpening, tonal compensation, color mode, color saturation, white balance, or noise reduction. Capture NX has a useful *image dust off* feature for subtracting dust spots caused by artifacts that settle on the sensor. Just take a blank dust reference photo, and the application "subtracts" dust artifacts in the same location in additional images you import.

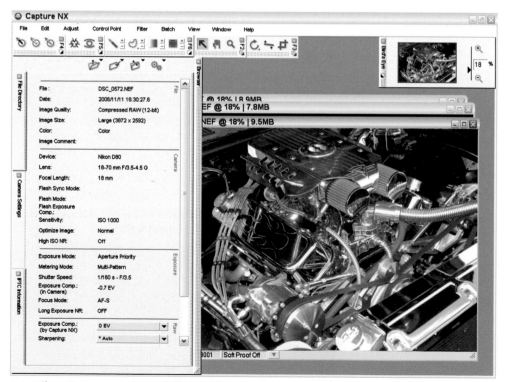

8.9 Nikon Capture NX has a full set of features for importing and converting NEF files, and making a host of fine-tuning adjustments.

Nikon Camera Control Pro

Nikon Camera Control Pro, an extra-cost utility priced at about $79, gives you a way to communicate directly with your D80 when it's linked to your computer with a USB cable just as if you had your eye glued to the viewfinder and were manipulating the controls on the camera itself. (Unfortunately, you can't preview the image you're about to take using your computer.)

For example, if you have a squirrel that visits your outdoor deck frequently, you can set up your D80 on a tripod close to a feeder, link it to your computer with a USB cable, and trip the shutter when the creature approaches. Camera Control Pro lets you see the viewfinder's LED readout from your computer, and even change the shooting mode and other settings without touching your camera. There are five tabs in the Camera Control Pro window, shown in figure 8.10.

8.10 Camera Control Pro enables you to control your D80 over a USB cable.

✦ **Exposure 1:** Here you can choose the exposure mode (Aperture Priority, Shutter Priority, or Manual), and then adjust the aperture itself if you're using a lens that sets the f-stop electronically; or can adjust the shutter speed (in Shutter Priority or Manual mode). You can add exposure compensation (EV) or flash exposure compensation (FEV) if you want to override the camera's exposure settings. If you want to keep the metered exposure, but use a different combination of shutter speed and f-stop, use the Flexible Program slider. The two buttons at the bottom of this tab activate the autofocus system and take a picture (AF and Start) or simply take the picture at the current focus setting (Start). These two buttons, as well as the viewfinder LED readout, are repeated on the other tabs.

✦ **Exposure 2:** Here you can move the Focus Area using directional buttons that mimic the D80's multi-controller. There is even a thumbnail of the focus zones as they appear in your viewfinder that shifts brackets as you change the focus area. You can also choose a Metering Mode, Flash Synch Mode, and change ISO settings (Sensitivity) or White Balance (including making fine adjustments to White Balance).

✦ **Storage:** Use this tab to specify the file format used to take your photo (JPEG, RAW, or RAW+JPEG), the JPEG compression level (Fine, Normal, or Basic), and resolution settings of the camera (Large, Medium, and Small).

8.11. Select the Focus Area, White Balance, or ISO settings here.

✦ **Mechanical:** This is an important tab that enables you to specify many frequently changed settings. You can choose from single shot or continuous shooting modes, as well as perform automatic bracketing (and select whether to bracket exposure, flash, or both) while choosing other bracketing parameters such as number of shots, bracket increment, and bracket order. It enables you to access single and continuous shooting modes, set up bracketing options, choose the autofocus mode (dynamic area, single area, and auto area selection; plus AF-C, AF-S, or AF-AI). There's even a battery level indicator, which is an excellent idea, because running your camera through a USB connection consumes a lot of power.

8.12 Choose file format and JPEG options here.

8.13 Fiddle with the mechanical controls of your camera, including focus options, here.

✦ **Image Processing:** You can use this tab to fine-tune your image even before you take it—just like the Optimize Image controls in the D80's Shooting menu. Choose Softer, Normal, Vivid, Black-and-White, or one of the other custom looks the D80 offers, and change sharpening, tonal compensation, color mode, saturation, and hue. Turn Long exposure Noise Reduction on or off, and specify the amount of High ISO NR (if you want any applied). Select User-Defined Custom Curve in the Tone Comp area and click the Edit button to create your own custom tonal curve.

Camera Control Pro also lets you change settings, including those that are clumsy to enter using the camera controls alone, such as the image comment appended to every photo. Perhaps the most interesting capability is the Time Lapse facility (choose Camera ➪ Time Lapse Photography), which enables you to take a series of pictures at intervals that range from seconds to days. Replace that squirrel (or bird) feeder with a flower bud just about to blossom and you can capture every moment as it unfolds. The Time Lapse utility can shoot from two to 9,999 shots, stored directly to your computer's hard drive, using a delay from one second to 99 hours, 59 minutes, and 59 seconds between shots. You can even bracket exposure or white balance between pictures. If you're shooting a very long time-lapse sequence, it's a good idea to use the D80's optional AC power supply to avoid having your battery run out before you finish your sequence. And keep your camera protected from the weather if you're shooting time-lapse photos outdoors!

8.14 Manipulate the fine-tuning process your camera performs.

Troubleshooting

One thing you'll grow to love about your Nikon D80 is its rugged build and toughness. Compared to a film SLR, it has considerably fewer mechanical parts that can fail — it has no film transport, wind lever, or motor drive, and has simplified linkages from the camera to lenses. Only the shutter itself and the viewfinder's flip-up mirror are major moving parts, and they are built to last tens of thousands of picture-taking cycles or more. The various switches, dials, and buttons, as well as the memory card door and flip-up electronic flash, are quite sturdy and should last the life of your camera.

Even so, there are certain components that do require some attention from time to time, ranging from the battery, to memory cards, to the D80's operating system itself. Eventually, the D80's sensor will pick up some dust and need a quick and easy cleaning.

In this appendix, I provide useful alerts that warn you about these potential areas, and offer advice for troubleshooting and maintaining your camera over what I expect to be a long and productive life.

Upgrading Your Firmware

Firmware is the D80's operating system, which oversees all the operations of the camera, from menu display (including fonts, colors, and the actual entries themselves), to all the camera's features that call for processing in the camera, to the support for devices that link with the camera, such as the memory card and your computer (when you've connected using the USB cable).

From time to time Nikon issues firmware upgrades that you can install yourself. In the past, upgrades for other Nikon models have fixed bugs in the firmware itself, improved the performance of features like autofocus, added options for printing images directly from the camera, and even given cameras entirely new features, as when the D80's big brother,

In This Chapter

◆　　◆　　◆　　◆

In This Chapter

Upgrading your firmware

Extending battery life

Fixing flash problems

Reviving bad memory cards

Addressing amp glow/noise

Cleaning your sensor

◆　　◆　　◆　　◆

the D200, was gifted with a new black-and-white imaging mode that later models (including the D80) already had.

The most recent firmware update for the D80, Version 1.01, issued in January, 2007, addressed a few issues. For example, the camera sometimes froze when using the Retouch menu to make changes in images that had previously been edited using a computer. Nikon's solution was to disable the ability to use the Retouch menu on such images. The situation was rather rare, anyway, as you'd need to remove the memory card from the D80, insert it in a card reader, edit the image with a computer, then re-insert the memory card in the camera.

The 1.01 firmware update also improved the performance of long exposure noise reduction, fixed errors in the English, Polish, Swedish, and Traditional Chinese menus, and enabled the electronic analog exposure display when extreme over- or under-exposure are encountered when using Program, Shutter Priority or Aperture Priority modes when the built-in flash is flipped up.

If your D80 was a recent purchase, you may already have the 1.01 firmware installed. If not, upgrading your firmware is easy. If you're computer savvy, you might wonder how your D80 is able to overwrite its own operating system. Nikon's secret method is to perform the upgrade in two steps, so the entire camera operating system (OS) is not replaced in one fell swoop. Each of the two pieces of the firmware is fully capable of managing the camera's basic firmware update functions without the other, so you can replace one half of the firmware, and then the other in turn. It's a little like an airplane with a pilot and copilot. You can replace either of them with yet another crew member with no dire results, as long as the other remains in control at all times.

Performing updates

When the time comes to update your firmware, the process is easy. Follow these steps:

1. **First, check the version number of your current firmware to confirm that a later version is available.** In the Setup menu, scroll to Firmware version and press OK or the right directional key. The current version displays on a screen (see figure AA.1).

2. **Turn the D80 off.**

3. **Make sure you have a freshly charged EN-EL3e battery inserted in the camera, or are using the optional AC adapter.** You don't want the D80 to run out of juice during the upgrade process.

4. **Download the new firmware from the Nikon Web site and place it into a new folder on your computer hard disk drive.** The firmware is in two files, Camera A firmware and Camera B firmware. The names of the files will be something like:

 AD800101.bin

 BD800101.bin

5. **Turn the D80 on and format a memory card so that it is empty of image files or (most important) any other firmware files left over from the last time you upgraded.**

6. **Copy either of the two firmware files to the top (root) directory/folder of the memory card.** You can copy the files using a direct USB connection from your computer to the D80, or turn off

the D80 and remove the memory card so you can copy from your computer using a memory card reader. It makes no difference which of the two BIN files you copy first, although I always like to start with Camera A firmware to avoid any chance of confusion.

7. **When the firmware is copied, either turn off the camera (if you're using a direct link), or remove the memory card from your card reader.** Insert the card into the D80.

8. **Turn the D80 on.**

9. **Press the Menu button and find Firmware version in the Setup menu.** Press OK or the right directional control.

10. **From the screen, choose Update and press OK or the right directional control.** Select Yes from the screen that appears next to start the upgrade. The firmware is updated. *Do not turn the camera off, open the memory card door, or use any of the controls while the upgrade is processing.* It may take a minute or two.

11. **When the Update Complete message appears, you can turn the D80 off.**

12. **You can then turn the D80 back on, and access the Firmware version screen from the Setup menu to confirm that the update has been completed.**

13. **Format the memory card once again, and repeat steps 6 through 12 with the second firmware file.**

AA.1 You can determine the current firmware version from the Setup menu.

Extending Battery Life

The D80's EN-EL3e lithium ion battery (which is also compatible with the Nikon D200, Nikon D70 and D70s, and Nikon D50 – but not the Nikon D40) should provide you with 500 to 1,500 shots per charge (or even more), depending on how you are using the camera. However, certain features, such as the LCD or built-in flash provide a special drain on the battery. Then, it's time to pop the battery into the Nikon MH-18a Quick Charger for about two and a half hours to revitalize it and bring it back to full power. You can recharge the D80's battery at any time, even after just a few shots, with no danger of the battery building a memory of reduced capacity (which was the case with old-style nickel-cadmium batteries). It's fine to recharge daily, or just before heading out for a new shooting session. I've gotten nearly 2,000 pictures from a single charge, and always carry a spare battery or two with me, so power is rarely a concern.

If you do plan to burn through thousands of exposures, or will be separated from a source of current for recharging, you can mount the MB-D80 Multi-Power battery pack/vertical grip on the D80. It holds one or two EN-EL3e batteries, or six AA alkaline, nickel metal hydride, lithium, or nickel manganese cells. In a pinch, or when you're working in an indoor, studio environment, you can also power the D80 with the Nikon EH-5 AC adapter.

To maximize the number of shots you can get from a single charge, minimize the use of features that use the most power. You can review the status of the battery at any time by choosing Battery info from the Setup menu, where you can view the percentage of battery life left, the number of pictures taken on the current charge, and the predicted charge life for the battery before you need to replace it (see figure AA.2). In approximate order of impact on battery life, these features are:

AA.2 The D80's Battery info screen provides current power status information.

✦ **Built-in flash:** The D80's built-in flash is ample for most picture-taking situations, but it provides quite a drain on the battery. That's especially true if you use the optional modeling light feature that fires off a series of bursts in quick succession so you can preview the lighting effects of the flash unit. If you'd like to stretch the useful life of the D80's internal battery, either reduce your use of the internal flash, or switch to an external flash such as the Nikon SB-600 or SB-800, which both use separate AA battery supplies.

✦ **LCD display:** That big, beautiful 2.5-inch color LCD on the back of your D80 pulls a lot of power. You absolutely must use it to make settings changes and to review photos that might need some exposure tweaks. But do you really need to stare at each and every picture you shoot for 10 or 20 seconds? You can save a lot of battery power by turning off the automatic display of each shot after exposure. Turn off Image review in the Custom Setting menu (CSM 06), change the Monitor Off default to 10 seconds or 5 seconds (CSM 27), and crank down the LCD brightness setting in the Setup menu.

✦ **Autofocus and vibration reduction:** Cranking the lens in and out of focus requires power. You can save a little juice by using AF-S (single autofocus) to avoid focusing and refocusing constantly when you don't need to. Vibration reduction (VR) also eats up power. If you're using a VR lens, turn off the vibration reduction feature when you don't need it, especially when the camera is mounted on a tripod or you're already using high shutter speeds at shorter focal lengths that don't benefit much from VR.

✦ **RAW drainage:** Nikon cameras seem to use more power when saving files in RAW mode. If you don't need a RAW version of your image, but do need to take a lot of pictures on a single charge, consider using JPEG Fine instead of RAW or one of the RAW+JPEG options.

✦ **New battery:** It just might take a new battery several charge/discharge cycles to achieve its maximum capacity. Some D80 owners report getting 10 to 20 percent more shots per charge after they've seasoned their new batteries.

Fixing Flash Problems

The D80's built-in flash is reliable, so much so that any problems you're likely to have will probably be caused by incorrect settings or other human errors. If one of the following situations occurs, my diagnosis and suggested cures should help you put things right quickly.

✦ **Flash overheats/refuses to fire:** It's easy to forget that you turned on the built-in flash's modeling light during your last session, and then mistake the extended preflash for a red-eye preflash. Continued use of the modeling light feature (say, ten consecutive shots, one after the other) can cause the flash to overheat. The D80 then disables the flash before any harm has been done. Unless you really want to use the modeling light feature, go to the Custom Setting menu and use CSM 26 to turn it off.

✦ **Consistent under/overexposure:**
There are several possible causes
for flash exposures that are always
wrong. You have used flash expo-
sure compensation and forgotten.
Press the Flash/Flash EV button on
the left side of the D80's prism and
use the sub-command dial to
return Flash EV to 0.0. It's also pos-
sible you've switched the flash to
Manual mode using CSM 22.

✦ **Consistent underexposure:**
Accidental Manual mode can also
be the problem if you have consis-
tently dark flash photos, without
occasional overexposures. Check
CSM 22 to make sure you haven't
manually set the flash to reduced
power. You can adjust the D80
from full power down to 1/32 its
normal output. The latter setting is
almost guaranteed to give you
underexposures in your flash pic-
tures.

✦ **Unsightly shadows:** The flip-up
flash may not have enough eleva-
tion to prevent casting a shadow of
the lens hood or even the lens
itself in your subject area when
you use the 18-200mm, 18-70mm,
18-55mm, 17-55mm, or similar
zooms at their widest settings,
especially for pictures of close sub-
jects. You can try removing the lens
hood or zooming in slightly.

AA.3 Oops! The dark shadow at the bottom
of this close-up photo was caused by a
lens's hood blocking the flash.

Reviving Bad Memory Cards

Memory cards, including the SD cards used
in your D80 (they aren't called *Secure
Digital* cards for nothing!) rarely fail on their
own. You're far more likely to lose one, step
on it, or run it through the wash/rinse cycle
of your washing machine than to have it fail
during use. There's not really anything that
can wear out within these solid-state
devices.

Preventing trouble with memory cards starts with what you do or don't do. SD cards are small and easy to misplace if you're not careful. For that reason, it's a good idea to keep them in their original cases or a *card safe* offered by Gepe (www.gepecard-safe.com), Pelican (www.pelican.com), and others.

It's also wise to use them carefully. Don't remove the card while the camera is writing images to the card. If you do, you lose any photos in the buffer and may damage the file structure of the card, making it difficult or impossible to retrieve the other pictures you've taken. The same thing can happen if you remove the card from your computer's card reader while the computer is writing to it.

If you are having problems with a memory card and the images on it are important to you, stop using that card immediately. Don't take another picture. Safely power down your D80 and remove the card and, as soon as possible, insert it into a card reader on your computer and attempt to copy the files to a safe folder on the computer. Avoid the temptation to link your D80 and computer with the USB cable and copy the files that way: It's possible that a camera/card incompatibility is at work that might not be present if you transfer the images with your card reader instead.

If your computer's card reader doesn't let you transfer the images, and those images are very valuable (say, a wedding that might be difficult to restage), you can always consult a professional data recovery firm, which will charge you hundreds of dollars and still might be unable to recover your photos. You can also find software online specifically for salvaging photos from memory cards or from other media, such as floppy disks or hard disks. Although I've never used any of them and so can't recommend a specific solution, some of the best-regarded include Photo Rescue 2, Digital Image Recovery, MediaRecover, Image Recall, and Recover My Photos. For more ideas and links, check out www.ultimateslr.com/memory-card-recovery.php.

Addressing Amp Glow/Noise

Many digital cameras exhibit a phenomenon known as *amp glow* or *amp noise*, which refers to faint signals generated by electrical components near the sensor, and are most noticeable over long exposures, particularly at high ISO settings, and with images that have extensive underexposed black areas. When the Nikon D80 was introduced, some users, particularly those fond of astrophotography and other pursuits that use long exposures, reported that the new camera did a particularly poor job of suppressing amp glow under the kind of conditions likely to cause it. A few were able to detect amp glow, which appears as purple glowing areas along the top of the image area (see figure AA.4), at shutter speeds as brief as 1/60 second. Others found it at longer shutter speeds, in the several-second range, and the phenomenon is very likely to appear with exposures

The good news is that extreme amp glow appears to have been a problem with some early D80 models, and it has been largely corrected by Nikon in more recent ones. By largely corrected I mean that if you make an exposure that's sufficiently long, virtually all digital SLR (dSLR) cameras exhibit amp glow. In addition, the effects of this problem are difficult to discern even when they're present; you might have to use the Auto Levels or Auto Contrast controls of Photoshop or another image editor to make the effect clearly visible. Unless you're an astrophotographer or routinely make exposures more than 30 seconds long, you probably don't need to worry about this problem. If you do find it bothersome, I recommend talking to Nikon to see if they are willing to exchange your early-model camera for one that exhibits less (or no) amp glow.

Other kinds of noise

While the D80 does a pretty good job of suppressing noise, whether caused by long exposures or high ISO settings, right out of the box, you can do a few things to banish those multicolored speckles.

✦ **Fine-tune ISO Auto.** The ISO Auto setting, available only when P, S, A, and M modes are used, automatically boosts the ISO sensitivity if necessary when a good exposure can't be obtained at the current ISO setting. While that can be helpful under certain conditions, if this ISO increase results in unwanted noise, you might find the feature more trouble than it's worth. You can turn the ISO Auto feature off in the Custom Settings menu (CSM 07), or switch it on if you wish. If you do use it, fine-tune the feature by specifying the maximum sensitivity setting that will be used with one CSM 07 option. If you prefer that the ISO Auto boost go no higher than ISO 800, you can choose that. You can also specify the slowest shutter speed that will be used as the threshold for activating the ISO Auto feature. For example, if ISO can be changed whenever the shutter speed required is slower than 1/60 second, you can specify 1/4 second instead to delay activation. That might be a smart move if

AA.4 Amp glow may manifest itself only after long exposures.

you're using a Vibration Reduction lens and know that you can safely take pictures at 1/8, 1/15, or 1/30 second without the need to increase the ISO.

✦ **Turn long exposure noise reduction on.** You can find this option in the Shooting menu. When the option is activated, the D80 applies noise reduction (NR) for photos taken at shutters speeds of about eight seconds or longer.

✦ **Turn high ISO noise reduction on.** This option is also found in the Shooting menu. Even when it is turned off, the D80 still applies some noise reduction to images taken at ISO 800 or higher. When this feature is turned on, you have your choice of Normal noise reduction (applied to images when ISO settings of ISO 400 or higher are used), Low noise reduction (a diminished amount of NR is applied), or High noise reduction (a maximum amount of NR is applied).

✦ **Relegate noise reduction to a software tool.** Applications and utilities that process RAW files, such as Nikon Capture, Nikon Capture NX, Adobe Camera Raw, Photoshop, and other software applications, such as Noise Ninja or Neat Image can remove noise. Removing speckles during post-processing gives you greater control, and eliminates the shooting delays that can result from in-camera noise reduction features.

Cleaning Your Sensor

No matter how careful you are, dust will eventually find its way inside your camera and onto the sensor. Although sensor dust

is annoying, it's not a serious problem — unless you use a very small f-stop (on the order of f/16 or f/22), you may not even spot it — and it can easily be cleaned off. Unfortunately, many D80 owners panic at the first sign of sensor dust, and pale at the thought of reaching inside their camera to work on an exposed sensor. Panic isn't necessary. In the first place, the sensor itself is protected behind a hard glass filter. In addition, what neophyte dSLR owners think is sensor dust might in fact be something else.

If you see tiny specks in your viewfinder or dust on your camera's mirror, that isn't sensor dust. Neither has any effect on your photographs, and you can often quickly remove the dust with an air blower. (Avoid touching the mirror with any sort of cleaning tissue or cloth as it's easy to scratch its front-surfaced mirror coating.)

A bright spot in the same location in all your photos is not sensor dust either (see figure AA.5). That's most likely a *hot pixel* (one that turns on when the sensor becomes warm from a long exposure, regardless of whether there is picture information in that spot), or a *stuck pixel* (one that is permanently on or off).

A few bad pixels may not be noticeable, but if you have more than a couple, they can be removed by a process called *pixel mapping*, which any Nikon Service Center can do for you. These pixels can also show up on your D80's color LCD panel, but unless they are abundant, the wisest course is to just ignore them. They harm nothing.

Actual sensor dust is likely to show up as an irregular out-of-focus blob that appears in the same place in every photo. Such artifacts may be visible only at smaller f-stops and vanish at larger apertures. They're easiest to see in areas without much detail, such as sky. To test for sensor dust, take some test

shots of a plain, blank surface (such as a piece of paper or a cloudless sky) at small f-stops, such as f/22 and a few wide open. Open your image editor, copy several shots into a single document in separate layers, and then flip back and forth between layers to see if any spots you see are present in all layers. You may have to boost contrast and sharpness to make the dust easier to spot.

Your best bet for dealing with sensor dust is to avoid it entirely, by working only in clean areas when possible and not changing lenses when in areas prone to dust. Keep your lenses clean — it's easy for dust specks on the rear bayonet to infiltrate farther, past the shutter, and onto your sensor. Minimize the time your camera has no lens mounted, and when you do change lenses, point the D80 downwards so that any dust tends to fall away from the inside of the camera. Keep the mirror box area clean with a blower to reduce the amount of dust that might get past the shutter.

AA.5 A hot or stuck pixel is usually surrounded by other erroneous pixels that aren't defective, but which are incorrectly activated by the sensor's processing algorithms that are misinterpreting the truly errant photosite.

Tiny or infrequent dust spots on your images can be cloned out with an image editor or eliminated using a tool like Photoshop's Dust & Scratches filter. When the spots really become bothersome, it's time to consider an actual cleaning. You might find that your local camera shop will do it for you and show you how to do it in the future, but it's really not that big a deal.

To clean your sensor, first make sure that your D80 is operating on a full-charged battery or is attached to an AC adapter. Then, move on to the Setup Menu and choose the Mirror Lock-Up options. Select ON and press the OK button. You see a message:

```
When shutter button is
pressed, the mirror lifts and
the shutter opens. To lower
mirror, turn camera off.
```

Go ahead press the shutter release, remove the lens from the D80, and clean the sensor using one of the following methods:

✦ **Air cleaning:** Use a strong blast of air from a tool designed especially for cleaning sensors, such as the Giottos Rocket (see figure AA.6). You can also use a clean nasal aspirator or ear syringe. Do not use canned air, which can baste your sensor with propellant, or compressed air, which may be too strong and end up forcing dust underneath the sensor's protective filter. This works well for dust that's not clinging stubbornly to your sensor and should probably always be your first approach.

✦ **Brushing:** Pass a soft, very fine brush across the surface of the sensor's filter, dislodging mildly persistent dust particles and sweeping them off the imager. You can find special brushes designed especially for cleaning sensors that are free of contaminants that might adhere to the sensor.

✦ **Liquid cleaning:** Use a soft swab dipped in a cleaning solution such as ethanol to wipe the sensor filter, removing more obstinate particles. Photographic Solutions' Eclipse is an especially pure solution for this process. You can find inexpensive swabs and other supplies at Web sites such as www.visibledust.com and www.copperhillimages.com.

AA.6 An air blower can safely blast off sensor dust.

AA.7 Use only a pure solution designed for digital camera cleaning when using swabs to wet-clean your sensor.

Glossary

additive primary colors The red, green, and blue hues that are used alone or in combination to create all other colors that you capture with a digital camera, view on a computer monitor, or work with in an image-editing program, such as Photoshop. See also *CMYK color model*.

AE/AF lock A control on the D80 that lets you lock the current autoexposure (AE) and/or autofocus (AF) settings prior to taking a picture, freeing you from having to hold the shutter release partially depressed, although you must depress and hold the shutter release partially to apply the feature.

ambient lighting Diffuse, nondirectional lighting that doesn't appear to come from a specific source but, rather bounces off walls, ceilings, and other objects in the scene when a picture is taken.

analog/digital converter The electronics built into a camera that convert the analog information captured by the sensor into digital bits that can be stored as an image bitmap.

angle of view The area of a scene that a lens can capture, determined by the focal length of the lens. Lenses with a shorter focal length have a wider angle of view than lenses with a longer focal length.

anti-alias A process that smoothes [the look of] rough edges in images (called *jaggies* or *staircasing*) by adding partially transparent pixels along the boundaries of diagonal lines, which our eyes then merge into smoother lines. See also *jaggies*.

aperture-preferred A camera setting that enables you to specify the lens opening or f-stop that you want to use, while the camera selects the required shutter speed automatically based on its light-meter reading. See also *shutter-preferred*.

artifact A type of noise in an image, or an unintentional image component produced in error by a digital camera during processing, usually caused by the JPEG compression process in digital cameras.

aspect ratio The proportions of an image as it would be when printed, displayed on a monitor, or captured by a digital camera.

autofocus A camera setting that enables the D80 to choose the correct focus distance for you, usually based on the contrast of an image (the image is at maximum contrast when it is in sharp focus). You can set your camera for *single autofocus* (the lens is not focused until the shutter release is partially depressed) or *continuous autofocus* (the lens refocuses constantly as you frame and reframe the image).

autofocus assist lamp A light source built into a digital camera that provides extra illumination that the autofocus system can use to focus dimly lit subjects.

averaging meter A light-measuring device that calculates exposure based on the overall brightness of the entire image area. *Averaging* tends to produce the best exposure when a scene is evenly lit or contains equal amounts of bright and dark areas that contain detail. The D80 uses much more sophisticated exposure-measuring systems, which are based on center-weighting, spot-reading, or calculating exposure from a matrix of many different picture areas. See also *center-weighted meter* and *spot meter*.

backlighting A lighting effect produced when the main light source is located behind the subject. You can use backlighting to create a silhouette effect or to illuminate translucent objects. See also *frontlighting* and *sidelighting*.

barrel distortion A lens defect, usually found at wide-angle focal lengths, that causes straight lines at the top or side edges of an image to bow outward into a barrel shape. See also *pincushion distortion*.

blooming An image distortion caused when a photosite in an image sensor has absorbed all the photons it can handle, so that additional photons reaching that pixel overflow to affect surrounding pixels, producing unwanted brightness and overexposure around the edges of objects.

blur To soften an image or part of an image by throwing it out of focus, or by allowing it to become soft due to subject or camera motion. You can also apply blur in an image-editing program.

bokeh A buzzword used to describe the aesthetic qualities of the out-of-focus parts of an image. Some lenses produce "good" bokeh while others produce "bad" bokeh. *Boke* is a Japanese word for "blur," and the *h* was added to keep English speakers from rhyming it with *broke*. Out-of-focus points of light become discs, called the *circle of confusion*. Some lenses produce a uniformly illuminated disc. Others, most notably mirror or catadioptic lenses, produce a disc that has a bright edge and a dark center, creating a "doughnut" effect, which is the worst from a bokeh standpoint. Lenses that generate a bright center that fades to a darker edge are more desirable because their bokeh allows the circle of confusion to blend more smoothly with the surroundings. The bokeh characteristics of a lens are most important when you're using selective focus (for example, when shooting a portrait) to deemphasize the background, or when shallow depth of field is a given because you're working with a macro lens, with a long telephoto, or with a wide-open aperture. See also *circle of confusion*.

bounce lighting The light bounced off a reflector, including ceiling and walls, to provide a soft, natural-looking light.

bracketing Taking a series of photographs of the same subject using different settings, including exposure, color, and white balance, to help ensure that one setting is the correct one. The D80 enables you to choose the order in which bracketed settings are applied and the number of frames to be shot in the bracketed set.

buffer The digital camera's internal memory, where an image is stored immediately after it is taken until it can be written to the camera's nonvolatile (semipermanent) memory or a memory card.

burst mode The digital camera's equivalent of the film camera's motor drive, the burst mode is used to take multiple shots within a short period of time.

calibration A process used to correct for the differences in the output of a printer or monitor when the output is compared to the original image. Once you've calibrated your scanner, monitor, and/or your image editor, the images you see on the screen more closely represent what you'll get from your printer, even though calibration is never perfect.

Camera Raw A plug-in included with Photoshop and Photoshop Elements that can manipulate the unprocessed images captured by digital cameras, such as the D80's Nikon Electronic Files (NEFs).

camera shake The movement of the camera, aggravated by slower shutter speeds, which produces a blurred image. Nikon offers several vibration reduction lenses that shift lens elements to counter this movement, including a new 18200mm VR (vibration reduction) lens introduced at the same time as the Nikon D200, which was unveiled almost a year before the D80.

CCD See *charge-coupled device (CCD)*.

center-weighted meter A light-measuring device that emphasizes the area in the middle of the frame when you're calculating the correct exposure for an image. See also *averaging meter* and *spot meter*.

charge-coupled device (CCD) A type of solid-state sensor that captures the image. It is used in scanners and digital cameras, including the Nikon D80, but not its pro camera sibling, the D2X, which uses a CMOS sensor.

chromatic aberration An image defect, often appearing as green or purple fringing around the edges of an object, caused by a lens failing to focus all colors of a light source at the same point. See also *fringing*.

circle of confusion A term applied to the fuzzy discs produced when a point of light is out of focus. The circle of confusion is not a fixed size. The viewing distance and amount of enlargement of the image determine whether you see a particular spot on the image as a point or as a disc. See also *bokeh*.

close-up lens A lens add-on that enables you to take pictures at a distance that is less than the closest focusing distance of the lens alone.

CMOS See *complementary metal-oxide semiconductor (CMOS)*.

CMYK color model A way of defining all possible colors in percentages of cyan, magenta, yellow, and frequently, black. K represents black, to differentiate it from blue in the RGB color model. Black is added to improve renditions of shadow detail. CMYK is commonly used for printing (both on press and with your inkjet or laser color printer).

color correction Changing the relative amounts of color in an image to produce a desired effect, typically a more accurate representation of those colors. Color correction can fix faulty color balance in the original image, or compensate for the deficiencies of the inks used to reproduce the image.

complementary metal-oxide semiconductor (CMOS) A method for manufacturing a type of solid-state sensor that captures the image that is used in scanners and digital cameras such as the Nikon D2X.

compression Reducing the size of a file by encoding, using fewer bits of information to represent the original. Some compression schemes, such as JPG, operate by discarding some image information, while others, such as TIFF, preserve all the detail in the original, discarding only redundant data.

continuous autofocus An automatic focusing setting (AF-C) in which the camera constantly refocuses the image as you frame the picture. This setting is often the best choice for moving subjects. See also *single autofocus*.

contrast The range between the lightest and darkest tones in an image. A high-contrast image is one in which the shades fall at the extremes of the range between white and black. In a low-contrast image, the tones are closer together.

dedicated flash An electronic flash unit, such as the Nikon SB-600 or SB-800, designed to work with the automatic exposure features of a specific camera.

depth of field (DOF) A distance range in a photograph in which all included portions of an image are at least acceptably sharp. With the Nikon D80, you can see the available depth of field at the *taking aperture* by pressing the depth-of-field preview button, or estimate the range by viewing the depth-of-field scale found on many lenses.

diaphragm An adjustable component, similar to the iris in the human eye, which can open and close to provide specific-sized lens openings, or f-stops to control the amount of light striking the film or sensor.

diffuse lighting Soft, low-contrast lighting.

digital processing chip A solid-state device found in digital cameras that's in charge of applying the image algorithms to the raw picture data prior to storage on the memory card.

diopter A value used to represent the magnification power of a lens, calculated as the reciprocal of a lens's focal length (in meters). Diopters are most often used to represent the optical correction used in a viewfinder to adjust for limitations of the photographer's eyesight, and to describe the magnification of a close-up lens attachment.

equivalent focal length A digital camera's focal length, which can be translated into the corresponding values for a 35mm film camera if the sensor is smaller than 24mm x 36mm. You can calculate this value for lenses you use with the Nikon D80 by multiplying by 1.5.

exchangeable image file format (Exif) A format that was developed to standardize the exchange of image data between hardware devices and software. A variation on JPG, Exif is used by most digital cameras, and includes information such as the date and time a photo was taken, the camera settings, the resolution, the amount of compression, and other data.

exposure The amount of light allowed to reach the film or sensor, determined by the intensity of the light, the amount admitted by the iris of the lens, and the length of time determined by the shutter speed.

exposure lock A camera feature that lets you freeze the automatic exposure at the current value.

exposure value (EV) EV settings are a way of adding or decreasing exposure without the need to reference f-stops or shutter speeds. For example, if you tell your camera to add +1EV, it provides twice as much exposure, either by using a larger f-stop, a slower shutter speed, or both.

fill lighting In photography, it is the lighting used to illuminate shadows. You can use reflectors or additional incandescent lighting or electronic flash to brighten shadows. One common technique outdoors is to use the camera's flash as a fill.

filter In photography, it is a device that fits over the lens, changing the light in some way. In image editing, it is a feature that changes the pixels in an image to produce blurring, sharpening, and other special effects. The D80 includes several in-camera filters in its Retouch menu, under the Monochrome and Filter Effects submenus. Photoshop also includes several interesting filter effects, including Lens Blur and Photo Filters.

firmware The camera's "operating system," which determines how images are exposed, processed, and stored to the memory card, and what features are available in the menus, as well as how menus are displayed. Camera manufacturers such as Nikon issue firmware updates from time to time that you can use to fix bugs or add new features.

flash sync The timing mechanism that ensures an internal or external electronic flash fires at the correct time during the exposure cycle. The flash sync speed for a single lens reflex (SLR) is the highest shutter speed that can be used with flash; ordinarily, with the Nikon D80, it is 1/200 of a second. See also *front-curtain sync* and *rear-curtain sync.*

focal length The distance between the film and the optical center of the lens when the lens is focused on infinity; usually measured in millimeters.

focal plane A line, perpendicular to the optical access, which passes through the focal point forming a plane of sharp focus when the lens is set at infinity. A focal plane indicator is etched into the Nikon D80 at the lower-left corner of the top panel next to the Mode dial.

focus lock A camera feature that lets you freeze the automatic focus of the lens at a certain point, when the subject you want to capture is in sharp focus.

focus servo A digital camera's mechanism that adjusts the focus distance automatically. You can set the focus servo to single autofocus (AF-S), which focuses the lens only when the shutter release is partially depressed, and continuous autofocus (AF-C), which adjusts focus constantly as the camera is used. The automatic autofocus

(AF-A) setting switches between the two, depending on whether the subject is moving or not.

focus tracking The capability of the automatic focus feature of a camera to change focus as the distance between the subject and the camera changes. One type of focus tracking is *predictive,* in which the mechanism anticipates the motion of the object being focused on, and adjusts the focus to suit.

fringing A chromatic aberration that produces fringes of color around the edges of subjects, caused by a lens's inability to focus the various wavelengths of light onto the same spot. Purple fringing is especially troublesome with backlit images. See also *chromatic aberration.*

front-curtain sync The default kind of electronic flash synchronization technique, originally associated with focal plane shutters, which consists of a traveling set of curtains, including a *front curtain* (which opens to reveal the film or sensor) and a *rear curtain* (which follows at a distance determined by the shutter speed to conceal the film or sensor at the conclusion of the exposure). For a flash picture to be taken, the entire sensor must be exposed at one time to the brief flash exposure, so the image is exposed after the front curtain has reached the other side of the focal plane, but before the rear curtain begins to move. Front-curtain sync causes the flash to fire at the beginning of this period, when the shutter is completely open, in the instant that the first curtain of the focal plane shutter finishes its movement across the film or sensor plane. With slow shutter speeds, this feature can create a blur effect from the ambient light, which appears as patterns that follow a moving subject with the subject shown sharply frozen at the beginning of the blur trail. See also *rear-curtain sync.*

frontlighting The illumination that comes from the direction of the camera. See also *backlighting* and *sidelighting.*

f-stop The relative size of the lens aperture, which helps determine both exposure and depth of field. The larger the f-stop number, the smaller the aperture itself.

graduated filter A lens attachment with variable density or color from one edge to another. A graduated neutral density filter, for example, can be oriented so the neutral density portion is concentrated at the top of the lens's view with the less dense or clear portion at the bottom, thus reducing the amount of light from a very bright sky while not interfering with the exposure of the landscape in the foreground. Graduated filters can also be split into several color sections to provide a color gradient between portions of the image.

gray card A piece of cardboard or other material with standardized 18-percent reflectance. Gray cards can be used as a reference for determining correct exposure or for setting white balance.

high contrast A wide range of density in a print, a negative, or another image.

highlights The brightest parts of an image containing detail.

histogram A kind of chart showing the relationship of tones in an image using a series of 256 vertical bars, one for each brightness level. The horizontal axis represents pixel brightness, with dark pixels on the left and bright pixels on the right, while the vertical axis shows the number of pixels in each brightness range. A *histogram chart,* such as the one the D80 can display during picture review, typically looks like a curve with one or more slopes and peaks, depending on

how many highlight, middle, and shadow tones are present in the image. The D80 includes a brightness (luminance) histogram as well as separate red, green, and blue (RGB) histograms in its information display.

hot shoe A mount on top of a camera used to hold an electronic flash that provides an electrical connection between the flash and the camera.

hyperfocal distance A point of focus where everything from half that distance to infinity appears to be acceptably sharp. For example, if your lens has a hyperfocal distance of 4 feet, everything from 2 feet to infinity appears sharp. The hyperfocal distance varies by the lens and the aperture in use. If you know you'll be making a grab shot without warning, sometimes it's useful to turn off your camera's automatic focus, and set the lens to infinity, or, better yet, set the hyperfocal distance. Then, you can snap off a quick picture without having to wait for the lag that occurs with many digital cameras as their autofocus locks in.

image rotation A feature that senses whether a picture was taken in horizontal or vertical orientation. That information is embedded in the picture file so that the camera and compatible software applications can automatically display the image in the correct orientation.

image stabilization A technology, which Nikon calls *vibration reduction*, that compensates for camera shake, usually by adjusting the position of the camera sensor or lens elements in response to movements of the camera.

incident light Illumination falling on a surface.

International Organization for Standardization (ISO) A governing body that provides standards used to represent film speed, or the equivalent sensitivity of a digital camera's sensor. Digital camera sensitivity is expressed in ISO settings.

interpolation A technique digital cameras, scanners, and image editors use to create new pixels that are required whenever you resize or change the resolution of an image based on the values of surrounding pixels. Devices such as scanners and digital cameras can also use interpolation to create pixels in addition to those actually captured, thereby increasing the apparent resolution or color information in an image.

ISO See *International Organization for Standardization (ISO)*.

jaggies The staircasing effect of lines that are not perfectly horizontal or vertical, caused by pixels that are too large to represent the line accurately. See also *anti-alias*.

JPEG A file in *lossy* format (short for *Joint Photographic Experts Group*) that supports 24-bit color and reduces file sizes by selectively discarding image data. Digital cameras generally use JPEG compression to pack more images onto memory cards. You can select how much compression is used (and, therefore, how much information is thrown away) by selecting from among the Standard, Fine, Super Fine, or other quality settings your camera offers. See also *RAW*.

Kelvin (K) A unit of measure based on the absolute temperature scale in which absolute zero is zero. It is used to describe the color of continuous-spectrum light sources, and is applied when you set white balance. For example, daylight has a color temperature of about 5500K, and a tungsten lamp has a temperature of about 3400K.

lag time The interval between when the shutter is pressed and when the picture is actually taken. During that span, the camera may be automatically focusing and calculating exposure. With digital single lens reflex (dSLR) cameras such as the Nikon D80, lag time is generally very short; with non-dSLRs, the elapsed time easily can be one second or more.

latitude The range of camera exposures that produces acceptable images with a particular digital sensor or film.

lens flare A feature of conventional photography that is both a bane and a creative outlet. It is an effect produced by the reflection of light internally among elements of an optical lens. Bright light sources within or just outside the field of view cause lens flare. Flare can be reduced by the use of coatings on the lens elements or with the use of lens hoods. Photographers sometimes use the effect as a creative technique, and image editors like Photoshop include a filter that lets you add lens flare at your whim.

lighting ratio The proportional relationship between the amount of light falling on the subject from the main light and other lights, expressed in a ratio; for example, 3:1 indicates that the highlight areas of the subject are three times as bright as the shadow areas.

lossless compression An image-compression scheme, such as TIFF, that preserves all image detail. When the image is decompressed, it is identical to the original version.

lossy compression An image-compression scheme, such as JPEG, that creates smaller files by discarding image information, which can affect image quality.

macro lens A lens that provides continuous focusing from infinity to extreme close-ups, often to a reproduction ratio of 1:2 (half life-size) or 1:1 (life-size).

matrix metering A system of exposure calculation that looks at many different segments of an image to determine the brightest and darkest portions. The 3D Color Matrix system used by the D80 looks at a wide area of the frame and sets exposure according to the distribution of brightness, color and distance with consideration for the image composition.

midtones Parts of an image with tones of an intermediate value, usually in the 25- to 75-percent range. Many image-editing features enable you to manipulate midtones independently from the highlights and shadows.

mirror lock-up A feature that gives you the capability to retract the single lens reflex's mirror to reduce vibration prior to taking the photo (with some cameras), or, with the Nikon D80, access to the sensor for cleaning.

modeling flash A series of low-power flashes triggered in rapid succession to simulate continuous lighting and to give you a preview for how the illumination from the flash unit will appear in the finished photo.

NEF (Nikon Electronic File) Nikon's name for its proprietary RAW format.

neutral color A color in which red, green, and blue are present in equal amounts, producing a gray.

neutral density filter A gray camera filter reducing the amount of light entering the camera without affecting the colors.

noise In an image, it is pixels with randomly distributed color values. Noise in digital photographs tends to be the product of low-light conditions and long exposures, particularly when you've set your camera to a higher ISO rating than normal.

noise reduction A technology used to cut down on the amount of random information in a digital picture, usually caused by long exposures at increased sensitivity ratings. In the Nikon D80, noise reduction involves the camera automatically taking a second blank/dark exposure at the same settings that contains only noise, and then using the blank photo's information to cancel out the noise in the original picture. Although the process is very quick, it does double the amount of time required to take the photo.

normal lens A lens that makes the image in a photograph appear in a perspective that is like that of the original scene, typically with a field of view of roughly 45°.

overexposure A condition in which too much light reaches the film or sensor, producing a dense negative or a very bright/light print, slide, or digital image.

pincushion distortion A type of lens distortion, most often found at telephoto focal lengths, in which lines at the top and side edges of an image are bent inward, producing an effect that looks like a pincushion. See also *barrel distortion*.

polarizing filter A filter that forces light, which normally vibrates in all directions, to vibrate only in a single plane, reducing or removing the specular reflections from the surface of objects.

RAW An image file format, such as the NEF format in the Nikon D80, which includes all the unprocessed information the camera captures. RAW files are very large compared to JPEG files and must be processed by a special program such as Nikon Capture, Capture NX, or Adobe's Camera Raw filter after being downloaded from the camera. See also *JPEG*.

rear-curtain sync An optional kind of electronic flash synchronization technique, originally associated with focal plane shutters, which consist of a traveling set of curtains, including a *front curtain* (which opens to reveal the film or sensor) and a *rear curtain* (which follows at a distance determined by shutter speed to conceal the film or sensor at the conclusion of the exposure). For a flash picture to be taken, the entire sensor must be exposed at one time to the brief flash exposure, so the image is exposed after the front curtain has reached the other side of the focal plane, but before the rear curtain begins to move. Rear-curtain sync causes the flash to fire at the end of the exposure, an instant before the second or rear curtain of the focal plane shutter begins to move. With slow shutter speeds, this feature can create a blur effect from the ambient light, appearing as patterns that follow a moving subject with the subject shown sharply frozen at the end of the blur trail. If you were shooting a photo of The Flash, the superhero would appear sharp, with a ghostly trail behind him. See also *front-curtain sync*.

red-eye An effect from flash photography that appears to make a person's eyes glow red, or an animal's glow yellow or green. It's caused by light bouncing from the retina of the eye and is most pronounced in dim illumination (when the irises are wide open),

and when the electronic flash is close to the lens and, therefore, prone to reflect directly back. The D80 has two red-eye reduction features: one is a bright lamp that glows, causing the subject's pupils to contract (if they are looking at the camera), and a red-eye reduction feature in the Retouch menu. Image editors can fix red-eye by cloning other pixels over the offending red or orange ones.

RGB color model A color model that represents the three colors — red, green, and blue — used by devices such as digital cameras, scanners, or monitors to reproduce color. Photoshop works in RGB mode by default, and even displays CMYK images by converting them to RGB.

saturation The purity of color; the amount by which a pure color is diluted with white or gray.

selective focus Choosing a lens opening that produces a shallow depth of field. Usually this is used to isolate a subject by causing most other elements in the scene to be blurred.

self-timer A mechanism that delays the opening of the shutter for some seconds after the release has been operated.

sensitivity A measure of the degree of response of a film or sensor to light, measured using the ISO setting.

shadow The darkest part of an image, represented on a digital image by pixels with low numeric values.

sharpening Increasing the apparent sharpness of an image by boosting the contrast between adjacent pixels that form an edge.

shutter In a conventional film camera, the shutter is a mechanism consisting of blades, a curtain, a plate, or some other movable cover that controls the time during which light reaches the film. Some digital cameras use actual mechanical shutters for the slower shutter speeds and an electronic shutter for higher speeds.

shutter-preferred An exposure mode in which you set the shutter speed and the camera determines the appropriate f-stop. See also *aperture-preferred*.

sidelighting Applying illumination from the left or right sides of the camera. See also *backlighting* and *frontlighting*.

single autofocus An automatic focusing setting (AF-S) in which the camera locks in focus when you press the shutter release halfway. This setting is usually the best choice for stationary subjects. See also *continuous autofocus*.

slave unit An accessory flash unit that supplements the main flash, usually triggered electronically when the slave senses the light output from the main unit or through radio waves.

slow sync An electronic flash synchronizing method that uses a slow shutter speed so that ambient light is recorded by the camera in addition to the electronic flash illumination. This enables the background to receive more exposure for a more realistic effect.

specular highlight Bright spots in an image caused by reflection from light sources or a shiny surface.

spot meter An exposure system that concentrates on a small area in the image. See also *center-weighted meter* and *averaging meter*.

subtractive primary colors Cyan, magenta, and yellow, which are the printing inks that theoretically absorb all color and produce black. In practice, however, they generate a muddy brown, so black is added to preserve detail (especially in shadows). The combination of the three colors and black is referred to as CMYK. (K represents black, to differentiate it from blue in the RGB model.)

TIFF (Tagged Image File Format) A standard lossless graphics file format that can be used to store grayscale and color images, plus selection masks. See also *JPEG* and *RAW.*

time exposure A picture taken by leaving the shutter open for a long period, usually more than one second. The camera is generally locked down with a tripod to prevent blur during the long exposure.

time lapse A process by which a tripod-mounted camera takes sequential pictures at intervals, allowing the viewing of events that take place over a long period of time, such as a sunrise or flower opening. With the D80, time-lapse photography is accomplished by connecting the camera to a computer with the USB cable and triggering the pictures with Nikon Capture or Capture NX.

through-the-lens (TTL) A system of providing viewing and exposure calculation through the actual lens taking the picture.

tungsten light Illumination from ordinary room lamps and ceiling fixtures, as opposed to fluorescent illumination.

underexposure A condition in which too little light reaches the film or sensor, producing a thin negative, dark slide, muddy-looking print, or dark digital image.

unsharp masking The process for increasing the contrast between adjacent pixels in an image, boosting sharpness, especially around edges.

vignetting The dark corners of an image, often produced by using a lens hood that is too small for the field of view, using a lens that does not completely fill the image frame, or generating the effect artificially using image-editing techniques.

white balance The adjustment of a digital camera to the color temperature of the light source. Interior illumination is relatively red; outdoor light is relatively blue. Digital cameras often set correct white balance automatically or let you do it through menus. Image editors can often do some color correction of images that were exposed using the wrong white balance setting.

Index

Continued